Objects of Liberty

Objects of Liberty

BRITISH WOMEN WRITERS AND
REVOLUTIONARY SOUVENIRS

PAMELA BUCK

UNIVERSITY
OF DELAWARE
PRESS

NEWARK

Library of Congress Cataloging-in-Publication Data

Names: Buck, Pamela, 1975– author.
Title: Objects of liberty : British women writers and revolutionary
souvenirs / Pamela Buck.
Description: Newark : University of Delaware Press, 2024. | Series: Early
modern feminisms | Includes bibliographical references and index.
Identifiers: LCCN 2023024844 | ISBN 9781644533321 (paperback) | ISBN 9781644533338
(hardcover) | ISBN 9781644533345 (epub) | ISBN 9781644533352 (pdf)
Subjects: LCSH: Travelers' writings, English—History and criticism. | Souvenirs
(Keepsakes) in literature. | English prose literature—Women authors—History and
criticism | English prose literature—18th century—History and criticism. | English
prose literature—19th century—History and criticism. | Literature and revolutions. |
English literature—Political aspects. | BISAC: LITERARY CRITICISM / Women
Authors | LITERARY CRITICISM / Modern / 16th Century
Classification: LCC PR756.T72 B83 2024 | DDC 820.9/32—dc23/eng/202309252
LC record available at https://lccn.loc.gov/2023024844

A British Cataloging-in-Publication record for this
book is available from the British Library.

References to internet websites (URLs) were accurate at the time of writing. Neither
the author nor University of Delaware Press is responsible for URLs that may have
expired or changed since the manuscript was prepared.

♾ The paper used in this publication meets the requirements of the American
National Standard for Information Sciences—Permanence of Paper for Printed
Library Materials, ANSI Z39.48-1992.

udpress.udel.edu

Distributed worldwide by Rutgers University Press

In memory of Carol H. Flynn

Contents

List of Figures

Acknowledgments

This project began as my dissertation in the English PhD program at Tufts University. I thank Sonia Hofkosh, Carol Flynn, Sheila Emerson, and Susan Lanser for their insightful critiques and direction early in the process.

My thanks to colleagues who engaged with and helped me refine my ideas at conferences organized by the North American Society for the Study of Romanticism, the International Conference on Romanticism, the Romantic Studies Association of Australasia, the British Society for Eighteenth-Century Studies, the British Women Writers Association, and the Chawton House Library. I am grateful to David Palumbo and Anand Yang for their thoughtful comments on the proposal and manuscript, Emma Gleadhill for kindly sharing proofs of her work, and Kathleen Urda and Daniel Epelbaum for their support and friendship.

A University Research and Creativity Grant awarded by Sacred Heart University in 2016 enabled me to research the Wilmots' unpublished manuscripts at the Royal Irish Academy in Dublin, Ireland, and I appreciate the assistance of Sophie Evans in this endeavor. I also thank my department and Sacred Heart University for supporting a sabbatical in fall 2017 and a leave of absence in fall 2020 that gave me time to revise the manuscript.

I am extremely grateful to Julia Oestreich and Robin Runia at University of Delaware Press for their interest in the project as well as to the anonymous readers for their generous feedback on the manuscript. They have made finishing this book a possibility and a pleasure.

Part of chapter 3 was previously published as "Collecting an Empire: The Napoleonic Louvre and the Cabinet of Curiosities in Catherine Wilmot's *An Irish Peer on the Continent*" in the journal *Prose Studies* (2011) and is reprinted by permission of the publisher Taylor & Francis Ltd. Another section of the chapter was previously published as "From Russia with Love: Souvenirs and Political Alliance in Martha Wilmot's *The Russian Journals*" in the volume *Eighteenth-Century Thing Theory in a Global Context* edited by Christina Ionescu and Ileana Baird (2013) and is reprinted by permission of Routledge as conveyed through Copyright Clearance Center, Inc.

Introduction

In a letter from her 1790 tour of Paris, British writer Helen Maria Williams recounts her purchase of a snuffbox that contains a picture of the Abbé Maury, a French cardinal and archbishop of Paris who was also an active member of the National Assembly. Revolutionaries in France despised him for being a member of the aristocracy and a supporter of the old regime. The snuffbox that Williams bought was a common sentimental object in the eighteenth century. A small receptacle for holding tobacco, it was also exchanged as a valuable gift. Her snuffbox assumes a new political function when "you touch a spring, open the lid of the snuff-box, and the Abbé jumps up, and occasions much surprize and merriment." Unexpectedly containing a leaping figure of the clergyman, the snuffbox employs the sentiment of humor to provoke viewers' laughter. Williams uses the box to satirize a prominent political figure and indicate her sympathy for the revolution in France. Moreover, she promises to "bring the Abbé with me to England, where I flatter myself his sudden appearance will afford some diversion."[1] Collected in France and shared at home, the snuffbox acts as a souvenir that she hopes will captivate her audience and encourage them to share her revolutionary views. When circulated across national borders, objects like the snuffbox disseminated new cultural and political ideas.

Objects of Liberty explores the prevalence of souvenirs such as the snuffbox in British women's writing during the French Revolution and Napoleonic era. The project focuses on six writers who kept accounts of their travels to the Continent and participated in the consumption and production of Revolutionary souvenirs. Looking primarily at writing from 1790 to 1817, I argue that women writers used the material and memorial object of the souvenir as a unique strategy to circulate revolutionary ideas and engage in the masculine realm of political debate. Examining the work of Helen Maria Williams, Mary Wollstonecraft, Catherine and Martha Wilmot, Charlotte Eaton, and Mary Shelley, I show how they employed souvenirs to affect political thought in Britain. Purchasing, collecting, and displaying souvenirs gave women more opportunities for public involvement, allowing them to become political actors and advocate for citizenship. I also investigate how women used souvenirs to contribute to conversations about national identity and to challenge dominant narratives of empire and war. By

promoting relationships abroad through souvenir exchange, they created international alliances that helped establish Britain's role in an increasingly global world. This study considers souvenirs through the critical lenses of literature and material culture to broaden our knowledge of women's roles in the political discourse of the Revolutionary age.

To understand how the souvenir functioned in a Revolutionary context, I use the term in a more flexible way than it has traditionally been defined. In French, the term *souvenir* is a verb meaning "to remember." Introduced into English by writer Horace Walpole in 1775, it came to function as a noun indicating a material object that embodies a memory.[2] According to Rolf Potts, the souvenir is generally a small and relatively inexpensive object secured by a traveler as a memento of a journey. Often collected for those at home, souvenirs allow a traveler to share their experiences abroad. They include a wide variety of purchased or found objects, including keepsakes, relics, gifts, and physical fragments of a travel destination or experience.[3] Valued as an item as well as for the memories connected with it, the souvenir marks, in Susan Stewart's words, "the transformation of materiality into meaning."[4] Potts notes that the souvenir gains meaning when connected to greater world events.[5] During the Revolutionary period, it assumed an overtly political importance, and Richard Taws indicates that material objects like souvenirs were used to negotiate the historical significance of the Revolution and visually transmit its message.[6] As I will show, collecting and circulating souvenirs allowed women writers to bring distant political events and ideas from the Continent home and define the Revolution as a meaningful and memorable event to a British audience.

Collecting souvenirs was a standard practice of privileged Englishmen on the eighteenth-century Grand Tour, and women began to partake in this endeavor as political events in France heightened interest in the Continent. Part of an aristocratic education, the Grand Tour was a traditional trip around Europe whose itinerary involved visits to France, the Netherlands, Germany, and Italy. Souvenir acquisition was an essential part of the tour, as it allowed the social elite the opportunity to obtain art, books, pictures, sculpture, and other items of culture that reflected their wealth and worldliness and would increase their prestige and standing at home.[7] During the Revolutionary era, women became active tourists as a rising middle class and cheaper, more reliable transport made travel increasingly accessible and democratic. The Revolution itself provided the occasion for a new kind of political tourism, and female travelers ventured across the Channel to witness events on the Continent for themselves. Although following the same itinerary as their male counterparts, they sought out sites

like Revolutionary Paris and the battlefield of Waterloo. Emma Gleadhill notes that souvenirs empowered women by providing physical proof of eyewitness experiences, which lent the souvenirs a different kind of prestige in the form of authority.[8] They, along with female travelers' reports, generated interest in and actively shaped views of the Revolution in Britain.

Souvenirs allowed women to encourage support for revolutionary principles because they represented political events in engaging ways. In the Revolution Debate, a public controversy in Britain that lasted from 1789 to 1799, the British generally supported the new constitutional monarchy in France, but the Revolution's violence also led to opposition, fear, and divisive political polarization. After Edmund Burke published *Reflections on the Revolution in France* in 1790 defending the French aristocracy, writers such as Williams and Wollstonecraft responded by arguing for democracy.[9] The material qualities of the souvenir facilitated the widespread circulation of revolutionary ideas. As Chloe Wigston Smith and Beth Fowkes Tobin explain, small objects like souvenirs, which could be carried in pockets and held in the hand, were easily transported across borders due to their size.[10] Gillian Russell observes that their three-dimensionality emphasized the importance of touch, encouraging physical engagement with the object.[11] Williams's box, which requires opening to experience the revolutionary message, possesses this quality of tactile discovery.

Souvenirs were also valued for their visual appeal. Designed to be eye-catching, their attractiveness, simplicity, novelty, or humor, as in the case of Williams's springing abbé, could inspire collection or purchase.[12] Through their circulation, souvenirs allowed women to provide representations of the conflict in France to an audience in Britain. As they crossed borders, state Smith and Tobin, they conveyed ideas from abroad. By entering women's domestic and private spaces, objects with political imagery brought controversial conversations into the home.[13] In this new environment, souvenirs transformed from private possessions to semipublic items in a collection. Through the arrangement and display of these items, women could narrate political events and ideas.[14] Souvenirs destined for exhibit were instrumental in political exchanges, so that when Williams displayed the snuffbox that she brought back from France at social gatherings, Revolutionary notions could be consumed as readily as tobacco.

Despite their seemingly trivial nature, then, souvenirs provided women with a powerful means of conveying political ideas. As Caroline McCaffrey-Howarth contends, small objects scaled down large events to make the politics and history of the Revolution accessible to a broader public. In this reversal of scale, souvenirs created a form of visual shorthand of current

events that more effectively enabled political understanding.[15] Serena Dyer argues that smallness also facilitated an object's power as a political tool. Although small things are characterized by the contradiction between their significance and their diminutive size, their miniaturization does not decrease their political significance but rather concentrates and intensifies it. In a phenomenon that Dyer terms "monumental miniaturization," souvenirs capture the immense size and meaning of events on a small scale, such as the replicas of the Bastille circulating across France that Williams observed.[16] Smith and Tobin further note that feminine accessories considered frivolous, like jewels, fans, and snuffboxes, assumed importance when they responded to political events and helped negotiate national feeling.[17] Often unremarkable in themselves, souvenirs gain value through the significant meanings they embody.

The souvenir also possesses the ability to capture moments and transform them into memories. Material objects like tricolor cockades made of cloth or paper were ephemeral, quickly produced and easily discarded. Even more permanent objects, such as patriotic jewelry crafted of expensive materials like precious stones, are aligned with fashionable change.[18] However, ephemeral objects paradoxically provided the most effective means of capturing the historical significance of the Revolution. As Russell states, they had the power "to freeze time" and "enabled people to be 'there,' in the actual ephemeral present." Serving as "durable repositories of memory," they ensured the preservation of historic events.[19] Beverly Gordon notes that the souvenir similarly renders tangible the intangible. It has the power to encapsulate an "extraordinary experience" because its physical presence arrests a brief, transitory moment of time.[20] Taking a souvenir from its point of origin and bringing it home transforms it into a significant icon, with all the associations of its original environment. By collecting ephemeral objects like souvenirs and taking them back to Britain, women in the Revolutionary period could preserve their lived experiences and render the extraordinary events of the Revolution both present and important.

Unlike the fine art objects collected by men on the Grand Tour, souvenirs were often cheap, mass-produced items widely available to consumers across social classes, which allowed women to become consumers and followers of fashion.[21] Not always directly purchased, some souvenirs simply participated in the trend of consumerism as women started to collect and carry them around.[22] Yet, in the early years of the Revolution, souvenirs afforded women more opportunities for political involvement. Kelly Fleming explains that women's accessories often featured complex political symbolism, and fans, jewelry, ribbons, and cockades publicized political ideologies

and allegiances.[23] While British women may have been barred from voting or serving in Parliament, Elaine Chalus and Fiona Montgomery contend that their formal exclusion from politics did not mean they were excluded from public life altogether. Women adopted fashion to proclaim party allegiance and politicize public space because their engagement was more acceptable when it grew out of traditional female roles. By carrying or wearing revolutionary items while socializing and shopping, they put their politics on display.[24] In doing so, claims Chalus, they "subverted fashion, adopted it to serve their political purposes, and effectively turned themselves into political canvasses."[25] As they transformed ordinary fashion items into political statements, women became agents in the formation of public opinion.

Beyond women's employment of souvenirs as political symbols, they also used souvenirs to define themselves as political actors and advocate for citizenship. As Stewart states, the souvenir provides a narrative of interiority, not of the object, but of the possessor.[26] When collected on a tour, it became part of an individual account of the self. Politically charged fashion items functioned as souvenirs by allowing women to make both personal and collective statements of identity during this era.[27] As Potts maintains, the souvenirs one collects represent the person one wants to become.[28] For instance, donning a tricolor cockade when performing the role of Liberty in a play, Williams refashioned herself as a revolutionary figure. Women proclaimed that they were patriots who could contribute to the nation through souvenirs, and their participation in political life was ultimately a means of demanding broader access to citizenship.[29] Women's souvenirs further encouraged the formation of a cosmopolitan identity that crossed both gender and national lines. In wearing the cockade, an ornament emblematic of revolution beyond borders, Williams designated herself a "citizen of the world" to encourage Britain to adopt a more global view.[30] Even when Mary Wollstonecraft instead used the cockade to criticize the Revolution for failing to extend rights to women, souvenirs offered the promise of transformation by lending women new political identities.

As women gained agency, they collected souvenirs to challenge the dominant political narratives of the Napoleonic era. While men collected for power and control, notes Gleadhill, women tended to collect to negotiate and question male authority.[31] Grand Tourists employed the cabinet of curiosities to display their souvenirs, which helped advertise not only their prestige and status but also their worldliness and conquest.[32] As Napoleon conquered Europe, his Louvre Museum became a large-scale cabinet of art from subjugated countries that signaled the power of the French nation.

Stewart explains that the souvenir, which embodies remembrance, stands in opposition to the collection, which aims to forget the origins of objects by assembling them in a new context. The collection also legitimates a collector's need for possession, and in the enclosed, totalizing environment of the museum, it represents experiences within a mode of control and confinement.[33] Critical of the threat that Napoleon's rapidly expanding empire posed to Britain, Catherine Wilmot attempted to subvert his cultural dominance with her curiosity collecting. Russell observes that museum collections, with large art objects and institutional channels of dissemination, are relatively immobile, while the mobility of smaller objects contributes to their ability to escape regimes of control.[34] Wilmot's souvenir collecting, which eluded such control, defied Napoleon's imperial impulse.

During the Napoleonic era, women participated in shaping British national identity by promoting relationships abroad through their souvenir collecting. Souvenirs emerged from a culture of sensibility in the eighteenth century, and their sentimental exchange served to solidify personal friendships. Dyer notes that sentimental objects featuring public figures signaled larger political meanings and made political ideas more personal and affecting.[35] Objects of sociability could thus advance political agendas, making women important agents in negotiating diplomacy and creating international alliances.[36] As small things circulated beyond national borders, they bridged geographical spaces to create global networks.[37] Exchanging miniature portraits with Princess Ekaterina Dashkova of Russia, Martha Wilmot facilitated both a friendship and a political connection between their countries and suggested that building an alliance with a powerful country like Russia would provide Britain with an opportunity to block Napoleon's imperialism. Women also used souvenirs to advocate for the greater recognition and inclusion of Ireland and Scotland, whose support proved crucial in resisting Napoleon's attempts at invasion.[38] By establishing networks of sociability, women's circulation of sentimental souvenirs urged Britain to develop the international alliances needed to triumph in the Napoleonic Wars.

Women additionally employed souvenirs to redefine the masculine realm of war. After the Battle of Waterloo, elite male tourists brought back war booty for bragging rights.[39] Stewart calls such relics "anti-souvenirs," as they are "the mere material remains of what had possessed human significance." If souvenirs mark the conversion of materiality into meaning, then the anti-souvenir "marks the horrible transformation of meaning into materiality."[40] Potts argues, though, that these objects possess the same complex narratives as other souvenirs. Body parts like teeth or skulls are "war souvenirs,"

which signify the conquest and plunder of empire. In contrast are "tragedy souvenirs," whose emotional narratives are meant to help viewers understand a conflict they have not experienced.[41] Dyer adds that objects of national grief and mourning, which contain immense emotional power, could act as vehicles for the management of feelings or as signals for the appropriate emotions to express over war.[42] Although Charlotte Eaton gathered military relics during her visit to Waterloo to participate in British patriotism, she also collected tragedy souvenirs that memorialized the loss of life. Countering male collectors who used war souvenirs to present the battle as a victory, she conveyed the horror of war and balanced patriotism with the cost of conflict. In interpreting the male space of war through feminine concerns, she transformed the battlefield into a site of sympathy and commemoration as well as pride.

The souvenirs that women circulated further helped Britain envision its role in the global order that emerged after the Napoleonic Wars. Due to the era's fixation on celebrity, notes Potts, objects one used to remember close persons now evoked public figures and renowned leaders, promising a connection with greatness.[43] Increased demand for these souvenirs led to the creation of the gift shop, which made manufactured goods widely available. Noticing figurines of Napoleon for sale in a German store, Mary Shelley opted for a handmade wooden carving of Andreas Hofer, a local Tyrolean leader who died opposing Napoleon's invasion of Austria. Possessing an authenticity that the mass-produced figurines lacked, the Hofer carving enabled Shelley to challenge the myth of Napoleon as a Revolutionary hero. Potts also states that mass-market souvenirs can reinforce a narrative that sanitizes the broader realities of a person or event. Shelley argued that the Napoleon figurines overlooked the damage his wars did to the Continent. While tour guides popularized notions of what sights were worth seeing, collectors presented their own visions of how to view those sights.[44] Shelley's souvenirs allowed her to influence her readers' political views and encourage them to support liberal democracy across Europe.

Objects of Liberty contributes to recent scholarship on eighteenth-century material culture by redefining the souvenir in the Revolutionary context. Smith and Tobin's *Small Things in the Eighteenth Century* (2022) examines the history of how small things like fans, coins, and pottery were used, how their physical qualities aided their mobility, and how they negotiated larger political, cultural, and scientific shifts as they transported ideas across geographic borders. Russell's *The Ephemeral Eighteenth Century* (2020) looks at how printed ephemera such as tickets, playbills, and handbills, regarded as trivial and disposable, were essential in the development of the era's

culture. Russell investigates how the ability of seemingly meaningless objects to capture fleeting experiences renders them valuable. Typically small, souvenirs also transmitted political ideas as they circulated, and like ephemeral objects, they served as receptacles of memory. Yet not all souvenirs were tiny or ephemeral in nature. For instance, a Russian costume that Martha Wilmot sent home was large enough to risk seizure by border agents, while the miniature portraits that Dashkova gave her were priceless heirlooms meant to be preserved rather than discarded. My work defines the souvenir as a particular type of material thing whose personal and political value makes it a lasting memorial object.

This book also adds to recent literary studies on material culture by considering the souvenir alongside other objects represented in texts of this era. In *Artifacts* (2020), Crystal Lake asks what the small, fragmentary, often unidentifiable object of the artifact could reveal. She argues that eighteenth-century antiquaries used these old objects to establish what they claimed was a true account of history. She explores how writers such as Horace Walpole, Jonathan Swift, Lord Byron, and Percy Bysshe Shelley developed interpretations of the past based on the historical roles that they believed objects like coins, manuscripts, weapons, and grave goods once played. While artifacts resemble souvenirs as imagined entities, Lake contends that the souvenir, rooted more in memory than materiality, is not as important as the narrative it creates.[45] Although the souvenir is notable less for its intrinsic value than for being symbolic of a greater and more meaningful experience, I argue that it shares the ability to evoke a form of memory through its materiality and that its materiality was integral to late eighteenth- and early nineteenth-century women's creation of revolutionary narratives and intervention in contemporary debates. By providing an extended examination of the souvenir, my work considers its significance as a material object and focuses on female authors who transformed that materiality into an alternative mode of politics.

This project further extends new research that reveals the prominent role women played in society through material culture. Working from a historical disciplinary approach, Gleadhill considers how elite British female tourists developed a souvenir culture around the objects they brought back from their journeys in *Taking Travel Home* (2022). Focusing on the period between 1750 and 1830, she explores how women engaged in the masculine practice of the Grand Tour and used the souvenir to negotiate power in the realms of connoisseurship, science, and friendship. She shows how collecting souvenirs enabled women to challenge gender norms and develop their own subjectivity. I build on Gleadhill's work by offering an in-depth

examination of women's use of the souvenir in the political realm. Unlike elite female tourists whose collections supported Napoleon or the prerogatives of British imperialism, the writers I examine frequently used souvenirs to criticize ideologies of empire. While Gleadhill claims that the suspension of the Grand Tour during the Revolution and Napoleonic Wars prevented women's collecting, I show how collecting in this era not only continued but in fact was crucial to defining the souvenir and its role in enabling women's political involvement.

In my analysis of souvenirs, I primarily employ a literary methodology. I share with critics like Smith and Tobin an interest in relationality, or how people interact with things and how their actions are shaped by things. However, their goal is "to put the things in the foreground and the people in the background," whereas I prioritize human agency by examining how women responded to and used souvenirs.[46] While material culture scholarship provides a descriptive history of things, Melinda Alliker Rabb argues that literary texts bridge the gap between things and their representations, generating a process of understanding that alters the consciousness of human subjects.[47] My study likewise considers how the souvenirs invoked in women's texts shaped British views of the Revolution. Materialist approaches like thing theory and it-narratives further assume that objects are independent and animate.[48] On the contrary, Rabb contends that objects themselves do not narrate stories.[49] This is especially true of the souvenir, as most travel objects are unable to conjure an intuitive sense of significance for those who were not at the place or event the souvenir is from. As Stewart explains, the souvenir is always incomplete; it provides a trace of a distant experience that the object can evoke but not recover, requiring narrative discourse to attach it to its origins.[50] By focusing on women's travel narratives, I relate the material stories of the souvenir and offer evidence of its meaning and function.

In addition to using a literary methodology, I adopt the theoretical framework of new materialism to understand, as the title of this project indicates, the power of souvenirs as "objects of liberty."[51] According to Bruno Latour, who considers the agency of nonhuman subjects, objects are better defined as actants. Far "from being a simple tool," he notes, an actant "assumes all the dignity of a mediator, a social actor, an agent, an active being."[52] Building on this concept, Jane Bennett references the "vital materiality" of objects and contends that they "are encountered not as passive stuff awaiting animation by human power, but as lively forces at work around and within us."[53] In *Vibrant Matter*, she argues for the capacity of things to advance or impede the will of humans as well as to act as agents

or forces with trajectories of their own. As she states, the actant "has efficacy, can *do* things, has sufficient coherence to make a difference, produce effects, alter the course of events." She provides the example of metal, an inert substance associated with passivity that paradoxically possesses vital materiality in its effects.[54] Revolutionary souvenirs made of metal had a similar quality, and Bastille medals, bronze eagles, and Napoleon figurines could inspire patriotism or support for Revolutionary ideals. As objects, souvenirs were attractive for their potential to both embody and affect political views.

In harnessing the vibrant matter of souvenirs, women could achieve their objects or goals and become agents of political change. Bennett recognizes both human and nonhuman bodies as actants, which work collectively in "assemblages" or "groupings of diverse elements, of vibrant materials of all sorts."[55] Assemblages are less about a particular entity than about their joint force, as an actant's agency depends on its collaboration and interaction with others. As she states, such "temporary working assemblages are, as much as any individuated thing, loci of effectivity and allure."[56] She notes that these "systems enact real change," creating networks that drive new political movements capable of altering existing social structures. When actants collaborate, they also cease to be governed by a central power, instead posing a "democratization [that] can be broadened to acknowledge more nonhumans in more ways . . . to hear the political voices of other humans formerly on the outs," like those of women.[57] Working in assemblages with souvenirs, writers like Catherine Wilmot and Eaton supported the democratic notions of the Revolution by reframing centralized male hierarchies of power, including those of empire and war. Through these inclusive alliances, they also advocated for other marginalized groups like the Scottish, the Irish, and war veterans. By circulating representations of Revolutionary souvenirs, they endeavored to create support for change at home.

If new materialism shows how objects like souvenirs empower women politically, object-oriented feminism argues that they can help construct female subjectivity. According to Katherine Behar, this feminist intervention into new materialism aims to rethink the traditional relationship between subjects and objects in order to transform the power relations that objectification describes. She notes that feminism traditionally has involved ways of orienting politics through subjectivity. While directing it toward objects may seem to risk abandoning the concerns of real human subjects like women, the object world reveals the exploitation that women, perceived as objects, have experienced under patriarchy throughout history.[58]

By adopting a perspective of continuity between all objects, whether animate or inanimate, object-oriented feminism posits that women can, in Bennett's words, "become vibrant things with a certain effectivity of their own, a perhaps small but irreducible degree of independence."[59] When Williams and Wollstonecraft debate whether ornaments like the tricolor cockade contribute to the formation of women's political identities or perpetuate their continued treatment as objects, they engage fundamental questions about women's status and pose ways that the material world could allow them to achieve selfhood and freedom.

The theory of new materialism informs my literary methodology as well. As Bennett explains, texts function as special bodies, with literary things being "not simply a representation, but rather a nonhuman agent." They too can have material effects, illuminating our perception of "those bodies whose favored vehicle of affectivity is less wordy," such as everyday objects. Literature thus "can help us feel more of the liveliness hidden in such things and reveal more of the threads of connection binding our fate to theirs."[60] In *Reassembling the Social*, Latour similarly emphasizes the importance of making objects talk through narratives, which offer depictions of what material things can help others do. Written accounts are also important for tracing social connections and putting objects rendered mute by distance or time back in circulation.[61] By uncovering networks of assemblages, texts render the movement of the social world of objects visible to the reader. Martha Wilmot's journals, for instance, render visible the social process of diplomatic exchange as she circulated miniature portraits that she received from Dashkova to encourage Britain to form an alliance with Russia. In conveying the meanings of souvenirs and reconstructing their networks, Revolutionary-era women's writing made apparent the souvenir's dynamic nature and political impact. Considering literature as material reveals how women's texts and souvenirs worked together to influence British readers and their ideas about the Revolution.

With regard to scope, this book examines works by women writers that follow the pivotal moments of the period, from the Revolution Debate of the 1790s to the rise of Napoleon's empire and his defeat at the Battle of Waterloo in 1815. While most studies end here, I briefly trace the reemergence of ideas of liberty in the European nationalist movements of the 1840s to show how souvenirs marked an origin of activity and persisted as a mode of political intervention for women. Since souvenirs assume numerous forms, I include objects as varied as consumer goods, personal gifts, and bodily relics. Some women acquired physical objects, though others used the souvenir as a conceptual device for addressing political issues or

created literary souvenirs in their texts. For example, Wollstonecraft employed the rare-show, a small display or scene viewed in a box, as a metaphor for political deception, while Eaton's descriptive guide to Waterloo imitates the panorama key, a printed map that provided a visual representation of the battlefield. I analyze published and private letters, journals, and histories that women kept on their journeys, which provide firsthand evidence of the practices and culture of collecting.[62] In focusing on women and souvenirs, I offer new interpretations of familiar works by Williams, Wollstonecraft, and Shelley. I also help recover lesser-known writings by the Wilmots that are instrumental to understanding the Napoleonic era. Limited scholarship exists on female Scottish travelers or women tourists at Waterloo, and I fill these gaps by including Eaton's work.

In chapter 1, I argue that Helen Maria Williams employs the sentimental souvenir to create sympathy for revolutionary ideas. I show how her first volume of *Letters from France*, written during a trip to Paris in 1790, intervenes in the Revolution Debate to support values of liberty and equality and pose a new model of the nation. Williams describes miniature models of the Bastille in the letters that evoke sentiments of horror to convey the political abuses of the old regime and suggest revisions to England's monarchical government. Purchasing a snuffbox that mocks a prominent Catholic leader, she employs its sentiment of humor to challenge the power and privileges of the Church and urge support for religious and economic freedom. She shows how women repurpose their feminine jewels as Revolutionary ornaments to assume political identities and advocate for female citizenship. Although sensibility itself is not radical, she uses the sentimental object as a revolutionary strategy to circulate democratic ideas and forge a more cosmopolitan national identity in Britain. Her souvenirs are significant for marking a new direction in thinking about the nation and women's political involvement during the early Revolutionary period.

Chapter 2 shows how Mary Wollstonecraft responds to Williams in the Revolution Debate. Traveling to Paris during the Reign of Terror, she wrote *An Historical and Moral View of the French Revolution* in 1794 to explain the violent turn of events in France. I argue that she uses souvenirs in her work to counter the political spectacle of the Terror. Observing how guillotine executions incite emotion and enable tyranny, she employs the optical toy of the rare-show to reveal the illusions fostered by the old regime and perpetuated by the Jacobins.[63] She also exposes a commemorative medal honoring the patriotism of the National Assembly as a form of propaganda aimed at winning popular support while covering a plot against the Revolution. Contradicting Williams, she attributes women's failure to

obtain rights or citizenship to their reliance on ornaments, which as objects of luxury and sensibility allow politicians to manipulate them. In the face of an increasingly repressive form of nationalism in Britain, her discussion of souvenirs enables her to separate democratic ideals from their failed practice and encourage readers to continue supporting them.

Chapter 3 moves beyond the Revolution Debate to examine how Anglo-Irish writers Catherine and Martha Wilmot collected souvenirs to oppose Napoleon's expanding empire and its threat to liberty. In a journal kept during her tour of the Continent from 1801 to 1803, Catherine Wilmot shows how Napoleon uses the Louvre, a collection of art objects taken from conquered countries, to legitimate his empire. I argue that she constructs a cabinet of curiosities in her journal to counter his method of imperial acquisition. In journals recorded between 1803 and 1808 in Russia, Martha Wilmot details exchanging souvenirs with Princess Ekaterina Dashkova to encourage an alliance between Russia and Britain against Napoleon. Relying on female sociability, she accepts miniature portraits from Dashkova to establish a political bond as well as a masquerade costume to make foreign, exotic Russia fashionable at home. Appealing for equal representation under the British Empire, the Wilmots positioned Irish collecting as central to Britain's success against France. The circulation of material objects in their journals also shows how Britain began to develop international connections and redefine itself as a more global nation.

Building on responses to Napoleon in the previous chapter, chapter 4 examines relic collecting after his defeat in the Battle of Waterloo as depicted in Scottish writer Charlotte Eaton's *Narrative of a Residence in Belgium* of 1817. I argue that, while British tourists sought material reminders of their victory, Eaton gathered souvenirs to redefine masculine ideas of patriotism and advocate for a more inclusive national identity. Visiting the site a month after the battle, she created a panoramic map to guide her readers' viewing of the field and balance victory with the destruction of war. She also collected military relics of the Scottish Highland regiments to emphasize her country's contributions to Britain's triumph. Unlike her male contemporaries, who sought skulls and other body parts as symbols of British power, she gathered tragedy souvenirs to honor the sacrifices made by common soldiers and reveal the impact of their deaths on the women and families they left behind. As Waterloo became a memorable event, her souvenirs encouraged remembrance of the citizens upon whom victory depended to help shape a more comprehensive sense of Britishness.

This study concludes by tracing the trajectory and influence of Revolutionary souvenirs in the post-Napoleonic era. Decades after the end of his

empire, Napoleon remained a mythic figure in the British imagination and across Europe. Through the example of Mary Shelley's *Rambles in Germany and Italy* of 1844, however, I show how material objects continued to promote the cause of liberty. I argue that Shelley uses souvenirs in her writing to challenge revisionist histories of Napoleon by evoking the democratic spirit of the Revolution and advocating for liberal reform. Collecting figurines of Revolutionary heroes to endorse the emerging nationalist movement in Germany, she countered British collecting that nostalgically idealized Napoleon's rule. Her souvenirs participated in the larger debate over Britain's alliance with Germany to safeguard peace and liberalism on the Continent. In helping to redefine Britain as an integral part of an interconnected Europe, her work renews the cosmopolitan vision of earlier women writers.

Women's souvenir collecting not only had a profound impact on the politics of the Revolutionary era but also produced enduring cultural legacies. Stewart postulates that "the souvenir generates a narrative which reaches only 'behind' . . . rather than outward toward the future."[64] However, Amy Ogata contends that it in fact "directs the gaze from the past towards the future; it keeps the trajectory of nostalgia flowing in the direction of hope and progress."[65] Indeed, souvenirs often reappear at anniversary celebrations and other major occasions. In 1889, Parisians reconstructed a miniature Bastille at the Exposition Universelle to commemorate the centennial of the Revolution, presenting the uprising as a timeless event. Revolutionary souvenirs framed the conflicts of later eras as well. Poppy flowers, which Eaton notices growing from the graves of soldiers on the Waterloo battlefield, returned when Moina Michael and Anna Guérin sold cloth versions of them at the end of World War I as a symbol of peace and remembrance. More recently, the pink pussy hats popularized by the Women's March in Washington, D.C., in 2017 resembled the liberty cap that Williams wore to advocate for gender equality. This book ultimately argues for the importance of remembering women's objects of liberty, as they continue to shape the social and political conversations of our time.

1

Helen Maria Williams's Sentimental Objects in *Letters from France*

Traveling to France in 1790 to witness the Revolution firsthand, Helen Maria Williams, a British poet, novelist, and reformer, became the main correspondent of Revolutionary events for an English audience through her *Letters from France*. She was a moderate liberal Dissenter, and her early work, such as poems on the American War of Independence and the abolition of the trade in enslaved people, reveals her commitment to Enlightenment ideals of liberty and human rights. She was a supporter of the French Revolution before her trip, and her enthusiasm only grew when, arriving in Paris on July 14, she experienced the first anniversary celebration of the fall of the Bastille. The purpose of her three-month journey, undertaken with her mother and sisters, was to tour Paris and visit family friends. Her initial set of letters became the first of an eight-volume series written through 1796; the series itself is of a mixed genre of epistolary account, travel guide, history, and sentimental literature. Although she framed the volumes as personal letters to a friend, she published and circulated them widely in England. The first volume, written during the 1790 journey, conveys excitement over political events in France and support for the Revolution against old-regime tyranny. In these letters, Williams takes her readers on a tour of important Revolutionary sites and events. After the success of her first two volumes, she established a permanent residence and salon in Paris, through which she created a network of prominent writers, thinkers, and politicians.[1]

Over the past two decades, there has been a growing body of criticism on Williams's *Letters*, especially in relation to sensibility, politics, and material culture. During the Revolutionary era, sentiment became a preferred discourse for women travel writers.[2] It authorized their interventions in the largely masculine public domain and allowed them to establish political identities. Sentiment also served as a medium for heterodox views, including political radicalism. Mary Favret and Gary Kelly contend that Williams

championed the Revolution for its distinctly feminine and politically liberating potential of sensibility.[3] Jacqueline LeBlanc extends this work, arguing that Williams's "sentimentalism draws on an eighteenth-century culture of feminine sensibility sprung from the expansion of consumerism and leisure culture."[4] Deborah Kennedy notes that Williams uses consumer goods in her work to engage in both the abolition and Revolution debates.[5] Examining the impact of Williams's work in Britain, Elizabeth Bohls argues that the author employs sentimental aesthetics to convey revolutionary ideas, while Angela Keane claims that commerce allowed Williams to facilitate political relations between France and England.[6] As LeBlanc asserts, Williams's *Letters* shows how sentimental consumer objects inspire political and economic change, thus demonstrating "an intriguing and radical correspondence between revolutionary politics and a culture of commercial sensibility."[7]

In this chapter, I argue that Williams employs sentimental objects in the *Letters* as souvenirs to create sympathy for revolutionary ideas and encourage reform in Britain. Looking primarily at the first volume of *Letters*, I examine how she uses miniature models of the Bastille that evoke sentiments of horror to convey the political abuses of the old regime. Championing the construction of a political system that involves and represents the people, she advocates for revisions to England's constitution. Purchasing a snuffbox that mocks a prominent Catholic leader, she adopts the sentiment of humor to challenge the power and privileges of the Church and aristocracy. By circulating the box across national borders, she urges support for religious and economic freedom. She contends that women play an essential role in the Revolution through their display of jewels. In showing how they use ornaments to support the new nation, influence the political decisions of men, and assume patriotic identities, she argues for female citizenship. Her account intervened in the Revolution Debate between conservatives like Edmund Burke, who feared threats to traditional institutions, and liberals such as Richard Price, who saw France's new republic as a chance to fulfill the promise of Enlightenment ideals.[8] By introducing revolutionary freedoms at home, her souvenirs suggested ways to improve Britain's constitutional monarchy and served as tangible reminders of the cause of liberty.

Williams's discussion of souvenirs in *Letters* is significant for enabling her to pose a more global and inclusive form of national identity. As revolutionary ideals influenced countries across Europe and the Atlantic, they established a new model of the nation as a democratic entity. Adriana Craciun asserts that the proliferation of these notions led Williams to embrace "a radicalized cosmopolitanism" at odds with narrow, conservative

views of the nation in Britain. Williams's circulation of souvenirs allowed her to import democratic ideas and forge a cosmopolitan identity not defined by Britain's national boundaries. She also used souvenirs to envision women's inclusion in the nation. While there was a long-standing tradition of excluding women from political discussion in Britain, Craciun notes, the cosmopolitanism that emerged in France was "overtly feminist in attempting to carve out new 'rights of women' based on transformed Enlightenment ideals."[9] Rooted in consumer sensibility, Williams's souvenirs allowed women to remain properly feminine while advocating for rights and engaging in the public sphere. While sensibility itself is not radical, she employed it as a revolutionary strategy to undermine assumptions about women's roles. By using souvenirs to contribute to the discussion of national identity in Britain, her *Letters* marks a new direction for thinking about the nation and women's political involvement during the late eighteenth century.

The Bastille: National Memory, Political Change

On July 14, 1789, an angry mob attacked the Bastille prison in Paris. A medieval fortress, the Bastille's eight-hundred-foot-high towers dominated the city's skyline. When the prison was assailed, it held only seven prisoners, but for revolutionaries it stood as a symbol of the French monarchy's dictatorial rule. The storming of the Bastille marked the beginning of a new nation that overthrew its monarchy and set up a republic based on the ideas of "liberté, égalité, fraternité." The event became one of the defining moments in the Revolution that followed.[10] As the prison turned into a popular Revolutionary symbol, it generated consumer spin-off items like collapsible miniature models, playing cards, and chess pieces aimed at shaping citizens for a new society.[11] Once reduced in size, it also began a journey beyond the borders of the nation. Britain was fascinated with the storming of the Bastille, leading to a demand in collectible objects such as Wedgwood medallions and jugs featuring its image. Poet William Wordsworth, who supported the Revolution during its early years, notably took a stone from the prison as a memento of his tour of the Continent in 1791.[12] As consumer and tourist goods, Bastille souvenirs spread revolutionary ideas as they traveled, serving as reminders of the tyranny of the past and the cause of liberty. As memorial objects, they also played an important role in the process of national transformation and commemoration.

In her letters, Williams assumes the role of political tour guide when she takes her readers to the ruins of the prison. "Before I suffered my friends at Paris to conduct me through the usual routine of convents, churches, and

palaces, I requested to visit the Bastille," she states.[13] Rather than see the customary tourist sights associated with the grandeur of the old regime, she prefers to experience those connected to its horrors:

> We drove under that porch which so many wretches have entered never to repass, and, alighting from the carriage, descended with difficulty into the dungeons, which were too low to admit of our standing upright, and so dark that we were obliged at noon-day to visit them with the light of a candle. We saw the hooks of those chains by which the prisoners were fastened round the neck, to the walls of their cells. . . . There appears to be a greater number of these dungeons than one could have imagined the hard heart of tyranny itself would contrive; for, since the destruction of the building, many subterraneous cells have been discovered underneath a piece of ground. . . . Some skeletons were found in these recesses, with irons still fastened on their decaying bones. (1.1.22–24)

Pierre-François Palloy, a mason and architect who had participated in the siege on the prison, capitalized on its fall by selling tickets to tourists like Williams who wanted to view its notorious underground cells.[14] She uses the material elements of the prison to help her audience visualize the tyranny that it represents. By retracing the prisoners' entrance into the prison, she enables readers to imagine what they experienced. She also evokes sympathy for the prisoners by referring to them as "wretches"; despite being criminals, they face an unfortunate fate to which the skeletons in the dungeon attest. The "chains" and "irons" that bound the prisoners serve as proof of their former subjugation. Of the Bastille's architecture, Halina Adams notes that the structure's low ceilings and limited illumination further reinforce the sense of confinement, while its hidden cells signify the uncivilized and constricting state of pre-Revolutionary France.[15] Drawing on the sentiment of Gothic terror, Williams focuses on the harsh conditions of the prison and its large number of secret chambers to reveal that the oppression of the old regime was more brutal, and more extensive, than her readers might have known.

Although Williams evokes the tyranny of the Bastille, she also uses souvenirs to show the transformation of the prison. As Figure 1.1 shows, some of the most popular souvenirs were miniature models of the prison. As she relates, "The person employed to remove the ruins of the Bastille, has framed of the stones eighty-three complete models of this building, which, with a true patriotic spirit, he has presented to the eighty-three departments of the kingdom, by way of hint to his countrymen to take care of their liberties in future" (1.1.32). Referencing Palloy, she indicates how he turned a large

Figure 1.1. Pierre-François Palloy, scale model of the Bastille, c. 1789–1794, stone, 37 × 98 × 50 cm. Carnavalet-History of Paris Museum.

quantity of the prison's rubble into souvenirs. The models were replicas made to look like the prison, including its towers and carved windows. Realistic down to the last detail, they had working doors, grilles, and drawbridges, and the clock was painted to read 5:30, which was the moment of surrender. These replicas maximized the three-dimensional nature of the prison, making visible to viewers its interior geography.[16] Assigning a time to the Bastille's fall, they also marked the moment when the structure changed meaning from old-regime oppression to revolutionary liberty. The name for the replicas, "Relics of Freedom," pointed to their new symbolism as well as their souvenir status.[17] Formed of the very stones of the prison, notes Williams, the models provide a material link to the Bastille. Despite their transformative quality, they also point to the past; by showing what the abuse of power produced, they remind the French to continue to embrace the Revolution's ideals.

Souvenirs of the Bastille encourage remembrance by making the Revolution publicly available. As Williams observes, Palloy purposely correlates the "eighty-three complete models" of the prison with the "eighty-three departments of the kingdom" (1.1.32). In sending the models to these various government departments, he moves the ruins from the site of the prison and the capital around the rest of the country. Since not every citizen of France could be present in Paris to celebrate the fall of the Bastille, the models brought the celebration to the people. A wide audience would have visually consumed them when paraded through the streets at local festivals.[18] As Simon Schama explains, the replicas stood in for the actual Bastille, and "by contemplating or touching them the citizen could share in the

intensity of the great Revolutionary Day."[19] Medals were another popular artistic medium through which to remember key Revolutionary events like the fall of the Bastille, and Palloy commissioned the engraving of a large number of them.[20] Struck in lead and sold to the public, the Bastille medals were inexpensive and easily obtainable. Williams commends him for acting "with a true patriotic spirit" (1.1.32). By making the Revolution accessible to the common people, he acknowledges that France is a nation composed of many citizens. Though themselves static objects, the Bastille souvenirs spread revolutionary ideas across every region of France as they circulated, influencing a broad audience and replicating revolutionary ideals.

Medals of the prison provide the French with a way to commemorate supporters of the Revolution. "All those who had assisted in taking the Bastille," Williams notes, "were presented by the municipality of Paris with a ribbon of the national colours, on which is stamped inclosed in a circle of brass, an impression of the Bastille, and which is worn as a military order" (1.1.30). She references a ceremony held on the first anniversary of the fall of the Bastille in Paris, at which members of the National Guard received medals honoring their role in the Revolution. Designed by engraver Augustin Dupré, these medals, shown in Figure 1.2, feature a representation of the demolition of the prison, indicated by an inscription across the top stating "Siege de la Bastille."[21] In the foreground, a mob of people surrounded by clouds of smoke gather with guns, powder kegs, and torches, while in the background, the prison's towers burn. Intended for personal display and visual consumption, the medals provided material evidence of the conquerors' heroism. An inscription reading "Prise par les citoyens de la ville de Paris" along the bottom with the date of the demolition reminded viewers of the fateful day and the guard's victory. As Williams's language suggests, the medals "stamp" their wearers with a patriotic identity. Circular in shape, they enable the guard to join a circle of citizens who share revolutionary ideals. The Bastille medals provide a sense of unity, and those who wear them proudly indicate their role in the formation of the nation.

In commemorating the Bastille's fall, the medals act as reminders of the Revolutionary cause. As Lake explains, numismatic objects like medals acted as mnemonic devices that could effectively reinforce memory.[22] Like the figure of the prison printed on the national ribbon, the medals make an "impression" on or influence those who wear and view them, so that a memory of the event will leave its trace in their minds (1.1.30). Creating the medals from former prisoners' chains, Palloy desired to connect them to their origin, much as the models carved from the rocks of the prison are.[23]

Figure 1.2. Bertrand Andrieu, *The Storming of the Bastille, July 14, 1789*, 1789, French, tin, copper, and wood, 10.8 cm. Carnavalet-History of Paris Museum.

By fashioning the medals partly of brass, which was a material commonly used for memorial tablets, he further indicated a desire to recall the prison. Acting as an "order," notes Williams, the medals command that viewers remember the Bastille. They also featured rings enabling their recipients to wear them.[24] As the small, portable ornaments circulate on the bodies of their wearers, they spread revolutionary ideas as effectively as the miniature models of the prison.[25] Williams notes that the French, "lest they should be tempted, by pleasure, to forget one moment the cause of liberty, bind it to their remembrance in the hour of festivity, with fillets and scarves of national ribband" (1.1.206). When tied to the body, the beribboned medals secure the event in memory. While the people may appear bound in simply a new way, the Bastille medals they wear promise freedom through their presence.

Refashioned for the public, Bastille souvenirs reverse the old regime's hierarchy of power. In moving the remains from the site of the prison, notes

Williams, Palloy puts the stones at a "remove" from their usual function (1.1.32). The remains are then "framed" or turned into something new. Though the replicas of the Bastille closely resemble the prison, they are, after all, only copies. Their miniaturization distances them from the original. According to Stewart, scale makes a difference: "The miniature and the gigantic may be described through metaphors of containment—the miniature as contained, the gigantic as container." Williams notes that Bastille models transform the hulking prison that once served as the container of French citizens into a small, contained, and easily managed object. The Bastille is also reduced in size and encircled or confined by the strength of the brass on the patriotic medals; the prison is thus represented as a prisoner and placed in the wearers' control. Stewart notes that souvenirs of tragic events or places are handled "at the expense of risking contamination" because of their connection to their source, but that they also enable events to be "recapitulated more safely" because of their distance from the original.[26] Similarly, the small size of the Bastille souvenirs lessens the threat of pollution, despite their material link to old-regime corruption, and renders the dangerous prison safe. By converting it into souvenirs, the people undermine government authority and take political power, quite literally, into their own hands.

Souvenirs of the Bastille further subvert the old regime by turning the former prison into commodities for consumption. On a visit to Orléans, Williams stays at the Place du Martroy, where "pleasure and business are united . . . not only does it present fine sights, and resound with patriotic songs, but there, by way of interlude, the corn-market is held: gowns, petticoats, sweetmeats, grapes, and Bastilles of sugar are also sold in little booths erected for that purpose" (1.2.20–21). In this commercial area, the enjoyment of shopping joins the business of politics, with patriotic songs and Bastille candies offered alongside other consumer goods. Converted into candy, the threatening former prison becomes not only safe but also sweet. In purchasing the treat, consumers can possess the Bastille. As Stewart suggests, the souvenir is "that which can be enveloped by the body." Consuming it "functions to miniaturize and interiorize those distanced experiences."[27] Once taken in, the Bastille candies become part of the self and past events become physically obtainable. At the same time, consumption suggests destruction, so that eating the candy is comparable to the demolition of the prison. The presence of female clothing at the market further suggests that women partake in the Bastille's transformation. Dyer and Smith state that public markets offered women freedom through commercial activity.[28] As consumer goods, the Bastille candies allow them to engage in politics as they shop and take ownership of the Revolution.

The material transformation and commemoration of the Bastille occurs at the actual site of the prison as well. On her tour, Williams attends a celebration of its demolition, where she observes how completely the revolutionaries have altered the area: "The ruins of that execrable fortress were suddenly transformed, as if with the wand of necromancy, into a scene of beauty and of pleasure. The ground was covered with fresh clods of grass, upon which young trees were planted in rows, and illuminated with a blaze of light. Here the minds of the people took a higher tone of exultation than in the other scenes of festivity. Their mutual congratulations, their sense of present felicity, their cries of 'Vive la Nation,' still ring in my ear!" (1.1.21). As nature replaces objects of tyranny, the horrors of the former prison become beautiful. Instead of dark dungeons, instruments of torture, and decaying skeletons, all associated with death, Williams encounters a well-lit outdoor space covered in flourishing "young trees." Unlike the "ruins" of the prison, which signify the political collapse of the old regime, the trees are symbolic of the growing nation. They are also specifically liberty trees, which had served as symbols of colonial resistance to British rule before the American Revolution.[29] France's liberty trees similarly represent their country's uprising and the people's opposition to aristocratic control. Williams notes how despite the prison's conversion, the French construct their new nation from the remains of the old. The transformed Bastille simultaneously reminds them of their escape from the past and symbolizes their hope for the future.[30] In attributing the alteration to "necromancy," she alludes not only to the magic of the change but also to the ability to tell the future by communing with the dead (1.1.21). The Bastille's rehabilitation thus shows that France desires to preserve its national memories to advance politically. The cries of freedom that "still ring" in her ears indicate that remembering the prison is essential to the Revolution's success.

In contrast to the new nation represented by the renovated Bastille, the Palace of Versailles epitomizes France's former government. After her tour of the prison, Williams recounts, "We are just returned from Versailles, where I could not help fancying I saw, in the back ground of that magnificent abode of a despot, the gloomy dungeons of the Bastille, which still haunt my imagination, and prevented my being much dazzled by the splendour of this superb palace" (1.1.83). While Paris was the official capital of France, Versailles was home to the royal residence and served as the center of political power until the Revolution. The palace troubles her because the nobility was complicit in the Bastille's existence. Overly ornate in "splendour" and possessing a "superb" façade, it seeks to distract viewers from the political corruption it holds, but Williams fails to be enchanted.

Versailles may be impressive in its lavish beauty, but since it housed a "despot," she deems it hardly "magnificent" in deed. As a result, she finds herself gazing on the prison as she looks at the palace.[31] Though the Bastille is a "gloomy dungeon" compared to Versailles, the palace conjures up memories of the former prison, and the two buildings become for Williams similar vestiges of old-regime tyranny (1.1.83). The Bastille functions as a conceptual souvenir whose remembrance hangs over the palace to "haunt" the aristocracy after its fall. By superimposing the image of the prison onto the palace, she engages in her own form of necromancy, foretelling the misfortunes of those who do not change along with the nation.

For British readers, Williams employs souvenirs of the Bastille to shape their response and refute opposition to the Revolution. Acknowledging "the gloomy forebodings of the enemies of the new constitution," she addresses those who criticize the demolition of the prison and the old regime that it represented (1.1.105). She justifies France's resorting to the extreme political move of revolt, stating, "After having visited the Bastille, we may indeed be surprised, that a nation so enlightened as the French, submitted so long to the oppressions of their government; but we must cease to wonder that their indignant spirits at length shook off the galling yoke" (1.1.24). While the pronoun "we" references her companions on the tour, it also extends to her audience at home. Typical of the epistolary form, Williams's letters, addressed to an anonymous friend in England, reach out to readers personally to encourage approval of the Revolution. Believing the details of her tour should convince critics to abandon their concerns, she marvels at "those who have contemplated the dungeons of the Bastille, without rejoicing in the French revolution." Instructing them to form the appropriate reaction to events in France, she emphasizes that their experience of the Bastille should lead, like her own, to joy. Arguing that the ruins of the prison are visual proof of the "terror" of the past, she invites readers to adopt her view and agree that the French are justified in overthrowing the old regime (1.1.74).

To convince readers further, Williams argues that memories of the Bastille will guarantee the success of the new nation. She relates the story of her friend Thomas du Fossé, whose aristocratic father uses a lettre de cachet to imprison him for marrying a woman beneath his social status. Calling the situation "domestic tyranny," she aligns it with old-regime abuses of power (1.1.123). The aristocracy misused these government-authorized letters to such an extent that they appeared on the list of grievances presented to the new National Assembly. The method by which his father incarcerates him only adds to her sense of injustice over the situation. Du Fossé

spends eleven years in prison until "the 15th of July, 1789, the very day after that on which the Bastille was taken" (1.1.189). Freed by the Revolution, he renounces his title in favor of its values, having realized "that the common rights of man are of more value than he ever found the rights of nobility in the solitude of his dungeon" (1.1.212). By telling a personal story, Williams evokes sympathy for the Revolution while also providing evidence for why the nation will prosper. "A people just delivered from the yoke of oppression," she states, "will surely have little inclination to resume their shackles; to rebuild the dungeons they have so lately demolished . . . to exchange their new courts of judicature . . . for the caprice of power, and the dark iniquity of lettres de cachet" (1.1.105–106). As vivid reminders of the horrors of the past, souvenirs of the Bastille ensure that the French will not re-create a tyrannical government.

Williams also defends France's new government by showing how it remains rooted in the past. Conservative British critics like Burke employed architectural metaphors to condemn the Revolution.[32] In *Reflections on the Revolution in France*, he claims that the former French constitution possesses "the walls, and in all the foundations of a noble and venerable castle" that the country "might have repaired" and "built" upon.[33] Comparing the government to a structure like Versailles, he contends that preservation is preferable to destruction, for the old structures contain the authority of the past. In contrast, Williams argues that "the temple of Freedom which they are erecting, even if imperfect in some of its proportions, must be preferable to the old gloomy Gothic fabric which they have laid in ruins" (1.1.68). Using the Bastille as a metaphor for the old regime, she claims that the French must eradicate the "Gothic fabric" to establish a new constitution. The "temple" visually manifests their intentions; with its "proportions," it recalls the democratic buildings, and ideals, of antiquity. Additionally, she asserts, "the French will carefully preserve, from the wreck of their monarchical government, the old charter they have so long held," following their critics' advice by returning to an earlier, more traditional form of government (1.1.197). Much as they create models from the Bastille's stones, so the French fashion their new constitution from the remains of the old government. Williams evokes the prison to show that they build the nation on the memory of the past. As they do so, Bastille souvenirs are reminders of what to change as well as what to retain.

Williams not only justifies political changes in France but also admonishes Britain to learn lessons from the Bastille's souvenirs. "When we look back on the ignorance, the superstition, the barbarous persecutions of Gothic times" in France, she states, it is "something to be thankful for, that

we exist at this enlightened period, when such evils are no more" (1.1.65). Although "Gothic times" refers to the Middle Ages, it also characterizes, through the Bastille, the years before the Revolution. However, the "enlightened period" that is newly arrived in France is not yet present in her country; as she suggests, "more perfect systems of legislation may perhaps be formed than England can boast. *Her* Magna Charta was obtained not in the illumination of the eighteenth, but in the Gothic darkness of the twelfth century" (1.2.114). While France has adopted a constitution formed like a temple of freedom, England still clings to a Bastille-like government. Rather than criticize the Revolution, she concludes, Britain should examine its own outmoded political system. Yi-Cheng Weng explains that France served as a "national 'Other' that enabled Williams . . . to comment on matters at home and to construct a sense of national identity."[34] Williams calls for democratic reform like that enacted in Revolutionary France when she states, "may England rectify the abuses and corruptions which have crept into her government" (1.2.115). Due to her Bastille souvenirs, she hopes that Britain will "look back" at France's political progress as a reminder to pursue its own (1.1.65).

The Snuffbox: Sentimental Commerce,
International Exchange

According to Lynn Festa, the snuffbox was the most celebrated sentimental object of the eighteenth century.[35] A small, ornamental box for holding tobacco, the snuffbox was a stylish accessory that assumed personal meaning through the owner's relationship to it. When exchanged, the boxes communicated feelings between the giver and the receiver.[36] Snuffboxes consequently served as beautiful and cherished mementos of their givers.[37] Festa calls this merging of persons and emotions through the transfer of things "sentimental commerce."[38] During the French Revolution, the snuff box acquired new political meaning. Instead of simply representing personal connections, snuffboxes were carried as advertisements of one's political beliefs.[39] Portraits often adorned the lids, with Revolutionary leaders like Lafayette, Mirabeau, and Marat taking the place of loved ones. Some boxes were fashioned in the shape of Revolutionary symbols like liberty caps.[40] Others contained secret portraits or double lids and containers to hide political views and ensure both public and private use. Political radicals even used them to administer poison to their adversaries.[41] Despite its political transformation, the snuffbox hardly lost its emotional impact. As supporters capitalized on the sentimental object to circulate their political

message, it became a souvenir that made the Revolution and its ideals both meaningful and memorable.

Williams engages in the sentimental commerce of political ideas through her own exchange of a Revolutionary snuffbox. After her visit to the National Assembly, she reflects on the speeches of Abbé Maury, "whose picture I have just purchased in a snuff-box" (1.1.52–53). Jean-Sifrein Maury, a Roman Catholic who represented the clergy at the Estates-General of 1789, distinguished himself by defending the old regime and the aristocracy as a means of protecting his own career.[42] Williams notes that he "is one of the most distinguished members of the National Assembly . . . but he has done his talents the injustice to make them subservient to the narrow considerations of self-interest" (1.1.51). In arguing against "civil and religious liberty," he becomes "more detested than admired" by revolutionaries. She then describes the operation of her snuffbox: "You touch a spring, open the lid of the snuff-box, and the Abbé jumps up, and occasions much surprize and merriment. The joke, however, is grown a little stale in France: but I shall bring the Abbé with me to England, where I flatter myself his sudden appearance will afford some diversion" (1.1.52–53). Containing a picture of Maury, the snuffbox sends a political message by poking fun at his "detested" character. By displaying the box, Williams indicates her sympathy for the Revolution; by promising to bring it to England, she employs the sentimental object to persuade readers to adopt her political views.

With her snuffbox, Williams not only engages in sentimental commerce but also literally commercializes revolutionary sentiment. As she tells her readers, "I have just purchased" the box as a consumer item. These items enable the consumption of revolutionary ideals as commodities sold in shops. She notes that the Palais Royal "is a square, of which the Duc d'Orleans's palace forms one side. You walk under piazzas round this square, which is surrounded with coffee-houses, and shops displaying a variety of ribbons, trinkets, and caricature prints, which are now as common at Paris as at London" (1.1.77). Tourists like Williams could buy revolutionary ideas in the form of tricolor ribbons, "trinkets" like snuffboxes, and other goods in the commercial area of the Palais Royal. The shops were located near coffeehouses, which served as public social spaces where citizens gathered to read newspapers and discuss current events and politics. As accessible meeting places for all social classes and women as well as men, coffeehouses allowed for the democratic exchange of ideas. Indicating that they are "now as common at Paris as at London," Williams encourages international connection by showing how the Revolution adopts Britain's model of political debate (1.1.77). The coffeehouses at the Palais Royal

became centers of rebellion, fostering serious conversations about the king and the old regime.[43] By aligning them with souvenir shops, she suggests that items like the snuffbox spread political ideas as effectively as newspapers. Directing her readers to this commercial area with the imperative statement "you walk," she leads them toward sympathy for the Revolution on her tour of the city.

To sell the Revolution to her English audience, Williams chooses a snuffbox that employs the sentiment of humor. Aware that in London her readers "hear of nothing but crimes, assassinations, torture, and death," she uses the snuffbox to counter images of violence (1.1.217). In her box, the image of Maury "jumps up" due to the device of a spring, much like a toy jack-in-the-box, and his startling "sudden appearance" is a "surprize" (1.1.53). Her box resembles those that featured secret portraits and hidden springs to help convey their commentary. Its humor depends on its tactile qualities, and she explains how readers can "touch a spring" and "open the lid" to make Maury emerge. According to Ron Jenkins, "The power of laughter offer[s] a welcome relief from the anxiety of . . . political change." During times of instability, "laughter is experienced as a wave of liberating release."[44] Williams's snuffbox generates laughter to bring levity to the heated Revolution Debate at home while encouraging her readers to sympathize with the political changes it introduces. Her box similarly relieves tension through the literal "release" of the abbé on a spring. As a "diversion," the amusing box distracts the audience from the dangers the Revolution poses (1.1.53). Through sentimental humor, she attempts to defuse a potentially threatening political situation and encourage acceptance of revolutionary ideals.

Despite Williams's political use of the snuffbox, its status as a "joke" calls into question how seriously her readers should take it. By appearing to be a trivial object, though, the snuffbox in fact exerts greater political control. As Sianne Ngai argues about cute objects, their physical smallness makes them seem inconsequential. However, cuteness depends on this asymmetry of power. Appearing nonthreatening allows the cute object to gain others' confidence and take control over them. The cute object thus leverages power relations by using its apparent weakness or submissiveness to exert influence and domination.[45] Williams's snuffbox likewise seems harmlessly cute while politically influencing her readers. This quality also characterizes the women who carry such objects. As she states, "We often act in human affairs like those secret springs in mechanism, by which, though invisible, great movements are regulated" (1.1.38). Like the box, women are seemingly insignificant, yet their souvenirs are the "mechanism" by which they covertly "regulate" sentiment. Since the political message of

the snuffbox is "invisible" under its humor, the audience falls for the joke. The mechanized figure of the abbé will then "spring" on them a new political view, and Williams believes that she and her sentimental snuffbox will help drive the "great movement" of the Revolution. The box is admittedly a toy, but because it toys with the viewer, the joke is on those who mistakenly see it as a mere amusement.

Through its humor, Williams's satiric snuffbox operates as a tool of resistance against the old regime. Jenkins notes that humor is part of a "defiant tradition" and that, under an oppressive political system, a "public display of comic insubordination is emblematic of the way laughter" is used "to subvert . . . authority."[46] Such humor enables "the celebration of an imagined victory over the . . . forces that had oppressed."[47] During the Revolution, Williams's snuffbox similarly uses comedy to undermine France's former government. Part of the humorous surprise is that the formerly respected abbé's appearance inside the snuffbox, which is normally a repository for tobacco, is unexpected (1.1.53). Festa explains that diverting the proper function of the box changes its significance.[48] In the case of Williams's box, its purpose is now to conjure up and manipulate readers' feelings about a person. By circulating Maury's image in a box that denigrates him as a joke, she reduces his reputation to mere snuff. Although she does not resort to poisoning her adversary, the mockery of the box succeeds in blighting his character. Giving the opposition a familiar but detested face, the box turns the iconic abbé into a scapegoat for the faults of the old regime. Her humorous snuffbox therefore allows readers to imagine a political victory over France's former government.

Williams's snuffbox not only resists the old regime but also subverts its political hierarchy. She relates a story about the Duke of Orléans, who discovers "a wooden cage" while touring the labyrinths of the Mont St. Michel abbey in Normandy "which was made by order of Louis the Fourteenth, for the punishment of an unfortunate wit, who had dared to ridicule his conquests in Holland, no sooner gained than lost" (1.1.40). Laughing at the king's ineffective imperial ventures, the jokester finds himself imprisoned in the cage for using humor to criticize the old regime. Williams recounts how the duke "beheld with horror this instrument of tyranny, in which prisoners were still frequently confined." The Duke of Orléans was a Bourbon prince who actively supported the Revolution and advocated for a constitutional monarchy. His elevated status would have given him permission to destroy the cage, and Williams consequently attributes to him "the glory of having, even before the demolition of the Bastille, begun the French revolution" (1.1.40–41). Like the dungeons of the Bastille, the cage is another

subterranean prison that represents the oppressions of the old regime. While its destruction is a smaller-scale event than the taking of the Bastille, she views such a reversal of power as an equally revolutionary moment. Her humorous souvenir also overturns aristocratic power. At court, Maury was renowned for his quick wit, but in the cage of the snuffbox, he becomes the object of the people's wit.[49] By allowing viewers to laugh freely at the old regime, the box transforms an "instrument of tyranny" into one of revolutionary liberty (1.1.40).

The snuffbox's small size and repetitive message further enhance its sentimental and memorial appeal. According to Ann Jessie Van Sant, "miniaturization of experience" leads to "microsensation," or a heightening of senses, "to give near-epic force to a sentimental exchange." The diminutive object paradoxically "occupies full stage," and this "temporary reordering of scale allows the featuring and reassertion of a value (a sentiment) already known and simply in need of revivification." Focusing on the small, she argues, magnifies emotions.[50] Though a miniature item, Williams's snuffbox similarly elevates sensation as it "occasions much surprize and merriment" from her audience (1.1.53). Maury, who jumps out of the box and commands complete attention, in effect becomes the occasion. Much like the figure pressed down by the spring, the box compresses the large-scale Revolution into one small object. Repeatedly and mechanically telling the same joke, Williams's snuffbox also reiterates revolutionary ideas to render them unforgettable. Her box calls up the springing abbé and, with him, memories of events in France. By keeping revolutionary sentiments at the forefront of her readers' minds, the box acts as a souvenir that reminds Britain to have sympathy for France's attempt to establish a government like their own. In containing the Revolution, her snuffbox becomes the receptacle for and constant reminder of its ideals.

By circulating the snuffbox in Britain, Williams aims to make Revolutionary events seem more real to her audience. She promises to "bring the Abbé with me to England," and making a "sudden appearance," he will arrive as if in person. Though the box contains merely a representation of him, the mechanized figure conveys his presence. Stewart's theory of how the inanimate comes to life through the toy helps illustrate the intentions of Williams's snuffbox. As she explains, the toy "is a device for fantasy . . . once the toy becomes animated, it initiates another world, the world of the daydream." The "animated" abbé in Williams's toylike box similarly allows the viewer to imagine him in Britain. Through the "fantasy" the box evokes, the viewer can also enter the world of events in France. As Stewart argues, "The toy ensures the continuation, in miniature, of the world of

life 'on the other side,'" namely the world occupied by inanimate objects.[51] For Williams, the snuffbox represents "life on the other side" of the Channel. Because it evokes the Revolution in a lifelike way, she believes the box will be popular once she circulates it across national borders. Noting that the joke has "grown a little stale in France," she recognizes that it requires a fresh audience to be funny, and it will be a novelty for those in Britain (1.1.53). Her snuffbox not only brings the inanimate object to life but also transports the life of the Revolution home in a box for her readers.

As it moves across national borders, Williams's snuffbox spreads revolutionary ideas about religion. She supported the Dissenters' campaign to repeal the Test and Corporation Acts, a series of English penal laws that imposed civil disabilities on Roman Catholics and nonconformists; she also admired the French National Assembly for voting in favor of the principle of the freedom of religion.[52] In a letter describing the taking of the national oath in the town of Nègre-Pelisse, she endorses the egalitarian religious notions inspired by the Revolution. As she recounts, "Half of the inhabitants being Protestants, and the other half Catholics, the Curé and the Protestant Minister ascended together one altar, which had been erected by the citizens, and administered the oath to their respective parishioners at the same moment, after which, Catholics and Protestants joined in singing Te Deum" (1.1.63). As the opposing religious groups both sing the Christian hymn and join their services "together" on "one altar," they signal a desire for unity despite their differences. Williams exclaims, "Surely religious worship was never performed more truly in the spirit of the Divine author of Christianity, whose great precept is that of universal love!" (1.1.64). She suggests with the term "universal" that religious tolerance is not only a shared Christian value but also an essential democratic ideal. By targeting Maury, who supported the religious restrictions of the old regime, the snuffbox allows her to advocate indirectly for the repeal of the acts in England and offer readers a lesson in religious liberty.

Williams also uses the snuffbox to introduce ideas of economic equality. As part of its agenda of reform, the Assembly nationalized Catholic Church property and its revenue.[53] She notes that Maury, "before the revolution, was in possession of eight hundred farms, and has lost sixty thousand livres a year in consequence of that event" (1.1.52). The Assembly then introduced assignats, which were paper money supported by the value of properties confiscated from the Church. They became an immediate source of political controversy, and constitutional monarchists like Maury deemed them an illegitimate seizure of property.[54] The French carried out this debate through souvenirs, including a snuffbox that displays on its lid the portraits

Figure 1.3. Circular medallion with heap of trompe-l'oeil assignats and portraits of several figures of the French Revolution, c. 1794–1820, paper, 112 × 103 mm. © The Trustees of the British Museum.

of the various Assembly members, including Maury, against a background of assignats, as seen in Figure 1.3.[55] The image of Father Time hovers above the portraits with his scythe, suggesting the importance of moving the reforms forward quickly. Composed of the inexpensive material of wood, this box would have been accessible to common citizens and allowed them to partake in the debate. Since its earliest production date was 1794, Williams would not yet have seen it, but it suggests that her snuffbox participates in a political trend. Instead of representing all members involved in the controversy, hers directly indicts Maury for his unwillingness to surrender his extensive property to help fund the new nation. As a consumer item, it ironically capitalizes upon Maury, exchanging him like a commodity in the marketplace for the Revolution's economic benefit.

Williams not only sends a snuffbox to England but also transports several from England to circulate democratic ideas about abolition in France. When she arrived in Paris, she brought snuffboxes with cameos featuring the Wedgwood design "Am I Not a Man and a Brother." She hoped that the boxes, which were valuable gifts that abolitionists used to promote their cause, would encourage the French to extend freedom to enslaved people as well as their own citizens. Kennedy points out that the "consumerist and fashionable appeal" of the boxes would have represented the horrors of enslavement in a convincing but "aesthetically pleasing way."[56] Although they helped Williams advocate for her cause abroad, she used them to remind England of its political commitments as well. The Committee for the Abolition of the Slave Trade, composed mainly of Dissenters, was the first to present a petition against the trade to the British Parliament. In France, she applauds Mirabeau, the "friend . . . of the African race" because he "proposed the abolition of the slave-trade to the National Assembly" (1.1.48). While France was only beginning to address the issue, she warns that "if our senators continue to doze over this affair as they have hitherto done, the French will have the glory of setting us an example, which it will then be our humble employment to follow." Playing on England's rivalry with France, she raises her country's competitive spirit to be the first to abolish the trade. While the snuffboxes transmit abolitionist ideas abroad, they also send them back to Britain to encourage political action on the issue of enslavement.

In circulating the snuffboxes, Williams increases her readers' sentimental connection to the Revolution by emphasizing shared political ideals. She claims that the sentiment of liberty originated not in Revolutionary France but in England: "The example of the revolution in America is supposed to have had considerable influence on the French nation: and from whom did the Americans imbibe their love of freedom? They loved it because they were of the English race, and had studied the writings of English philosophers, and the examples of English patriots" (1.2.115). Making a transatlantic argument, Williams notes that America's fight for liberty inspires France, but because England inspired America, England and France share the same political ideals. Tracing the origin of liberty to the English and calling them "patriots" further ties them to the French cause, so that to dismiss the Revolution would be to repudiate the very principles on which the British nation rests. Drawing on the message conveyed by her abolition boxes, she adopts the metaphor of enslavement to portray France's fight for freedom. She reminds England that it enjoyed liberty at a time "when the nations around her were sunk in the most abject servitude.

If those nations now find the path of freedom, it is by pursuing the track which England first explored" (1.2.115). The Revolution therefore enables the French to liberate themselves from their enslavement under the old regime. By showing how France follows England's lead, the abolition boxes reveal the connection of revolutionary sympathies to engage Britain's support.

Purchased and circulated between countries, Williams's snuffboxes enable the exchange of revolutionary ideas. Keane states that she envisioned "the possibility of both commercial and cultural international relations" between Britain and France through a system of trade joining the countries and their political visions.[57] As Williams suggests, "It may possibly be within the compass of human ability to form a system of politics, which, like a modern ship . . . unites those together whom nature seemed for ever to have separated, and throws a line of connection across the divided world" (1.1.222). The ship is a simile for the political experiment in France that forms a link or "line of connection" to the British neighbors from whom they are "divided" by disagreement. However, it is also a literal vessel in her narrative, carrying the goods, like snuffboxes, of commercial trade. When these consumer items travel along actual lines of connection formed by trade routes, they bring with them revolutionary sentiment. As Festa contends, the transmission of objects like the snuffbox has a surprisingly globalizing effect, with trade in sentimental consumer items facilitating cross-cultural agreement and transforming those engaged in the exchange.[58] Transporting both goods and ideas, Williams's ship is itself an enlarged version of the snuffbox. Crossing the Channel by boat on her way home to England, she not only carried a snuffbox but also emerged out of her own box to deliver the Revolution.

Jewels: Political Fashions, Female Citizens

During the early years of the Revolution, women marched at the head of bread riots, submitted petitions to the government, joined political clubs, and took part in the storming of the Bastille. Williams believed that women's display and circulation of Revolutionary ornaments constituted another form of female activism. Elaine Chalus argues that women's use of fashion to declare political allegiance was a long-standing practice in the eighteenth century. As a form of social politics, women ornamented their clothing with ribbons, cockades, and other political symbols; when worn at social functions, these objects attracted attention and made forceful, visual declarations of women's political views.[59] On September 7, 1789, a group of eleven wives and daughters of artists who sympathized with the Revolution's

Figure 1.4. French Revolution cockade, 1789, French, printed silk and card. German Historical Museum, Berlin. © akg-images.

ideals placed tricolor ribbons in their hair and publicly donated their jewelry to the National Assembly.[60] The historic occasion was immediately commemorated in paintings and souvenir prints. Figure 1.4 shows the tricolor cockade, an inexpensive and popular consumer item easily obtained at milliners' shops, which women wore on liberty caps and refigured in jewelry to show their support for the Revolution.[61] For Williams, these material adornments acted as souvenirs by allowing women to make personal and collective statements of revolutionary identity. By depicting them in her letters, she advocates for women's political inclusion and the reimagining of Britain as a more global nation.

Recounting the women's donation of jewels to the National Assembly, Williams contends that the action constitutes a memorable form of political activism. She praises "those who have acted with a spirit of distinguished

patriotism; who, with those generous affections which belong to the female heart, have gloried in sacrificing titles, fortune, and even the personal ornaments, so dear to female vanity, for the common cause" (1.1.37). Marcia Pointon notes that jewels were frequently women's only valuable material possessions. In offering them to the Assembly, the women give up their most important property for the sake of the Revolution, exhibiting a patriotism that renders them prominent and worthy of respect. They also propose them as a form of payment to help alleviate the national debt, which had been brought about partly by the aristocracy's extravagant spending, especially that of King Louis XVI and Marie Antoinette at Versailles. While jewels themselves are "personal ornaments," they become useful goods when entering the consumer market (1.1.37). A portable form of wealth, jewelry would have been sold or melted down to form currency.[62] As their jewels help the nation, the women transform economic value into moral worth. Though they lose their ornaments, they gain another form of importance through their renown, and with their financial contribution, they involve themselves in an essential way in the formation of the new nation.[63]

While the women's donation of jewels may seem like a trivial action, Williams believes that it signifies a radical change in women's identities within France's social hierarchy. Julie Ellison remarks, "One cannot help but wish that Williams's praise for the sacrifice . . . were more ironic."[64] However, she overlooks the importance of jewels to the aristocratic "ladies" whom Williams discusses (1.1.37). As objects of "vanity," the jewels are "dear" to women who rely on them not only for feminine beauty but also for status. In the eighteenth century, jewels were a fundamental part of a woman's self-presentation and societal value, and their acquisition or loss reflected social and economic standing.[65] The "personal ornaments" that women wear signify their "titles" and "fortune," Williams notes, and giving them up means "loss of rank." Donating jewels is a true sacrifice for those whose futures depend on them because "fortune" connotes destiny as well as wealth. Cherishing their jewels signifies how highly women regard the Revolution to part with them. In her critique of the donation, Ellison also misses the irony that Williams directs at women "who have carried their love of aristocratical rights so far as to keep their beds, in a fit of despondency, upon being obliged to relinquish the agreeable epithets of Comtesse or Marquise" (1.1.36). Suggesting that aristocratic titles are, like jewels, a form of adornment, she criticizes those women who refuse to give up their ornamental rank to support the Revolution.

Williams highlights the importance of the donation by comparing it to the noble sacrifices made by women in ancient Rome. In their speeches at

the National Assembly, French revolutionaries proclaimed their desire to reestablish the republican government that had fostered liberty at Rome. Williams adopts this rhetoric when she emphasizes that "it was the ladies who gave the example of *le don patriotique*, by offering their jewels at the shrine of Liberty; and, if the women of ancient Rome have gained the applause of distant ages for such actions, the women of France will also claim the admiration of posterity" (1.1.37). Citing the Roman religious tradition where citizens sacrifice precious things at a temple altar, she suggests that French women similarly make an offering of their valued ornaments to "Liberty." In capitalizing this term, she refers to the goddess Libertas, whom the Romans created simultaneously with the Republic just as the French turn to her at the birth of their own new nation. By referencing Rome, she also celebrates women's renowned participation in public affairs during the Second Punic War. Assuming part of the financial burdens of the war, Roman women agreed to sumptuary restrictions, giving up their gold and finery to the Senate. Following their lead, the senators voluntarily contributed their gold, silver, and coined bronze to the treasury.[66] Williams believes that French women's donation of their jewels will likewise "claim the admiration of posterity" and become in future generations a memorable patriotic act.

Much as Roman women inspired the Senate to make economic sacrifices, French women's contributions affect the Revolution's success by influencing the political decisions of men. "At the time when the ladies set the example of le don patriotique, by offering their jewels," Williams states, "the members of the National Assembly, in a moment of enthusiasm, took the silver buckles out of their shoes, and laid them on the President's table" (1.1.54–55). Like women's jewels, shoe buckles constituted an important part of men's self-presentation by indicating their status and sociability, so that surrendering them would convey a similar message about their sympathy for the Revolution.[67] By guiding men's actions, the women indirectly have a political impact. Their contribution is an example of how women were active through social politics. While women's political participation was limited, it was accepted if their actions remained within customary gender boundaries. Through indirect forms of involvement, such as partaking in public spectacles, women had a visible presence and could direct the decisions of others. As Chalus states, their activities were "logical extensions of traditional female roles" in a political culture.[68] Williams sees women's financial contribution as such an action, as it allows them to partake in a political movement dominated by men.

Williams argues that the women's renunciation of their jewels influences greater economic decisions as well, such as the passing of legislation to end

primogeniture. On her visit to the National Assembly, she observes that the members "were deliberating upon the division of property among brothers" (1.1.59). During the debate, "a young man of high birth and fortune . . . had come to conjure the Assembly to pass, without delay, that equitable decree, giving the younger sons an equal share of fortune with the eldest" (1.1.59–60). Like the titles and rank that women forego in surrendering their jewels, eradicating the system of primogeniture would deprive the oldest male heir of his full inheritance. It also would be an equally significant social and economic sacrifice, for as Pointon notes, "jewels were to women what real estate was to men."[69] Williams observes that the young man's request to ensure that all his siblings "were secure of a provision" supports the value of equality and applauds his action, saying that if "you have fallen in love with this young Frenchman, do not imagine your passion is singular, for I am violently in love with him myself" (1.1.60). Williams tells the story because she believes that the young man's behavior, as Kennedy states, "was exactly the kind that should be found attractive. It gave male readers a model for how to behave."[70] Once women influence men through their sacrifice, the men then become role models for the French nation. Speaking to "you," she persuades her British readers to also admire the young man's action and reflect on the limitations of their own system of primogeniture (1.1.60).

While women give up their aristocratic ornaments, they also wear jewels refashioned as Revolutionary souvenirs to assume political identities. Williams observes how her friend Madame Brulart, a novelist and educator known as the Comtesse de Genlis before sacrificing her title, now signals her support for the Revolution by donning a piece of jewelry with a political message: "Let us return to Madame Brulart, who wears at her breast a medallion made of a stone of the Bastille polished. In the middle of the medallion, *Liberté* was written in diamonds; above was marked, in diamonds, the planet that shone on the 14th of July; and below was seen the moon, of the size she appeared that memorable night. The medallion was set in a branch of laurel, composed of emeralds, and tied at the top with the national cockade, formed of brilliant stones of the three national colours" (1.1.38). The medallion combines a variety of symbols that tell a story of remembrance and honor. Like the Bastille replicas, it incorporates historically resonant material from the prison, so that both wearer and viewer are encouraged not to forget the old regime. By featuring the planets visible on "that memorable night," the medallion captures the event and perpetually returns the viewer to July 14 to relive the Revolution's origins. The alignment of one planet with the moon suggests the Revolution is an auspicious

occurrence. As a celestial body, the moon symbolizes the Revolution's grandeur and immense proportions, and its presence implies the global impact that this political movement will have. The laurel branch, a Greek symbol of triumph, denotes the victory of the new nation. Often used more generally to recognize achievement, it also honors women's contributions to the Revolution. The national ribbon at the top of the brooch ties all the symbols together to convey a patriotic statement.

Like the women's donation of jewels, Madame Brulart's wearing of a brooch composed of precious stones would hardly seem to be a revolutionary action. LeBlanc argues that her "display of wealth is, of course, deeply ironic in a woman who has renounced her title in solidarity with the revolution."[71] Women like Madame Brulart have not truly sacrificed their valuables if they only return in another fashion, she suggests, and the bejeweled medallion would not appear to be a genuine expression of sympathy for the Revolution. However, Williams's description shows that the jewels enhance the object's political statement. As she notes, the "brilliant stones" of the cockade not only glitter brightly but also designate the Revolution as a magnificent political movement (1.1.38). In particular, the diamonds, which represent endurance, signify the Revolution's lasting impact and heighten the medallion's status as a souvenir.[72] Revolutionary jewels further allow women to show their dedication to the movement. The beloved ideal of "*Liberté*" represented in equally precious stones shows that the object is valuable to the cause. Madame Brulart indicates how much she esteems the Revolution by prominently and sentimentally wearing the brooch "at her breast," near her heart. In return, the brooch confers honor upon her. As Adams argues, the reappearance of women's jewels as Revolutionary ornaments constitutes the nation's repayment for their patriotism and commemorates their support for the new nation.[73]

Despite its connection to the old regime, Madame Brulart's jewelry becomes revolutionary as it changes function in its new political context. As Arjun Appadurai explains, "The line between luxury and everyday commodities" can shift, so that "what looks like a homogeneous, bulk item of extremely limited, semantic range can become very different in the course of distribution and consumption."[74] Women frequently had their stones removed or reset to follow changing fashions.[75] During the Revolution, old-regime jewels signifying aristocratic power took on new meaning when commodified as patriotic souvenirs. The diamonds in Madame Brulart's medallion show her awareness of their former association with Marie Antoinette's lavish court lifestyle and the scandal of the Diamond Necklace Affair, an intrigue by the Comtesse de La Motte to procure, supposedly for

the queen but in reality for herself and her associates, a diamond necklace worth 1.6 million livres. The scandal confirmed beliefs about the queen's frivolity, and the arrest and imprisonment of others involved in the scheme deepened a sense of the tyranny of the old regime and contributed to the progress of the Revolution.[76] By wearing refurbished diamonds, Madame Brulart appropriates a luxury item associated with aristocratic wealth and excess and turns it into a democratic object. The Bastille stone enters a new semantic range as well. Polished and set alongside gemstones in the brooch, it is a symbol no longer of autocratic imprisonment but instead of revolutionary freedom.

Through her display of jewels, Madame Brulart refashions both herself and others as patriots. Featuring the Bastille stone and the national cockade, her medallion is the equivalent of the medals awarded to the National Guard on the first anniversary of the fall of the Bastille. Adams argues that the refashioned stone in her brooch links her personal, feminine sacrifices to the valor of those who stormed the fortress. Because the "medallion connects her to the Bastille heroes through the medium of the former prison," it "places her revolutionary sympathies and the courageous actions of vehement patriots on equal footing." It also provides her with a political identity. Due to her gender, Madame Brulart resembles common citizens in not being able to participate in the government directly. As Adams notes, however, "lower class and female participants . . . claim their stake in the nation by wearing objects that record the symbolic and literal changes" of the Revolution.[77] Her jewels signify both her actual and symbolic impact on society. Like the women whose donation influences members of the National Assembly, Madame Brulart contributes to shaping the beliefs of the nation's most prominent citizens. As the tutor of the Duke of Orléans's son, she instructs him in revolutionary values, so that Williams is "delighted to find him a confirmed friend to the new constitution of France" (1.1.35). By serving as educators, radical women like Madame Brulart subverted feminine roles and participated in politics indirectly to advance reform.[78]

Williams herself wears national ornaments to assume a revolutionary identity. She recounts how, at a party hosted by the Du Fossés, she performs in the play *La Fédération, ou la Famille Patriotique*, based on the national festival that commemorated the Revolution: "I recollected that one of the principle characters was a statue; upon which, I consented to perform le beau rôle de la statue. And, in the last scene, I, being the representative of Liberty, appeared with all her usual attributes, and guarding the consecrated banners of the nation, which were placed on an altar, on which was inscribed, in transparent letters, 'A la Liberté, 14 Juillet, 1789' . . . a scarf of

national ribband . . . was thrown over my shoulder" (1.1.204–205). During the Revolution, many allegorical personifications of Liberty appeared. Also called Marianne, she represented the new republic and its ideals of freedom and democracy. A feminine allegory signaled a break with an old regime headed by kings and expressed opposition to the monarchy.[79] First appearing on a souvenir medal in July 1789 to celebrate the storming of the Bastille, her profile soon became the official government logo and circulated around the country.[80] As the statue of Liberty, Williams becomes the embodiment of this allegorical figure, wearing adornments like the tricolor scarf. In calling her part "le beau rôle" or noble purpose, she indicates that she carries out an important function (1.1.204–205); the scarf draped over her shoulder is appropriately the area of the body where responsibility is symbolically borne. Like the women who donate their jewels at Liberty's shrine, her station by the altar conveys her devotion; by "guarding" the banners on it, she ensures the preservation of the new nation. In playing the central part in the drama, she becomes an active participant in the spectacle of the Revolution.

Wearing ornaments in the role of Liberty also allows Williams to advocate for women's identity as citizens. In the scene, another performer, who decorates her with a red Phrygian cap, says, "Ce bonnet sur-tout est devenu un emblème èloquent" (1.1.205). Historically, enslaved people in ancient Rome donned the cap once freed to signify their transition to citizens with rights.[81] During the Revolution, the hat, embellished with the tricolor cockade, came to symbolize liberty; as an adornment of Marianne, it represented female emancipation.[82] Calling it one of Liberty's most eloquent emblems suggests its power to convey a message for women's freedom. As Weng states, Revolutionary France provided Williams with an "opportunity to imagine a new female citizenship, for the Revolution consolidated an atmosphere and culture of openness" that built upon "the newly established system of liberty and equality." By supporting women who wear items of Revolutionary fashion such as jewels, ribbons, and liberty caps, Williams makes a case for "a new subject position that allows them to claim a space in a wider patriotism."[83] Highlighting events at which women wore these fashions, she shows how they signal opposition to their oppression under the old regime and their desire for equal rights in the new nation. By wearing the cap in the play, she projects herself into the landscape of the Revolution to envision women's political inclusion.

To bolster her argument for female citizenship, Williams contrasts her political involvement in France with the exclusion that women face in Britain. She not only participates symbolically in democracy through the play

but also witnesses it in person at the Assembly: "I have been at the National Assembly, where, at a time when the deputies from the provinces engrossed every ticket of admission, my sister and I were admitted without tickets . . . and placed in the best seats" (1.1.42). Attributing their preferential treatment to "being foreigners and women," she applauds the Assembly for including them in the political process, which is very different from their status in England. She observes how "our seats, which were immediately opposite the tribune from which the members speak, reminded [my sister] of our struggles to attain the same situation in Westminster Hall." Parliament had a public gallery, but it had banned women from attending since the 1770s. In contrast, she remarks, "we have attained this situation without any struggle" in France (1.1.43). Beyond inviting women to follow political debate, the question of whether to extend rights to them was actively under discussion at the time.[84] Williams recognizes that the members of the Assembly "are the men who engross the attention, the astonishment of Europe; for the issue of whose decrees surrounding nations wait in suspence, and whose fame has already extended through every civilized region of the globe" (1.1.45). Their decisions have a global impact; if they vote to give women citizenship, then other countries like England, she suggests, may follow their lead.

Through her Revolutionary souvenirs, Williams not only advocates for women's political identity but also introduces a cosmopolitan idea of national identity. British critics censured her for wearing the scarf of Liberty, which they viewed as a betrayal of her own national values and traditions.[85] Ornaments like the tricolor scarf, however, facilitated a more comprehensive way of thinking about the relationship of different groups, particularly women and foreigners, to the French nation. They were also central to creating a revolutionary community that reached beyond national borders.[86] After witnessing the national festival, she asserts, "This was not a time in which the distinctions of country were remembered. It was the triumph of human kind; it was man asserting the noblest privilege of his nature; and it required but the common feelings of humanity, to become in that moment a citizen of the world" (1.1.14). While the term "citizen of the world" reflects Williams's awareness of the debate over whether to make women citizens, it indicates an internationalist position through which she argues for improvements for humanity beyond national affiliation as well.[87] Assuming the Revolution's markers of global identity thus enables her to engage in what Weng calls a "deliberate and powerful reimagining of world citizenship."[88] By embracing its symbolic ornaments, she attempts to persuade Britain to follow the French fashion and adopt a more democratic worldview.

Letters from France was important for its use of souvenirs to create sympathy for the French Revolution and encourage reform in Britain. Through the circulation of sentimental objects in her writing, Williams persuaded her readers to adopt revolutionary ideals of political, economic, and gender freedom and envision a new cosmopolitan model for the nation. During her lifetime, she enjoyed an international reputation and continued to report on the Revolution until her death in 1827.[89] Her subsequent work mirrored Britain's growing disenchantment with the rise of Napoleon, and her *Sketches of the State of Manners and Opinions in the French Republic* of 1801 showed a continued attachment to the original ideals of the Revolution in the face of his expanding empire. In response, Napoleon imprisoned her and censored her writing.[90] Although her English audience temporarily lost sympathy with her views during the Reign of Terror, her salon remained one of the most popular destinations in Paris. Her work had a lasting impact on other British women of the time, influencing Mary Wollstonecraft and Catherine Wilmot to write on political events in France. Her souvenirs succeeded in not only establishing support for the Revolution but also making it a memorable event, and the things she carried to Britain began to carry Britain to her.

2

Mary Wollstonecraft and Political Spectacle in *An Historical and Moral View of the French Revolution*

In December 1792, British writer and philosopher Mary Wollstonecraft journeyed to Paris, hoping to see her ideals of political liberty and women's rights realized by the French Revolution. In 1790, she had written *A Vindication of the Rights of Men* in response to Edmund Burke's conservative critique of the Revolution in *Reflections on the Revolution in France*; inspired by debate in the French National Assembly, she wrote *A Vindication of the Rights of Woman* in 1792, arguing in favor of extending education to women. Having read Helen Maria Williams's *Letters from France*, she planned to write a similar epistolary account of Revolutionary events for English readers. Within a month of her arrival, however, she witnessed King Louis XVI transported to the guillotine, and in February 1793, war broke out between Britain and France. During her time in Paris, she frequented Williams's salon and became part of the politically moderate Girondin circle, headed by many of the Revolution's leaders. When the Reign of Terror began in September of that year, the radical Jacobin party arrested Williams and her English friends and executed thousands of the Girondins. Disillusioned by the rupture between her political beliefs and their failure in practice, Wollstonecraft abandoned her epistolary project and instead wrote *An Historical and Moral View of the French Revolution* to explain the violent turn of events in France to an English audience who had lost sympathy for the Revolution. She began the work in 1793, completing only one of several projected volumes that covered the early months of the Revolution, and sent it to Britain for publication in 1794.[1]

Although *French Revolution* is not a direct response to Williams's *Letters*, Wollstonecraft similarly examines the role that material objects play in the Revolution. She argues that the Terror was the predictable consequence of a morally corrupt society constructed by the artificial hierarchical institutions

of the old regime.[2] While Williams saw Revolutionary icons as substitutes for those of the former government, Wollstonecraft believed that aristocratic objects of luxury and sensibility corrupted the Revolution, with the Terror evolving from centuries of arbitrary power. Unlike Williams, who believed sentimental objects could influence political reform, Wollstonecraft expressed concern over the seduction of their rhetoric.[3] Sentimental objects thus became tools in what Tom Furniss and Michelle Callander call the Revolution's deceptive political spectacle.[4] Whereas Williams employed sensibility to create sympathy for the Revolution and envision a public role for women, Wollstonecraft favored Enlightenment rationalism and advocated for reason to guide political action. As critics like Janet Todd, Gary Kelly, Virginia Sapiro, and Lori Marso have argued, she believed excess sensibility was especially dangerous for women.[5] A late eighteenth-century gender construction that divided men and women into distinct spheres, sensibility and the objects associated with it risked identifying women with the qualities that had initially justified their exclusion from politics.

In this chapter, I argue that Wollstonecraft uses the souvenir conceptually in *French Revolution* to reveal political illusions that undermine the Revolution's progress. As Catherine Packham observes, objects appear in her writing in a literal way as referents but also more figuratively as metaphors.[6] Wollstonecraft indicates how the captivating spectacles of guillotine executions incite violence and allow sentiment to predominate, leading to tyranny rather than freedom. In response, she uses the rare-show figuratively to argue for a political agenda based on reason as a more effective means of social change. She also invokes a commemorative medal made to honor the patriotism of National Assembly members, claiming that it acts as sentimental propaganda to win the nation's support while hiding plots against the Revolution. However, she contends that the medal also functions as a souvenir of the nation's new declaration, which circulates the Revolution's promises and encourages countries across Europe to embrace liberal ideals. She attributes women's failure to obtain rights to their reliance on jewels and ornaments, which continue to signify aristocratic sensibility and allow male politicians to manipulate them. Regardless, she argues that ornament could have aided the Revolution if utilized in moral ways. In Britain, newspapers and other media spread sensationalized depictions of the Terror.[7] Her conceptual souvenirs presented a competing view of events in France, separating the Revolution's ideas from their failed practice and encouraging hope in their eventual success.

Important to my argument is how Wollstonecraft employed material culture in her work to engage in late eighteenth-century political debate.

Countering Williams's belief that souvenirs signified liberty, she showed how they could be deceptive. As Ashli White explains, Revolutionary objects emphasized the potential distance between conviction and appearance, which undercut their very purpose. They were significant not for their straightforward representation of ideals but for the ways they manifested the unstable power and contested meanings of revolution.[8] Wollstonecraft addressed the complexities that arose in the production and circulation of political objects when deployed in the public sphere to identify a new nation. However, she also shared Williams's cosmopolitan radicalism and desire to look beyond national constraints in pursuit of political change.[9] Although she wrote largely about the events of 1789, her references to the Terror show that she hoped her work would influence decisions at home. In 1793, the British government had begun to conduct its own reign of terror, suspending civil liberties, imposing drastic censorship, and trying for treason anyone suspected of sympathizing with the Revolution. Packham notes that "resonant objects often retain a residual power as a persistent memory" in her work.[10] In the face of an increasingly repressive and narrow form of nationalism, Wollstonecraft's souvenirs served a memorial purpose, acting as reminders of the Revolution's goals to restore faith in the values of universal justice and an inclusive global society.

The Rare-Show: "A Scene in the Political World"

According to Favret, "the language of spectacle and stage fashioned popular response to the French Revolution from its earliest days." While initial commentators like Williams expressed "astonishment at the wonderful Spectacle" of the Revolution, many in Britain were inclined to see it as a "theater of massacres and follies" or "like the scenes of a tragedy and luridly lit" during the Terror.[11] In *French Revolution*, Wollstonecraft draws on the rhetoric of theater by comparing events in France to a rare-show. Although the term could refer to a public spectacle, it also designated a popular visual entertainment that flourished in the late eighteenth century. Like a miniature theater, the rare-show consisted of a box featuring a small display, usually of a battle, foreign place, or historic or recent event. Having at least one hole on the side through which to look, it offered a three-dimensional experience and created a sense of mystery and curiosity that drew in its viewers. Exhibited at fairs in urban centers across Europe, the rare-show traveled to amuse and instruct a wide range of people, as Figure 2.1 shows. It further generated small, inexpensive souvenirs for middle-class viewers, such as folding paper accordions, parlor-sized peep shows, and handheld

Figure 2.1. Scene at a Fair: A Peep Show, eighteenth century, French, pen and brown ink, brush and brown wash, 6 7/16 × 4 15/16 in. (16.4 × 12.5 cm). The Metropolitan Museum of Art.

peep eggs, which acted as reminders of the scenes on view and influenced understanding of the events depicted.[12] She employs the rare-show as a conceptual device in her text to similarly shape her readers' attitudes toward the Terror.

Wollstonecraft uses the figure of the rare-show to reveal how political spectacles have formed the French nation throughout history. She begins her account by looking back at the Crusades, a series of religious wars in the medieval period, stating, "If we turn then with disgust from ensanguined regal pomp, and the childish raree-shows that amuse the enslaved multitude, we shall feel still more contempt for the order of men, who cultivated their faculties, only to enable them to consolidate their power, by leading the ignorant astray; making the learning they concentrated in their cells, a more polished instrument of oppression."[13] Partaking in the tradition of Enlightenment philosophy that believed European civilization advanced in stages of improvement, Wollstonecraft adopts the rare-show to provide a critique of France's progress. Carried out under the "regal pomp" of government power, the Crusades relied on violence to attain their goals. Reenactments of military exhibitions from the wars and grand public scaffold dramas, which restaged battlefield beheadings, enthralled the populace with bloody visual spectacles.[14] She expresses her "disgust" for these shows; viewed by the "multitude" of the French public, they are a low form of entertainment directed at the "childish," uneducated masses (23). The rare-show was originally a scientific device that sank to the level of a children's entertainment as it moved into the realm of popular culture.[15] Richard Balzer notes that "rare-show" thus "became a term of derision used by social commentators to mock the most common forms of entertainment."[16] By focusing on the rare-shows of the medieval court, Wollstonecraft shows how France is rooted in barbaric forms of political spectacle that prevent the progress of civilization.

Wollstonecraft claims that these feudal spectacles contributed to the nation's oppression. With the phrase "if we turn . . . from," she directs attention away from the shows to the reality that they concealed (23). Behind the scenes, the clergy, who supposedly represented the progress of civilization through education and moral understanding, used their knowledge to subjugate the people. While "polished" French society may have looked advanced, the institutions of government and Church were as base as the political displays that they employed to deceive the nation. As Balzer explains, the rare-show was an optical toy that played visual tricks on its viewers. Its purpose was to "create an illusion" or "conjure up an image and make it more powerful than reality." Rare-show operators used an internal

mechanism to change the scenes inside the box and manipulate the views. Hence, Balzer states, "viewing adults are . . . taken advantage of" when they submit to its entertainment.[17] Like rare-show operators, Wollstonecraft notes, the clergy used theatrics to manipulate the people and "lead" them "astray" (23). Instead of enlightening the populace, the shows allowed the medieval court to control and "enslave" the nation. Through her rare-show analogy, she suggests that the court, by relying on visual display rather than political strength for its power, upheld political structures that subjugated the nation.

Although intended to liberate the nation from oppression, Wollstone-craft argues, the Revolution replicates the spectacles of the past in the Ter-ror. She describes executions at the guillotine as resembling France's former medieval shows when she states, "The entrance into Paris, by the Thuiller-ies, is certainly very magnificent . . . the beauty of the buildings in the noble square, that first attracts the travellers eye . . . render[s] the view, as the city is approached, truly picturesque. . . . But how quickly vanishes this prospect of delights! . . . The elegance of the palaces and buildings is revolting, when they are viewed as prisons, and the sprightliness of the people disgusting, when they are hastening to view the operations of the guillotine, or care-lessly passing over the earth stained with blood" (215–216). Public execu-tions at the guillotine, which killed nearly seventeen thousand citizens, became a daily spectacle in Paris.[18] A popular form of entertainment, they attracted large crowds of spectators. As in a theater, the guillotine scaffold acted as a stage, with onlookers resembling an audience.[19] Highly visible and visual in nature, executions occurred during the day at the Place de la Révolution, a central location in the city.[20] Situated near the Tuileries Pal-ace, which was the home of Louis XVI and the National Assembly, the guillotine linked theater and politics by usurping the king's authority and indicating Revolutionary leaders' support for the executions.[21] As Figure 2.2 shows, vendors selling souvenir prints of the executions filled the site, further circulating their image.[22] Positioning herself as a "traveller," Wollstonecraft also provides a view of the Terror with her metaphorical rare-show. Look-ing in with her "eye" to the "entrance" of the city, she gazes as if through a peephole at a "picturesque" scene (215–216). As the "prospect . . . vanishes" and the guillotine takes the stage, she observes how the scene changes, with people hurrying to watch the entertainment. By contrasting "the beauty of the buildings in the noble square" with the blood-stained streets, she empha-sizes the gruesome and incongruous nature of the executions. Unlike the prints commemorating beheadings, her rare-show view echoes the "ensan-guined" medieval shows, and both evoke her "disgust" (23).

Figure 2.2. Isidore Stanislas Helman, after Charles Monnet, *Execution of Louis XVI*, 1794, engraving. Bibliothèque Nationale de France.

Due to their reliance on violent spectacle, guillotine shows render the French nation as unenlightened as it was before the Revolution. The normality of the executions most shocked witnesses, as well as the way that they fueled the bloodlust of the crowds.[23] Noting the audience's "sprightliness" and "careless" indifference to the bloodshed, Wollstonecraft implies that the shows do not effectively transform the populace (216). She explains that "if a relish for the broad mirth of *fun* characterize the lower class of english, the french of every denomination are equally delighted" (25). Considered the pinnacle of the Enlightenment, the Revolution aimed to use reason to challenge and demolish tyrannical institutions.[24] However, she observes that the guillotine shows, coarse in taste, instead degrade their audiences. Consequently, the entire nation sinks to the level of the masses as entertainments that normally "characterize the lower class" typify every social group in France (25). Such popular entertainment has made the people "equal" but not free, and her sarcastic emphasis on "*fun*" reveals her derision of their debasement. By comparing the French to the lower class in England, she enables her readers to conceptualize France's lack of enlightenment. Britain had ended the practice of public beheadings early in the eighteenth century, a sign of improved manners, sensibility, and responsiveness to the public.[25] England's decision indicates its social advancement, whereas France's rehabilitation of public displays of violence suggests its regression.

Comparing the guillotine executions to another famous spectacle, the fall of the Bastille, Wollstonecraft shows how tyranny revives during the Terror. For Williams, the prison's demolition signaled the end of feudalism, but Wollstonecraft reveals that its crimes return:

> I tremble, lest I should meet some unfortunate being, fleeing from the despotism of licentious freedom, hearing the snap of the *guillotine* at his heels; merely because he was once since noble, or has afforded an asylum to those, whose only crime is their name—and, if my pen almost bound with eagerness to record the day, that levelled the Bastille with the dust, making the towers of despair tremble to their base; the recollection, that still the abbey is appropriated to hold the victims of revenge and suspicion, palsies the hand. . . . Down fell the temple of despotism; but— despotism has not been buried in it's ruins! (85)

Like Williams, Wollstonecraft is initially "eager" to "record" the memorable occasion of the Bastille's fall, but instead she documents how the guillotine replaces the medieval prison as a new form of "despotism." While some died at the guillotine for their political opinions or actions, many lost their lives for little reason beyond mere "suspicion." Under the Law of Suspects, the Jacobins targeted anyone who appeared to support their enemies.[26] While Williams hoped that the Revolution would abolish the lettres de cachet and arbitrary imprisonments of the old regime, Wollstonecraft observes how mass incarceration takes their place, as the Jacobins repurpose abbeys as prisons. In October 1793, a new law further made all persons who protected priests or members of the aristocracy liable to summary execution, and she expresses fear over encountering a "noble" due to the threat that associating with them could pose to her own life (85). Far from ending the tyranny of the Bastille, the guillotine perpetuates it.

As the shows of the guillotine replace the spectacle of the Bastille's fall, Wollstonecraft argues that the revolutionaries replicate the abuses of the past. Under the Jacobins, power became concentrated in the hands of a small group of men, led by Robespierre, which functioned as a dictatorship.[27] These extremists set out to destroy their enemies by means of execution.[28] As Jessica Goodman notes, the Jacobins "both manipulated and misrepresented the opinions of the public, using the guise of the 'general will' to justify carrying out personal vendettas through the medium of the guillotine."[29] Wollstonecraft likewise states that one of the motives for the executions was "revenge" (85). She describes the Jacobins as "the worst of tyrants" because they "pretended to be subordinate to [the nation's] will, though acting the very part of the ministers whom they execrated" (193).

Caught up in the political spectacle, the Revolution's leaders claim to side with the people while deceiving them about their true intentions. As with medieval shows, this allows them to manipulate the nation. While the taking of the Bastille enabled the people to subvert and appropriate the authority of sovereignty, the guillotine shows removed them from their role as actors and returned them to the traditional position of spectators.[30] As Goodman explains, the "masses are told they control the operation of the guillotine, even as the true puppeteers show themselves to be pulling the strings."[31] The Jacobins thus abuse their power by becoming the medieval tyrants they sought to overturn.

Wollstonecraft also contends that the Jacobins fail to deliver justice with the guillotine shows. In theory, the guillotine demonstrated equality, as its mechanical nature made it appear to be an instrument of impartial justice.[32] The Jacobins also changed its name from the "Louisette" to avoid any connection to the king; linking it instead to its founder Joseph Guillotine, a physician and National Assembly member, they located authority within the nation. During their reform of the criminal code in 1791, the Assembly sought to abolish sentencing based on rank or social differences. The guillotine therefore offered an egalitarian form of capital punishment in which citizens would die in the same way. However, it evolved out of France's history of institutional violence and control. The formal staging of beheadings during the medieval era projected the power of the state and the authority of its leaders.[33] Rather than a means of popular justice, the guillotine symbolized Revolutionary terror in its totalitarian manifestation.[34] Wollstonecraft calls its fairness into question when she rails against "terming the assassin's stab the stroke of justice, because given with the mock ceremonials of equity, which only rendered the crime more atrocious" (216). The guillotine may execute its victims equitably, but its method remains criminal. Calling the shows "mock ceremonials," she suggests that they merely lend an appearance of justice to the revolutionaries' actions.

During her visit to Versailles, Wollstonecraft represents the palace, like the guillotine, as a view within a rare-show to further highlight the injustice of the Jacobins. As she relates, "How silent is now Versailles! . . . the eye traverses the void, almost expecting to see the strong images of fancy burst into life.—The train of the Louises, like the posterity of the Banquoes, pass in solemn sadness, pointing at the nothingness of grandeur, fading away on the cold canvass, which covers the nakedness of the spacious walls—whilst the gloominess of the atmosphere gives a deeper shade to the gigantic figures, that seem to be sinking into the embraces of death" (84). Versailles had been unoccupied since October 6, 1789, when

the mob had forced the royal family to return to Paris. The surveilling "eye" and the "canvass" of portraits adorning the walls indicate her touring of the "silent," empty palace, but they also refer to the painted scenes displayed inside a rare-show. As "images of fancy," they visually resurrect the Bourbon dynasty. The scene then shifts to one of "death," referencing both the kings of the past and Louis XVI's execution at the guillotine. The king's execution horrified moderates like Wollstonecraft who advocated for the monarchy sharing power more equally with the National Assembly. In comparing the Bourbons to the "Banquoes" in Shakespeare's play *Macbeth*, she uses a theatrical analogy to suggest that the Jacobins' desire for power had corrupted the Revolution. Much as Macbeth murders Banquo, they killed the king to secure sovereignty; like Banquo's ghost, who returns to chide Macbeth for his tyrannical action, the Bourbons haunt Versailles. Pointing to "the nothingness of grandeur," they mourn the loss of their dynasty and warn of the fleeting nature of power. When Williams visits Versailles, the palace is a reminder of old-regime oppression, but in Wollstonecraft's rare-show view, it becomes a memorial of Jacobin tyranny.

Wollstonecraft uses the figure of the rare-show to argue for reform over revolution as a means of political change. Engaging in the debate over whether the French should have preserved their government, she argues that demolishing it has not guaranteed liberty:

> It is true, had the national assembly been allowed quietly to have made some reforms, paving the way for more, the Bastille, though tottering on it's dungeons, might yet have stood erect.—And, if it had, the sum of human misery could scarcely have been increased. For the *guillotine* not finding it's way to the splendid square it has polluted, streams of innocent blood would not have flowed, to obliterate the remembrance of false imprisonment, and drown the groans of solitary grief in the loud cry of agony—when, the thread of life quickly cut in twain, the quivering light of hope is instantly dashed out—and the billows suddenly closing, the silence of death is felt! (123)

While Williams believed that overturning the old regime was necessary for progress, she counters that leaving it in place would have allowed the French to make gradual improvements. Although this view echoes Burke's conservative argument, she embraces reform not from a shared reverence for the authority of the past but over a concern that violence hinders progress. Intended to "obliterate the remembrance of false imprisonment" represented by the Bastille, the guillotine instead replicates tyranny with its shedding of "innocent blood." Citing its victims' "loud cry of agony," she

Figure 2.3. Promenade de Longchamp, Optique No. 4, c. 1810, Paris, Gardet Papetier, hand-colored prints, 123 × 145 mm. Special Collections, J. Willard Marriott Library, The University of Utah.

contends that this fate is worse than the Bastille prisoners' "groans of solitary grief." The "billows suddenly closing" after beheading acts as a metaphor for the end of life but also describes the closing of the rare-show (123). Folding paper accordion peepshows consisted of bellows on the sides that linked front and back panels with prints in between them, as Figure 2.3 indicates.[35] When expanded, the overlapping prints of the peepshow created a sense of depth and provided a window into a miniature realm; when closed, they neatly collapsed into a box and fit in a pocket for easy transport, making them popular souvenirs as substitutes to experiencing the real thing.[36] This figure also depicts the Champs-Élysées, a popular Parisian street that led to the Place de la Révolution during the Terror. With her corresponding peepshow view, Wollstonecraft allows readers to imagine the scene at the scaffold to convince them of its horror and advocate for moderate political reform.

The language of spectacle also allows Wollstonecraft to defend the Revolution and explain its failure. Burke exploited the nation's capacity for murder and violence to denigrate the Revolution and its ideologies. According to Regina Janes, he "deprives the crowd of any motivation—ideological, political, or economic—for its violence. The violence stands alone, isolated, irreducible, and incomprehensible."[37] Although Wollstonecraft acknowledges the violence, she also provides a reason for it, namely that "the character of the french, indeed, had been so depraved by the inveterate despotism of ages, that even amidst the heroism which distinguished the taking of the Bastille, we are forced to see that suspicious temper, and that vain ambition of dazzling, which have generated all the succeeding follies and crimes. For, even in the most public-spirited actions, celebrity seems to have been the

spur, and the glory, rather than the happiness of frenchmen, the end" (123). While Burke blamed the people for the violence of the Terror, Wollstonecraft absolves them of guilt by arguing that despotic governments of previous eras have shaped their behaviors. Influenced by a society of spectacle, they become obsessed with image and appearance when they gain political power. Questioning the motives behind popular actions like the demolition of the Bastille, she contends that they may have been less about the good of the nation and more about a desire for "celebrity" and renown. As the taking of the prison turns into one more scene in the rare-show of politics, the people become part of the spectacle they fought to overturn. Considering that "their national character is, perhaps, more formed by their theatrical amusements, than is generally imagined," she asks, "is it surprising, that almost every thing is said and done for stage effect?" (25). Locating the Revolution's failure in the corruption of the past, she separates its ideals from the Terror and suggests that they are still worth pursuing.

In her desire to redeem the Revolution, Wollstonecraft argues that the French will eventually realize its goals. During the Terror, Goodman notes, authorities harnessed the hunger for public spectacle and "required theatres to produce plays exemplifying civic virtues and portraying the glorious events of recent Revolutionary history to encourage patriotism among their spectators." As in the guillotine shows, "emotional engagement was turned to political ends, with the moral values represented on stage generalized and made accessible to the audience."[38] However, Wollstonecraft observes that the people reject the propaganda of political spectacle. She relates how the "multitude had rushed into the different theatres, at the hour of opening them, and required, that they should be instantly shut; and that in consequence all the spectators had been sent away" (83). As Callander states, "Closing down theatres is the paradigmatic act of resistance" and provides "evidence of a change in cultural values."[39] Wollstonecraft subsequently predicts that "their amusements will flow from a more rational source. . . . If these have been supported hitherto by childish ignorance, they seem to be losing their influence" (164). Referring again to the French as children before the rare-show of politics, she claims that the people will grow into successful citizens if they institute a government based on moral substance rather than spectacle. Optimistic that such shows are already losing their hold, she implies that there is hope for revolutionary progress.

Wollstonecraft uses the rare-show to exhort her readers not to abandon their belief in the Revolution, either. Parlor-sized peepshows came with a series of slides that portrayed one image, but when inserted into the back of the device and viewed against a strong source of light, transformed into

a completely different scene.[40] She captures a similar optical illusion in her text when she states, "The rapid changes, the violent, the base, and nefarious assassinations, which have clouded the vivid prospect that began to spread a ray of joy and gladness over the gloomy horizon of oppression, cannot fail to chill the sympathizing bosom and palsy intellectual vigour . . . it becomes necessary to guard against the erroneous inferences of sensibility; and reason beaming on the grand theatre of political changes, can prove the only sure guide to direct us to a favourable or just conclusion" (6). While the light points to the experience English viewers might have had of events in France through their parlor peepshows, it also serves as a metaphor for political changes in France. The Revolution's "ray of joy" sought to dispel the nation's "gloomy" feudal oppression, but the guillotine executions "clouded" the "prospects" or hopes for change. McCaffrey-Howarth notes that the extensive circulation of guillotine imagery in Britain functioned as a shock tactic, encouraging consumers to associate democracy with danger.[41] Wollstonecraft worries that fear and opposition now beset the "sympathizing bosom" of British supporters formerly moved by a politics of sentiment (6). She warns them not to fall prey to misleading emotions but instead to allow "reason" to shape their understanding. Depicted as a "beaming" light, reason promises to widen the Revolution's ray of hope, allowing them to look beyond the Terror at the "grand theatre" of events in France and judge them more fairly. Her use of light also evokes the Enlightenment, enabling her to place the Revolution squarely back in the line of historical progress despite the Terror's detour into feudalism. Rare-show souvenirs became an important means by which viewers remembered the events depicted.[42] Privileging her own "view," as her title suggests, she becomes a rare-show "guide" who persuades readers that her version of the Revolution, rather than that of the Terror, is the one to watch (6).

The Medal: "Fatal Mock Patriotism"

On August 4, 1789, the National Assembly announced a series of decrees intended to bring equality to France by abolishing numerous feudal rights and privileges enjoyed by the nobility and clergy. Benjamin Duvivier, known for his medals of Revolutionary heroes, and Nicolas Marie Gatteaux, an engraver who made Revolutionary playing cards, created the official medal that recorded the night when, in only a few hours, the Assembly abolished an entire aristocratic structure. A small, coin-shaped object struck in bronze, the medal served as a souvenir commemorating the historic event

Figure 2.4. Pierre Simon Benjamin Duvivier (obverse), *Abandonment of Privileges, August 4, 1789*, 1789, bronze, 63 mm. Carnavalet-History of Paris Museum.

and honoring the patriotism of the deputies who made sacrifices for the new nation. As Figure 2.4 indicates, the obverse side of the medal presents a profile bust of Louis XVI with the inscription "Restorer of French Liberty" around the edge. The reverse side, seen in Figure 2.5, shows the three orders, nobles, clergy, and bourgeoisie, gathered around an altar in the hall of the National Assembly. Led by the Vicomte de Noailles, they cast their titles to privileges at the altar, represented by scrolls of paper strewn around its base. Bearing the inscription "to the fatherland," the altar signifies the emerging nationalism that would shape France into a modern state. In the background, seated figures in the galleries are visible between the hall's columns. However, commentators considered the medal mere hyperbole. In contrast to the mythic story, there was division within the Assembly, as the deputies submitted to popular enthusiasm and the nobles and bishops introduced provisions to prevent the loss of their privileges.[43] Wollstonecraft builds on this commentary to argue that the medal is a souvenir commemorating legend more than reality.

In her discussion of the August decrees, Wollstonecraft uses the medal to reveal the Assembly's lack of commitment to the Revolution. She recounts

Figure 2.5. Nicolas Marie Gatteaux (reverse), *Abandonment of Privileges, August 4, 1789,* 1789, bronze, 63 mm. Carnavalet-History of Paris Museum.

how, after listing their declarations, the deputies propose the medal as a way of reinforcing their proposals:

> And then, not forgetting their national character, it was proposed, that a medal should be struck in commemoration.... And behold night closed on the renowned 4th of august! ... The next morning the different parties could scarcely believe, that they had more than the imperfect recollection of a dream in their heads. So quick, indeed, had been the determinations of the meeting ... [that] they seem in reality to have been mostly the effect of passion, of ambition, or a vain desire of vengeance; for those who were led only by enthusiasm, and the vanity of the moment, esteemed their conduct as highly extravagant, when they had time to cool. (139–140)

Fashionable during the Revolution, the production of medals preserved for posterity portraits of illustrious persons or memories of important actions. Medals were made to last; by virtue of their physically durable medium, they could propagate images that would be far more permanent than similar ones rendered in other media, such as canvas paintings. As Lake explains, they were therefore considered the most reliable type of object for the preservation of historical facts.[44] Wollstonecraft notes that the

Assembly proposes the medal "in commemoration," suggesting their intention for it to serve as a souvenir calling to remembrance their accomplishment in future times (139–140). However, she also indicates that the deputies do not adhere to their political promises. Drawn up quickly, the decrees appear merely a "dream," as if their patriotic promises had never happened. Though they remember their proposals on the night they make them, they forget them the following day. The medal thus does not "strike" their minds or leave a lasting impression. Meant to honor the deputies for their sacrifices, the object instead signifies their lack of devotion to the Revolution. Their emotions, felt only in "the moment," contrast with the lasting material and message of the medal. Using the imperative "behold" ironically, she draws attention to a wavering patriotism that undercuts the supposedly memorable event.

Wollstonecraft further shows how the nobility use the medal to cover their real intentions. After the fall of the Bastille, French citizens demanded the abolition of feudal rights, and the Assembly decided to issue the decrees to pacify them. However, the Vicomte de Noailles and the Duke d'Aiguillon secretly plotted to save their feudal rights by sacrificing their honorary titles, which were of little value, and demand payment of dues on the land, which had actual value. As Wollstonecraft explains, "The opposers of a new proclamation flattered themselves, that they should secure the general suffrage, by making it appear, that patriotism demanded great sacrifices . . . it was necessary to carry real offerings to the altar of peace" (135). In the Vicomte de Noailles's words, this would resolve the public crisis "by letting them see, that we are really employed for their good." The nobles' "offerings" are their titles, which on the medal are the scrolls of paper that make the sacrifice visible. Wollstonecraft's use of visual language with the terms "appear" and "see" emphasizes the materiality of their gesture, yet "appear" also suggests that they give only the impression of sacrifice. As they work to undermine the Revolution, the nobles make offerings that are not "real" but merely seem so on the medal. Featuring stately topics and composed of fine material, medals were a medium designed to impress viewers.[45] The nobles realize that the impactful medal will "secure the general suffrage" and win over the public (135). Although intended to help the nation envision the Assembly's patriotism, the medal is no more than an empty gesture.

The medal allows Wollstonecraft to reveal that the nobles are not true supporters of the Revolution. The Duke d'Aiguillon, "dreading the suppression of his pension . . . suddenly, from being a minion of the old court, became a loud patriot" (136). The role of "patriot" he assumes hides his motivation, which is concern over his economic status. The term "minion"

also suggests that he was a court lackey, showing a devotion to the monarchy that he did not truly feel to gain favor. By aligning the position of "minion" with that of "patriot," she contends that his sympathy for the Revolution is just as inauthentic. Although he attempts to convince the Assembly of his patriotism with "loud" proclamations, his "suddenly" changing position is neither reliable nor lasting. His actions stand in contrast to the medal, which supposedly conveys genuine and enduring patriotism. As Lake notes, numismatic objects could represent enduring virtues and create sentimental attachments to the past. However, they also could "depict falsehoods as monumental truths—and the falsehoods they impressed could be all the more convincing because coins and medals seemed able to speak so intimately to their interlocutors."[46] Lynn Festa further explains that their sentimentality could serve as a means of manipulating, as much as indicating, feeling; the object may mark a failed substitution, exposing an owner who has not identified with the feeling it represents but who uses the object to stand in its place. The owner only performs emotion through the object, which functions as a hollow sign.[47] In Wollstonecraft's account, the duke uses the sentimental object of the medal to espouse patriotic emotion that he does not actually feel, professing his devotion while deceiving the nation. For her, the medal becomes a way to expose his false revolutionary sentiment.

The patriotism celebrated by the medal is part of the nobles' plot to convince the Assembly to participate in forming the decrees. As Wollstonecraft recounts, "The motion of the viscount de Noailles excited a sudden enthusiasm" among the members, who make their own decrees so "that the duke d'Aiguillon should not be generous at the expense of others" (137). The problem with the sentiment is that it compels them to act out of shame instead of a genuine desire to give up their privileges; as she states, "A number of the nobility concurred in these sentiments; for who would be out-done in heroism? and demanded the renunciation of these unnatural privileges" (138). She further notes how "all the members seemed eager to point out to their colleagues the new sacrifices, that ought to be made to the good of their country." By setting the standard for what "ought" to be done, the vicomte and duke cover their lacking patriotism. The sacrifice of privileges, which leads to a "combat of generosity" in which the deputies compete to prove their national devotion, results in the "combat" or opposition to the good intentions by which they proclaim to act (140). She points out that this causes division, as "the nobles and clergy of the provinces, who had not been carried away by the enthusiasm of the 4th of august, felt themselves particularly aggrieved" by deputies who "had exceeded all bounds in voting

away the private property" on which they depend (150). As they further alienate the nobles from the common people, they foster class resentment rather than social equality.

The scene at the Assembly that the medal depicts also resembles a theatrical display aimed at convincing a popular audience. Like the rare-show, the sacrificing of privileges presents a spectacle intended to entertain more than enlighten. As Wollstonecraft observes, "Three parts out of four of the time, which ought to have been employed in serious investigation, was consumed in idle vehemence. Whilst the applauses and hisses of the galleries increased the tumult; making the vain still more eager to mount the stage. Thus every thing contributing to excite the emotions, which lead men only to court admiration, the good of the people was too often sacrificed to the desire of pleasing them" (156). As the medal visually captures, the legislators perform in front of an audience, namely the common citizens seated in the "galleries" of the hall, which as Williams noted was a typical practice in the French Assembly. Instead of basing their ideas in political thought, the deputies allow those who take the "stage" like actors and argue most vociferously to shape the debate. The "applauses and hisses" of the audience further amplify the dominance of "emotions" over reason and determine the deputies' actions; by encouraging the "vain" to take charge, the audience helps perpetuate a cycle that inhibits effective political change. As Furniss states, "Wollstonecraft suggests that the National Assembly itself became a profane theatre in which delegates played to the gallery [and] sacrificed the people's good to the desire of pleasing them."[48] The proposing of the decrees becomes no more than another spectacle, with the deputies acting on feeling and basing their political decisions on what amuses rather than what benefits the nation. In depicting the theatrical scene at the Assembly, the medal allows Wollstonecraft to imply that the event is not much more than a show.

The medal hides not only the nobles' lack of patriotism but also that of the king. Although Louis showed support for the Revolution publicly, privately he hoped that it would fade. As Wollstonecraft explains, he was "determined to play a part that would give an air of sincerity to his present conduct, whilst his object was secretly to favour the efforts of the counter-revolutionists; and if possible effect his own escape" (171). She observes how the nobility take advantage of the king's reluctance, commenting that "whilst they were settling these things in the assembly, the refractory nobles and clergy were intriguing to prevent the king from giving his assent to the promulgation of the decrees of the 4th of august" (170). Encouraged by the nobles to oppose the decrees, he bluntly refused to sanction them,

using his veto power to block their passing. This action eroded his popularity with the people and allowed the nobles to make him the scapegoat for the Revolution's failure. Wollstonecraft ironically notes that "a decree also passed, conferring gratuitously on the king the august title, it might savour of a style that scarcely befits the dignity of history, to say *nick-name*, of RESTORER OF FRENCH LIBERTY" (139). In capitalizing the king's new title, she imitates the inscription featured on the medal to show how this object completely misrepresents his role. Calling the title "gratuitous" and ridiculing it as a mere nickname, she suggests that it is hardly justified when he actively works to oppose liberty. The medal ultimately violates the "dignity of history" by providing an incorrect record of the king's actions.

Even though the nobles do make sacrifices, Wollstonecraft points out that their actual concessions do not amount to much. Caught up in the patriotic enthusiasm and spectacle, the other deputies failed to notice that the clauses for redeeming the feudal dues were ambiguous and allowed for the postponement of abolishing privileges. The third estate had only a vague idea of how feudal rights worked, so they saw the sacrifice of privileges as a greater renunciation than it truly was. In addition, the Assembly sanctioned only in principle what people had already accomplished in certain localities, such as sharing taxation, abolishing honorary offices, and replacing manorial courts with judges. Wollstonecraft shows that the nobles' propositions merely provide what the people should already possess: "These legislators . . . all talked of *sacrifices*, and boasted of generosity, when they were only doing common justice, and making the obvious practical comment on the declaration of rights, which they had passed in the morning.—If such were the rights of man—they were more or less than men, who withheld them" (140). The sacrifices that the nobility make are "the obvious practical comment" on the natural rights of the people. Their "generosity" consists in "only doing common justice," and instead of giving rights, they are simply no longer withholding them. As the term "boasted" suggests, their pride is unwarranted; "more or less than men" themselves, they are in no position to deprive their fellow citizens of liberty.

When the Assembly attempts to turn the declarations into laws, they also find that they are nearly impossible to enforce. As Wollstonecraft explains, "The decrees of the 4th of august, were then brought forward to be examined and explained," but "the ministers, not knowing how to act under the new trammels of responsibility, came to represent to the assembly;—that the laws were without force" (151). The deputies have trouble putting the vague renunciations into words, and while they made the people free in principle, they introduced "trammels" or restrictions in practice that

demanded they continue to pay tithes and dues. While the Assembly hoped to placate the people with their decrees, Wollstonecraft notes that it has the opposite effect, as "the very concessions of the nobility seemed to rouse the vengeance it ought to have allayed; and the populace vented their rage by burning the castles, which had been, as it were, legally dismantled of their feudal fortifications" (150). The citizens also "flew to arms, and three millions of men wearing the military garb, showed . . . their present resolve, no longer to couch supinely under oppression." The decrees embolden the people by making them believe they are equal while at the same time rendering them violent by withholding this equality in expecting payment. By following the nobles' plan, the Assembly unwittingly created the very conditions that led to the Terror. The medal may rouse enthusiasm, but it also becomes an indicator of what Wollstonecraft calls "fatal mock patriotism," or a false and dangerous sentiment that undermines the new nation (6).

Despite her indictment of the nobility, Wollstonecraft believes that they are not fully responsible for the Revolution's failure, as old-regime political practices have shaped their own: "The despotism of the former government of France having formed the most voluptuous, artificial character, in the higher orders of society, makes it less extraordinary to find the leading patriots men without principles or political knowledge" (142). She ties their medal to those of Louis XIV, who relied on them to an unparalleled degree, casting over three hundred during his reign. Serving as a vehicle of propaganda, the medals represented his military victories; embodied by gods and allegorical figures, such as the sun, he conveyed the message that the French must revere their monarch and other nations fear him.[49] Wollstonecraft notes how "the business of his life was adjusting ceremonials . . . imposing on the senses of his people . . . false political opinions" (26). While the term "ceremonials" may refer to the spectacle of ceremonies, it also indicates the objects connected with them, like ceremonial medals. His medals use materiality to persuade the nation and shape its political thinking. They also disguise his tyranny with images of success, leading the nation to support him "in spite of the imprisonment, exile, flight, or execution of two millions of french" (27). Although the Assembly intended to undermine the court by producing its own medal, theirs resembled official state ones in style and quality.[50] The medal thus indicates that the nation's political approach has not changed.

Wollstonecraft also argues that the medal does represent political progress, both in France and around Europe: "Much had been gained on the 4th of august by the nation: the old forms of feudal vassalage were

completely overturned—and France then stood at the point the most advantageous in which a government was ever constructed" (142). Even if the nobility has not completely renounced their privileges, abolishing their titles makes the establishment of a new government possible. Soon after the decrees, on August 26, the Assembly ratified the Declaration of the Rights of Man and the Citizen, a core statement of the values of the Revolution that had a major impact on the development of democracy. She contends that the medal will be a significant and lasting souvenir of a declaration that, "constantly present to all the members of the social body, may continually remind them of their rights" (155). Moreover, the medal has the power to shape principles abroad. Even in miniature, medals were elaborate and highly detailed, providing a platform for the recording and dissemination of information on current events.[51] As Lake notes, their small size facilitated their production in quantity and distribution to a wide audience, which ensured their survival over time and their success as souvenirs.[52] According to Wollstonecraft, "Europe ought to be thankful for a change, that, by altering the political systems of the most improved quarter of the globe, must ultimately lead to universal freedom, virtue, and happiness" (222). Once circulated across Europe, copies of the medal could help spread the ideals embodied in the declaration and convince other nations to adopt them.

Wollstonecraft further encourages England to consider its own government in relation to France's new declaration. Indicting her country's reactionary response to the Revolution, she states, "superficial politicians condemn it as absurd and chimerical, because it has not been attended with immediate success" (167). She reminds her readers that they cannot criticize the French because "even the system of the british constitution was considered, by some of the most enlightened as the sublimest theory the human mind was able to conceive, though not reducible to practice." If England has been able to establish a government once considered fantastical, she suggests, France can do the same. She also calls into question her country's belief in their constitution as superior. "Taking for granted that it was the model of perfection," she states, England "never seem to have formed an idea of a system more simple, or better calculated to promote and maintain the freedom of mankind" (113). Unlike France, which now has a declaration to guarantee its freedom, England "had no specific basis beside magna charta, till the habeas corpus act passed; or before the revolution of 1688, but the temper of men" (114). Without material items such as declarations and medals to render it permanent, England cannot fully possess a solid government. Britain's lawmakers thus "should not relax in their

endeavours to bring to maturity a polity . . . which promises more equal freedom" (167). Like Williams, she uses the souvenir to remind England to examine its own constitution and improve it.

Writing from the vantage point of the Terror, Wollstonecraft uses the medal to counter anti-revolutionary propaganda in England. The production and collection of medals became extremely popular in Britain, where they reflected changes in opinion about events in France.[53] In 1793, Matthew Boulton's Soho Mint in Birmingham switched from producing medals celebrating the French Republic to mourning the fall of its monarchy. One medal shows the king in the process of bidding farewell to his grieving family, another depicts his decapitation at the guillotine and the exhibition of his head to the crowd, and a third represents Marie Antoinette bound in a cart on the way to her execution. These medals, which were for public sale in England, helped spread counterrevolutionary messages. However, other medals continued to support the Revolution's sympathizers, such as one celebrating the release of members of the London Corresponding Society formerly arrested for treason. Representing a triumph over the government's violation of civil liberties, such medals make apparent Wollstonecraft's complaint that "liberty, though still existing in the small island of England, [is] yet continually wounded by the arbitrary proceedings of the british ministry" (115). While her fellow Britons engaged in the Revolution Debate through these contemporary tokens, she instead chooses to return to the souvenir medal of August 4, 1789, to explain the spiral into terror as well as to remind her readers of the Revolution's political success and the liberty that it continued to promise.

Jewels: "A Necessary Bauble to Please the People"

Although the Revolution initially brought some improvements to women's legal status, Wollstonecraft was disappointed that France did not ultimately extend rights to women. While Williams believed that using jewels and ornaments to support the Revolutionary cause could help women achieve political recognition and citizenship, Wollstonecraft reveals in her account that what appears to be a form of activism for women is merely a public display disguising their lack of political power. Revisiting the same historic event of women donating their jewels to the National Assembly covered by Williams, she argues that jewels, which continue to signify the influence of old-regime corruptions of vanity and luxury, become vehicles for subversive manipulation. She also examines the Women's March on Versailles of October 5, 1789, which she contends was inspired in part by the court's

desecration of the ornament of the tricolor cockade.[54] Descending into anarchy, the event manifested how the cockade transformed from a stylish, patriotic accessory into a symbol of conflict and violence. Unlike Williams, who argued that sentimental objects enabled women to adopt revolutionary identities, Wollstonecraft contends that they show how exaggerated notions of female sensibility corrupted women and prevented them from attaining citizenship.[55] Rather than souvenirs commemorating women's national inclusion, jewels and ornaments become lasting reminders of their absence from the political realm.

Wollstonecraft's commentary on material objects is consistent with arguments about gender, ornamentation, and consumer culture throughout her work. Noting the prevalence of objects in her writing, Packham deems them an essential part of her political philosophy. In *A Vindication of the Rights of Woman*, Wollstonecraft uses them to reveal problematic gender relations and challenge the construction of woman as object. As Packham explains, the "potential disillusion which . . . characterises our relations with objects in commercial society, structures gender relations too. Women . . . willingly participate in a culture of objectification, but whilst they understand this to give them a form of power, it belittles, even miniaturises them." Wollstonecraft indicates this by associating women with a multitude of domestic objects, such as "dolls, rattles, [and] toys." Women's desire for objects is ultimately problematic, Packham states, since it "represents a falsification of the proper destiny of humanity: self-improvement through virtuous action." Wollstonecraft thus calls for a "revolution" in female manners, believing that "female moral self-production will be accomplished via a reorientation to the objects," with "the trifling, the little and minute, apotheosized into the noble and sublime."[56] Her observations of French domestic luxury play a part in her explanation of the Revolution's failure as well. As women align themselves with Revolutionary objects rooted in aristocratic extravagance, they are similarly disempowered.

In opposition to Williams, who commemorates women's donation of jewels as a historic event in *Letters*, Wollstonecraft asserts in *French Revolution* that the gesture fails because the women do not renounce the values that their ornaments signify. She concedes that, as the members of the National Assembly debate advancing the goals of the new nation, the women attempt to participate in the civic action through their offer. She recounts how "the women too, not to be outdone by the roman dames, came forward, during this discussion, to sacrifice their ornaments for the good of their country. And this fresh example of public spirit was also given by the third estate; for they were the wives and daughters of artizans, who first renounced

their female pride—or rather made one kind of vanity take place of another. However, the offering was made with theatrical grace; and the lively applauses of the assembly were reiterated with great gallantry" (169). Calling the women "roman dames," she compares them, as Williams does, to the women whose surrender of their finery inspired the Roman Senate to make their own economic sacrifices for the Republic. However, she does not see their donation as a similarly momentous or patriotic gesture. While Williams states that French women offer the jewels "so dear to female vanity, for the common cause," Wollstonecraft questions the motivations behind their donation (1.1.37). She claims that "one kind of vanity take[s] place of another" as their excessive pride in the good deed replaces the "vanity" or object of the jewel (169). Women may give up their ornaments, but the self-interest that the jewels represent remains, indicating that they do not actually make a sacrifice. Adopting an ironic tone, she suggests that the women, who wish "not to be outdone" by their Roman predecessors, appear to act nobly but do the opposite as they compete for recognition with the heroes of antiquity. Instead of functioning as a reminder of their support for the new nation, the donation of jewels points to their own contribution instead, leading her to doubt whether they truly act "for the good of their country."

In publicly donating their jewels, Wollstonecraft contends, women emulate the aristocracy instead of assuming a revolutionary identity. While Williams argues that women give up their class distinction along with their jewels, Wollstonecraft shows how their possession of such ornaments reveals their imitation of their social superiors. Under the old regime, clothing identified the three estates; to restrict the third estate politically, the nobles prevented them from dressing in certain fabrics and accessories worn by the wealthy. Even before the Revolution, however, women of the third estate could obtain the fashions of the upper classes in secondhand clothing stores and adopt the nobility's forms of dress, including its jewels and trinkets.[57] Wollstonecraft emphasizes that the jewels are "given by the third estate," namely the women of the middle and lower classes (169). Though the donation of jewels by the less wealthy would appear to be a genuine economic sacrifice meant to prove the extent of their patriotism, she excoriates women who assume the pretensions of the upper class through the display of objects associated with luxury. As Kelly explains, Wollstonecraft's "criticism of fashion, luxury and display addressed both upper-class culture and emulation of that culture by the . . . lower classes."[58] Although women surrender their jewels, they mimic the court in their display of wealth to secure power in the Revolution. Aligned with the very class that the Revolution

aims to overturn, women fail to use their jewels to fashion themselves as patriots.

Wollstonecraft links women who donate their jewels to Marie Antoinette to show the debasing influence of the old regime on the Revolution. In contrast to Burke's idealized portrait of her in *Reflections* as the epitome of refined aristocratic elegance, argues Marso, "Marie Antoinette's status as queen symbolized, for revolutionaries, the feminization and corruption of the Old Regime. Propaganda at the time painted [her] as woman, foreigner, prostitute, adulteress, and coquette."[59] Wollstonecraft employs such rhetoric when she states, "The harlot is seldom such a fool as to neglect her meretricious ornaments . . . and the pageantry of courts is the same thing on a larger scale" (30). In comparing the queen to a prostitute, she criticizes her luxurious lifestyle and suggests that her jewels have no worth besides contributing to a court spectacle meant to impress the nation. She even portrays the queen herself as a jewel: "Her lovely face, sparkling with vivacity, hid the want of intelligence. Her complexion was dazzlingly clear" (72). Evoking qualities associated with gemstones, such as sparkle and clarity, she suggests that the queen is no more than a beautiful but trivial object. Pointon notes that diamonds became a point of reference in moral debates, with the terminology of polish and cut representing social values.[60] Wollstonecraft argues that aristocratic values, by emphasizing a woman's body and her ability to be charming over her mind and character, turn the queen into a tainted product of the old regime. The women who donate their jewels appear to renounce such values, but their reliance on ornaments associates them more with figures like the queen than their fellow revolutionaries.

Marie Antoinette and her lavish jewels not only signify the corruption of the old regime but also constitute a display that deceives the nation. Wollstonecraft portrays the queen as a manipulative, scheming, and dangerous woman, observing that, "before she came to Paris, she had already been prepared, by a corrupt, supple abbé, for the part she was to play" (73). Like an actor, she learns to play a role on the stage of the French court. Her life at Versailles encouraged such behavior, for as Wollstonecraft states, a "court is the best school in the world for actors; it was very natural then for her to become a complete actress and an adept in all the arts of coquetry" (74). Using her role to mislead the nation, "the queen became a profound dissembler" who "smiled but to deceive" (72–73). She notes how the queen's habits harmed the nation, as she wasted and extorted money by being "firmly attached to the aggrandizement of her house" and "sending immense sums to her brother, on every occasion" (73). As she concludes, "The state

had been fleeced, to support the unremitting demands of the queen" (33). According to Callander, Wollstonecraft associates the aristocracy "with a type of performance which displays a benevolent sensibility while it conceals a malevolent subtext. The queen, she suggests, is deliberately deceiving the nation's eyes, and in a way that manipulates political reality and potentially endangers the people and the polis."[61] By aligning her with other old-regime illusions like the rare-show, Wollstonecraft reveals how her deception undermines the Revolution.

Partaking in the spectacle of donating their jewels, women prevent their own freedom. Noting how their "offering was made with theatrical grace," Wollstonecraft suggests that it constitutes one more show in a theatrical Revolution (169). Renouncing their jewels in "public spirit," the women would seem to act for the benefit of the nation, yet the fact that they make the donation before the public implies that they intend to please an audience more than to bring about political change. Like their jewels, the women themselves become little more than objects for consumption. Due to their "desire for and display of ornaments and trinkets," states Kate Davies, "fashionable women were frequently seen as spectacular commodities themselves."[62] Although the women's sacrifice appears to render them revolutionary actors, they donate their jewels before the men of the Assembly who, through their "lively applauses," convey their approbation of the gesture but also their amusement at the show (169). Exhibiting "great gallantry" toward the women, they are chivalrous but do not necessarily see them as equals. As Wollstonecraft argues in *Vindication*, "Gallantry . . . tend[s] to make women the creatures of sensation," causing them to seek power through sensibility rather than rational thought and returning them to the traditional gender roles that the Revolution sought to overturn.[63] By relying on feminine objects like jewels to display their patriotism, the women diminish the possibility of their own liberty.

The women's donation fails not only to secure their rights but also to support the new nation's economy. During the eighteenth century, France had incurred significant debt, partly through the costs of maintaining the aristocracy's luxurious way of life at Versailles. Realizing that taxation alone would not solve the crisis, the country approached various European banks in search of a loan. Wollstonecraft observes that, "the loan sill failing, several individuals made magnificent presents; sacrificing their jewels and plate, to relieve the wants of their country. . . . These donations, which scarcely afforded a temporary supply, rather amused than relieved the nation" (173). While Williams argues that women's jewels are financially important because they serve as a form of payment to help alleviate the debt,

Wollstonecraft contends that the donations are barely of any financial use. As a "temporary supply," they suffice as payment only for a limited time and are not a lasting solution to the deficit. Williams also points out how the women's gesture inspires others to follow their lead. Wollstonecraft accedes that others give up their "jewels and plate" in emulation of the women's sacrifice but laments that the nation, "amused" at these empty economic gestures, does not take their action seriously. Instead, the donation inspires further displays of patriotism in which the "magnificent presents" are important for show instead of aid. Although such spectacles may impress the nation, they take precedence over alleviating serious problems like the national deficit.

While the women's donation inspires even the king to sacrifice his valuables, Wollstonecraft argues that his act is another spectacle meant to deceive the nation. Recounting how he donates his collection of Sèvres china, she states, "The king sent his rich service to the mint, in spite of the remonstrances of the assembly.—The disinterestedness of this action, it is absurd to talk of benevolence, may fairly be doubted; because, had he escaped, and the escape was then in contemplation, it would have been confiscated; whilst the voluntary offer was a popular step, which might serve for a little time to cover this design, and turn the attention of the public from the subject of the reinforcement of the guards to the patriotism of the king" (173). Porcelain was one of the most highly prized commodities in the world at this time, and the Sèvres manufactory made elaborate, highly decorated dinner services for the exclusive use of the royal court. Louis's Versailles service was the most costly and sumptuous that the company had ever created. Largely conceived as a showpiece for display, it signified luxury over practicality, much like women's jewels. Taking the king's gesture seriously, the Assembly objects. Donating the service, which was considered an extension of his body, would have been tantamount to the king sacrificing himself. Since foreign dignitaries also commissioned the porcelain as souvenirs for diplomatic gifts, they also realize that it would make a more significant contribution to the French economy if kept in circulation.[64] However, Wollstonecraft suggests that the king uses the patriotic action of renouncing his service to hide his defection. Although he maintained a supportive front toward the Revolution, in late 1791 he attempted to escape to the Austrian border, where he planned to raise an army and arrange an attack on the revolutionaries. The reason that he sacrifices his service so willingly, then, is that he would lose it regardless in the escape. As patriotic spectacles, the donations of goods thus inadvertently enable the Revolution's opponents to undermine the nation.

Wollstonecraft notes that, along with jewels, the cockade motivates women's revolutionary activism. Although a food crisis directly precipitated the Women's March on Versailles, the women also objected to the replacement of the new national ornament. Cockades represent allegiance to a cause, and the royal family, living in fear at Versailles, used them to cement alliances with the guards. At a series of banquets in early October, the queen and women of the court distributed white and black cockades to heighten royalist enthusiasm. The white cockade represented the House of Bourbon, while the black symbolized mourning over the dying monarchy.[65] The embrace of these anti-revolutionary colors could incite a crowd to disruption and chaos, and in her commentary on the event, Wollstonecraft claims that these ornaments create national division. She criticizes "the appearance of white and black cockades, which inconsiderate individuals displayed at the risk of their lives. These, said the parisians, are the first indications of a projected civil war" (195). The brandishing of old-regime cockades in place of the tricolor visually signifies that the aristocracy opposes the new nation. The ornaments carry powerful messages about their wearers' political stance, and a symbolic fight between cockades could lead to a literal one. Stating that "the queen was supposed to be at the head of this weak conspiracy, to withdraw the soldiery from siding with the people," she further blames Marie Antoinette for using aristocratic ornaments to thwart the Revolution's success (196).

Women use the tricolor cockade to protest the aristocracy's attempt to subvert the Revolution. In addition to the queen's circulation of pro-monarchy cockades, a number of drunken soldiers trampled the tricolor cockade at one of the banquets, as represented in Figure 2.6.[66] As Wollstonecraft quotes, "'The national cockade,' exclaimed Mirabeau, 'that emblem of the defenders of liberty, has been torn in pieces, and stamped under foot; and another ensign put in it's place'" (195). To revolutionaries, desecrating the tricolor cockade would have been tantamount to dishonoring the new nation. On their journey to Versailles, the women threatened anyone wearing cockades of another color. On their return with the royal family to Paris, "A number of the women preceded them . . . covered with national cockades, and dragging in the dirt those that were considered as symbols of aristocracy" (217). Unlike the wealthy, who could use their jewels to express their political views, those who marched to Versailles were largely "market women" who did not possess such ornaments of power (196). During the Revolution, simple clothing styles were favored over the elaborate fashions of the old regime, with the tricolor ribbon often the only ornament worn.[67] It was made of wool instead of silk, so that the dress of the

Figure 2.6. Print of the King's Bodyguard and the Flanders Regiment Trampling the National Cockade Underfoot, 1789, etching and engraving on paper. Waddesdon Image Library.

common people, rather than that of aristocrats at Versailles, became the new reference point for all classes. For peasant women, the democratic emblem of the tricolor cockade would appear to afford them a powerful tool of resistance.

Despite women's political advocacy through the cockade, Wollstonecraft disapproves of their actions in the march. While her stance may seem contradictory considering her desire for women's rights, she reveals how the women's belief in the ornament allows anti-revolutionary forces to manipulate them. As she reveals, "the first instigators of the riot were hired assassins" gathered by the Duke of Orléans, who wanted "to revenge himself on the royal family" (198). The duke then "put in motion a body of the most desperate women; some of whom were half famished for want of bread, which had purposely been rendered scarce to facilitate the atrocious design of murdering both the king and queen in a broil, that would appear to be produced solely by the rage of famine" (199). Stoking anger over the cockade allows him to use the women as a cover for his plot, and she argues that he "drove the mob on to perpetrate the mischief long designed, under the sanction of national indignation" (207). British commentators on the Revolution frequently pointed out the gap between what the cockade was supposed to signify and how those who used or wore it behaved.[68] Agitators like the duke could easily employ the Revolutionary cockade to mask their true intentions and engage in dishonorable acts because the French believed that the Revolutionary cockade conferred honor and dignity. Wollstonecraft thus does not oppose women's activism; rather, she uses the cockade to show how their reliance on an object of spectacle leaves them vulnerable to those in power and erodes their political influence.

Wollstonecraft further opposes women's actions in the march because they reinforce the gender categories that prevent women's liberty. As she contends, "It has, therefore, been the scheme of designing men very often since the revolution, to lurk behind them as a kind of safeguard, working them up to some desperate act, and then terming it a folly, because merely the rage of women, who were supposed to be actuated only by the emotions of the moment" (196). By acquiescing to the sentiments aroused by the cockade, they adhere to the gender stereotype of women driven by excess feeling rather than reason. Marso explains that Wollstonecraft believed "exaggerated notions of female sensibility corrupted both women and men, and worked against the extension of fundamental rights of citizenship to women."[69] Although focused on the events of 1789, she writes knowing the outcome for women. In 1792, the Assembly required all men to wear the cockade to demonstrate loyalty to the nation. Desiring to be men's political

equals, the Society of Revolutionary Republican Women, an extreme militant group, demanded that the law extend to women in 1793.[70] As other women opposed it, conflict arose, causing them to lose sight of their goals in disputes over fashion. The Jacobin government subsequently decided that they had no place in public affairs and disbanded all women's organizations. For Williams, the cockade may allow women to imagine themselves as citizens, but Wollstonecraft shows that it deprives them of this opportunity.

Wollstonecraft compares the French nation to women to show how reliance on old-regime ornaments and their ideologies has politically weakened the Revolution. She notes that Louis XIV, by awarding "decorations of stars, crosses, and other marks of distinction," produced "the luxury of the court" that "soon rendered the nobility as notorious for effeminacy as they had been illustrious for heroism in the days of the gallant Henry" (224–225). Resembling women in wearing "decorations," the leaders of the old regime succumbed to aristocratic display. As the ornaments shifted in meaning from masculine moral values like "heroism" to feminine ones such as luxury and pleasure, the French too were made "effemina[te]." Revolutionary leaders who adopt similar practices inherit the aristocracy's corrupt values. As she states, "A variety of causes have so effeminated reason, that the french may be considered as a nation of women; and made feeble, probably, by the same combination of circumstances," suggesting that they have become as politically weak as women are (121). An emphasis on luxury and spectacle, represented by ornaments, not only fails to give women liberty but also renders the nation powerless. According to Kelly, Wollstonecraft believed that the "revolutionary state had gone wrong by allowing the wrongly gendered culture and politics of the *ancien régime* to persist into the new order."[71] In designating Revolutionary France as effeminate, she uses the language of gender to show how its political failures originate in aristocratic practices.

Regardless of her critique of jewels, Wollstonecraft acknowledges that old-regime ornaments could have played an important role in the Revolution's success. She relates the Assembly's dilemma over what to do with Louis, as "they knew, that the king and court could not be depended upon; yet they had not the magnanimity to give them up altogether" (168). Comparing the king to an ornament, she states, "crowns are a necessary bauble to please the multitude," for at least "as long as the manners of barbarians remained: as savages are naturally pleased with glass and beads" (164). She denigrates the situation by calling him a trifling object, royal gems mere costume jewelry, and the people deceived by them uncivilized. At the same time, she concedes that a leader, however decorative, is valuable to a nation that has not yet learned to distinguish between ornate spectacle and real

political change. As Daniel O'Neill explains, she understands that "a limited monarchy . . . was a necessary transitional institution needed to satisfy ordinary people, as the society progressed . . . towards democratic self-government."[72] Sacrificing the king may have precipitated the Revolution's failure. Writing from the vantage point of 1794, however, she arrives at a hopeful conclusion, noticing that "in the progressive influence of knowledge on manners, both dress and governments appear to be acquiring simplicity" (164). As in *Vindication*, notes Packham, Wollstonecraft argues that objects could help society attain success if utilized in moral ways.[73] As the French advance anew in the wake of the Terror, the trend away from aristocratic jewels toward Revolutionary fashion indicates that the nation may finally follow the right political style.

Despite the increasing radicalization of the Revolution, Wollstonecraft remained committed to viewing it as part of the larger struggle for universal justice. In *French Revolution*, she used souvenirs to represent the failure of events in France to her English audience and encourage ongoing support for revolutionary ideals. Although her work enjoyed moderate critical success upon her return to England in 1795, the public viewed it as a dangerous source of political instability in its support of the Revolution. Its reception in Continental Europe and the United States was more positive, underlining the international appeal of her cosmopolitan values.[74] Her history also influenced her daughter Mary Shelley to reinstate these values in her cause for liberal reform in her travel journals from the Continent. While Wollstonecraft's feminist and literary works receive comparatively more critical attention today, Furniss argues that *French Revolution* is her best work. With it, she not only presented a history of events in France but also countered the growing anti-revolutionary stance at home, allowing sympathizers to retain their political principles. In believing that "a just society would emerge from the Revolution in which the rights of men, and of women, would be the origin and end of government," she offered one of the most profound and lasting political discussions to emerge out of the Revolution Debate.[75]

3

Imperial Collecting in Catherine and Martha Wilmot's Travel Journals

By the end of the eighteenth century, French republicanism had replaced revolution under the rule of Napoleon Bonaparte. Catherine and Martha Wilmot, two sisters from a well-connected Anglo-Irish family of landed gentry in County Cork, used their travel journals to oppose Napoleon's rapidly expanding empire. Catherine Wilmot traveled to the Continent after the Peace of Amiens temporarily ended war between Britain and France, accepting an invitation from family friends Lord and Lady Mount Cashell to accompany them on a Grand Tour of France and Italy.[1] Kept from 1801 to 1803, her journal consists of letters written to her brother Robert in Ireland that criticize Napoleon's domination of Europe. She frequented Williams's salon, which connected her to radical political and literary networks, and Williams's work provided a model for her political commentary.[2] Martha Wilmot's journals, which describe her stay in Russia from 1803 to 1808 with Princess Ekaterina Dashkova, show a desire for an alliance between Britain and Russia. She had received an invitation to visit from Dashkova, who had previously traveled through Britain and met the Wilmots through her friend Catherine Hamilton, a cousin of Martha's father.[3] While in Russia, she developed a close relationship with Dashkova and served as her companion. Although both sisters' journals remained unpublished, they circulated among an extensive network of family, friends, and prominent political figures, functioning as important material objects of international sociability.[4]

In this chapter, I argue that Catherine Wilmot engages in Britain's resistance to Napoleon and creates a unified national identity through the collecting of curiosities in her journal. Travelers often displayed their souvenirs in rooms, galleries, or boxes called cabinets of curiosities, like that in Figure 3.1, which was a standard practice of the Grand Tour.[5] During the Napoleonic era, notes Nigel Leask, this practice became "overladen with

Figure 3.1. Cabinet, mid-seventeenth century (stand twentieth century), workshop of Frans Francken II, Flemish, 1581–1642, ebony, ivory, tortoise shell, and gilt metal, 69 × 43 1/2 in. (175.3 × 110.5 cm). Wadsworth Atheneum Museum of Art, Hartford, CT. The Ella Gallup Sumner and Mary Catlin Sumner Collection Fund, 1983.21. Photograph courtesy of Allen Phillips / Wadsworth Atheneum.

new prerogatives of war and empire."[6] In France, Napoleon created a large-scale public cabinet with the Louvre Museum, whose collection of art objects taken from conquered countries and displayed in its galleries enabled him to boost his status as a ruler and legitimate his empire.[7] The first half of Wilmot's journal describes her visits to the imperial collections at the Louvre and social gatherings in Paris where she encountered French politicians and military officials. The second half details her travels around Italy to see art galleries, cabinets, and other curiosities and ends with her flight from the Continent as France resumed war with Britain. Wilmot depicts

the Louvre and its curiosities to criticize Napoleon's method of imperial acquisition. She also constructs a literary cabinet of curiosities in her journal that she uses to signify her opposition to the emperor. While supporting British collectors who use their cabinets to undermine French control of the Continent, she censures England's imperial collecting of her own country and repositions Irish collecting as central to Britain's success.

Catherine Wilmot's account contributes to a wider understanding of collecting in the period and women's role in it by demonstrating how this practice could be imperial but also subversive. Barbara M. Benedict argues that while state collections represent dominant political ideologies, the subjective and selective travel journal of an individual, marginalized figure is often used "to condemn social injustice." If Napoleon's museum represented his imperial power, Wilmot's literary cabinet served as the idiosyncratic collection that denounces such control as a political abuse and an international threat. Although she approved of British collecting, she did so in the belief that it would destabilize Napoleon's rule and thereby safeguard Ireland, a politically subject nation, from French invasion. Furthermore, Benedict notes that individual collectors "asked questions that challenged the status quo."[8] By desiring to know about the formation and spread of empire and challenging Napoleon's imperial practices through her literary souvenir collecting, she gained a political agency that turned her into a curiosity in her own right.

While Catherine Wilmot collects curiosities in her text to oppose Napoleon, Martha Wilmot details in her work the exchange of objects of female sociability with Dashkova to encourage an alliance between Britain and Russia against France. A key figure of the Russian Enlightenment, Dashkova was instrumental in the coup that brought Catherine the Great to power. Wilmot's journals provide a record of Russian social and political life, with observations of the royal courts at Saint Petersburg and Moscow and the country's peasant system at the princess's rural estate in Troitskoe. Catherine, who joined her sister in Russia between 1805 and 1807, contributed several letters to the journals. Upon her return to Britain, Martha brought back numerous souvenirs, including Dashkova's memoirs, a fan that had belonged to Catherine the Great, jewelry, clothing, miniature and full-size portraits, and other valuable gifts from the height of Russia's imperial age. Although these souvenirs signified the sentimental friendship that existed between Wilmot and Dashkova, they also functioned as diplomatic gifts signaling a desire for connection between their countries. As Napoleon's growing empire began to threaten Russia, Dashkova and other Russian leaders advocated for a union with Britain rather than France. The

act of giving Wilmot her imperial objects indicated that she shared her friend's desire to forge an international alliance.

To show how Martha Wilmot uses souvenirs in her journals, I examine her exchange of miniature portraits with Dashkova to establish a political bond through personal friendship as well as masquerade costumes to make Russia, a country unfamiliar to the British, fashionable at home. The trade in these objects reveals how she engaged in larger global trends of the time. Maxine Berg argues that Britain's political and national identity was formed through the worldwide circulation of goods. This was especially true during the Napoleonic Wars. As she states, "Opposition to the French and Catholicism provided one way of making connections among peoples of the British Isles. But identities were also made in trade and empire, in facing the 'otherness' of different civilizations and cultures."[9] By describing her exchange of objects of sociability with Dashkova, Wilmot likewise aims to create a connection between two very different but powerful empires to oppose France and strengthen Britain. Like her sister Catherine, she also employs souvenirs in her work to suggest that England face the otherness of its Irish colony as part of this national growth. The circulation of material items that she traces in her journals provides an essential view of how Britain had begun to develop alliances abroad and redefine itself as a more global nation.

The Cabinet of Curiosities: Subverting Napoleon's Louvre

According to Leask, public museums such as the Napoleonic Louvre "were associated with the social power of . . . state ownership which dared to collect the heterogeneous meanings of the world within the enclosing and totalizing walls of the cabinet."[10] These universal cabinets represented the world in microcosm as well as their owners' power over that world. Catherine Wilmot contends that the Louvre, full of objects taken from diverse countries, represents Napoleon's political dominance and allows him to establish a monolithic empire. In a letter of December 13, 1801, soon after her arrival in Paris, she discusses her tour of the museum: "We then visited the Musée Central des Arts, which is in the Louvre. As well as being the Sanctuary for French, Dutch, and German Masterpieces of genius it is possess'd of the plunder of Italy."[11] Through possession of objects, the museum allows Napoleon to set the geographic boundaries of his empire. Wilmot shows the power he wields over the Continent by listing all the countries from which he had taken art. The sheer size of the museum's collection, which included fifteen hundred old master paintings,

fifteen hundred antique sculptures, and twenty thousand drawings, would further impress upon viewers his prowess.[12] As he confiscates art, he transfers the cultural capital of those countries to France. The "Central" gallery that Wilmot visits is not only in the heart of the Louvre but also at the center of Napoleon's empire (11). As an enlarged version of the cabinet of curiosities, the museum represents in object form the control that he exerts politically.

Wilmot observes that an essential purpose of the Louvre is to exhibit France's imperial status. As she notes on her visit to the Musée Central des Arts, "This Gallery is open to Foreigners every day and to The Publick twice a week and like all the other National Institutions free of all expense and difficulty of access" (11). By efficiently collecting artworks for public viewing and remaining free of charge and easy to access, the Louvre increased its usefulness and enhanced its legitimacy.[13] Open to foreign visitors more often than to France's own citizens, it also enabled knowledge of Napoleon's empire to reach a wider audience abroad. Andrew McClellan argues that, while centralizing the cabinet may have seemed to undermine the purpose of the Grand Tour, "the point of building the Revolutionary Louvre was precisely to alter the priorities of European tourists and to make Paris the artistic capital of the modern world." Napoleon "well understood its value in the realm of politics and war," for the museum signified that France was the capital of a new political realm in the making.[14] Constructed in part to draw tourists to Paris, the Louvre acts as a form of political propaganda by presenting material evidence of France's superiority as an empire. Wilmot notes the museum's success when she states, "Such is the treasure of the collection that Paris need hardly hold forth another incentive to curiosity" (12). Filled with curiosities from other countries, the Louvre in turn evokes such wonder that it is the most anticipated tourist attraction in the city.

The Louvre signifies not only France's but Napoleon's status as a leader as well. Wilmot observes that his ability to obtain some of the most famous pieces of art represents the extent of his power. In the gallery of antiquities, she states, "the only one wanting to compleat the collection is the 'Venus de Medici' which has not yet arrived" (12). The Venus statue was a highlight of the Grand Tour in Italy, but pointedly, Napoleon has obtained it for his collection. She also sees the Apollo Belvedere, which she deems a "lovely godlike being" (11). Considered by the British to be one of the finest ancient sculptures, it became Napoleon's greatest boast as part of his collection. His ability to gather these important works suggests that he himself is a godlike being. According to Marjorie Swann, an individual's possessions act as an objectification of the self, so that the collection becomes a mode of

self-fashioning.[15] The qualities of the Apollo statue in the Louvre thus transfer to Napoleon, making a statement about his character. The emperor further appears as a hero for his resurrection of the statue. As Wilmot indicates, "Previous to its discovery in the 15th Century, the Apollo lay two thousand years under the ruins of Antium. At present the French have put an inscription on its pedestal, proclaiming that fate has no further influence" (12). Through his professed ability to save the statue from ruin and ignominy, Napoleon appears stronger than a force like fate. An epic version of the Grand Tourist, he successfully obtains and exhibits priceless works of art in his cabinet.

Napoleon uses his collection of antiquities to fashion himself more effectively as France's emperor. Swann explains that collecting antiquities was a form of domination through which a leader could establish and maintain superiority. Such collections were "intended as displays of cultural capital which would increase their owners' prestige among the elite . . . and garner enhanced power in the process." As a result, the "greatness of a ruler could be displayed through his accumulation of possessions," especially rare ones. Moreover, the agendas of aristocratic European and British art collectors throughout the eighteenth century were rooted in Renaissance humanism, so that Greek and Roman antiquities acted "as a source of ideas and values that underpin European society and culture."[16] Consequently, Greek and Italian statues became the most sought-after forms of art. By acquiring the Apollo and Venus statues, Napoleon exhibits his knowledge of antiquity and aligns himself with the top art collectors of the West, thereby suggesting his rightful status as leader. Wilmot points out that his ownership of the Apollo increases its appeal; "after having the world for its spectator, through the lapse of three centuries," the statue "now commands, if possible, heighten'd tributes of enthusiastic applause, from every individual" (11–12). While the statue becomes more popular through its association with Napoleon, it also acts as evidence of his cultural preeminence.

In addition to collecting artwork, Napoleon reproduces his own image in the form of a collectible to enhance his power. In an April 17, 1803, letter from Rome, Wilmot describes her visit to the studio of Antonio Canova, who "is look'd upon by many, to surpass the ancient sculptors . . . some of his productions would far outshine any that ever was seen in the world before" (179). While there, she observes how "delightfully represented" is "the Bust of Bonaparte," as are the King of Naples, Mars, Perseus, and Hercules. Napoleon's bust resides alongside other royal figures and mythological heroes in the studio, suggesting his prowess. It is also fashioned by an artist whose talents are equal to those who created the statues in the

Louvre. According to Philip Dwyer, Napoleon commissioned marble busts to be made of him because he "understood the potential of art to project his imperial image and to win over public opinion."[17] Wilmot notes that the busts would then feature in France's museums. After the Louvre, she visits "a most curious, and excellent collection" of sculptures of French rulers at Le Musée de Monuments François, including "Louis 12th, Henry 4th, Cardinal Mazarin, Charlemagne" and "Louis the 14th, a great black marble monarch, as are many of his predecessors" (14). Napoleon's sculpture connects him to these former French leaders and, ready for display, transforms him into a national curiosity.

Despite being impressed with the Louvre, Wilmot uses the museum and its curiosities to criticize Napoleon's imperial mode of appropriation. In a letter of June 19, 1802, she recounts a conversation that she has at a dinner party with a French general who was part of the attempted invasion of Ireland: "General Grouchy was second in command in the affair of Bantry Bay, on board the 'Fraternité,' and had every intention of snapping the grappling Irons which attach Ireland to England. We laugh'd heartily at the different circumstances under which our acquaintance wou'd have commenc'd had the business succeeded. However I took care to tell him 'had their philanthropic undertaking prosper'd as happily in Ireland as it did across the Alps, I should expect by this time to see our little Island hung up as a curiosity in the Louvre amongst the Italian trophies'" (72). By calling Ireland a "curiosity," she argues that the imperial process reduces countries to the level of collected objects. The French would have conquered and taken Ireland just like the Italian "trophies," other objects of art that Napoleon confiscated in war and now displays in the Louvre to indicate his success in battle. Susan Pearce points out that, when the collected object functions as a war trophy, it serves to "demonstrate dominance and control over competitors."[18] By taking objects from Italy, Napoleon indicates not only his power over that country but also his ability to secure it from rival empires like Britain. In comparing Ireland to an art object, Wilmot conveys her fears about French invasion. Referring to her country as a "little Island," she indicates that its small size and isolated status would have rendered it as easily attainable as the curiosities from Italy (72).

In comparing Ireland to the objects in the Louvre, Wilmot argues that her country would lose its identity if conquered by Napoleon. Grouped among the Italian art, it would get mixed up with the objects of other nations. In her discussion of collections, Stewart theorizes that, once obtained, objects are "magically and serially transported to the scene of acquisition." A collection such as a museum functions as "a world which is

representative yet which erases its context of origin." Rather than pointing to where they came from, collected objects, removed from their sources, shed their identities and assume that of their new environment. Subsequently, argues Stewart, "the collection replaces history with classification" by arranging objects according to its own methods.[19] In Wilmot's text, Napoleon's museum disrupts objects through such acquisition. Although she accedes that the Louvre has a "methodical arrangement," she also protests, "I must observe it is a thousand pities these Statues are so badly arranged; they look like noble Emigrants fallen from their high estate, huddling together in some degraded situation" (12). The precise order of the museum causes the statues to appear poorly organized to her because Napoleon has taken them out of their original context. In comparing the statues to emigrants, she claims that they, like displaced persons, have lost their status and in the process their heritage. Imagining Ireland as a curiosity allows her to explain how the French would similarly divest her country of its national character through acquisition.

Besides the objects that she sees in the Louvre, Wilmot points to the museums in Italy to build a case against France's imperial collecting. While touring Bologna, she notes in a letter of November 28, 1802, "We saw a multitude of other Churches, sadly robbed of their fine pictures" (123). At the Medici's house in Florence, she states in a December 17 letter that "the gallery of paintings founded by them 500 years ago, has suffer'd sadly by the pillage of the French" (126). While there, she reflects, "'Tis melancholy to see the famous octagonal chamber call'd the Tribuna with its five empty Pedestals" (127). In taking Italy's collections of statues, the French appropriate centuries of the country's history and its renowned displays. Repeatedly employing the emotional terms "sadly" and "melancholy," Wilmot evokes her readers' sympathy for the loss of the Italian works. She also deems Italy "robbed" and "pillaged" by the French to make imperial collecting appear a crime. She even observes in a letter of April 25, 1802, while dining with General Massena in Paris that he may be "mild and moderate in his manners" but accuses him of being "the arch Robber of Italy" (57). According to McClellan, Italy had "for centuries been looked upon as Europe's museum and the high point of the Grand Tour."[20] With its art taken, however, the country has lost this designation. Realizing that France could act "in Ireland as it did across the Alps," Wilmot suggests that her country would be just as bereft under Napoleon's empire (72).

By envisioning her country as a curiosity, Wilmot argues that Ireland cannot rely on France for its national independence. She uses her analogy of the curiosity to question the belief of Irish radicals that Napoleon would

bring the French Revolution to Ireland and free the country. While General Grouchy promises that France would have "snapp[ed] the grappling Irons which attach Ireland to England," she sardonically replies that this avowed "philanthropic undertaking" disguises Napoleon's imperial motives (72). Breaking England's rule over Ireland would only have enabled France to "snap" it up in turn. Once hung on the museum wall, her country would have been as attached to the French Empire as it is by Britain's "irons." While the general is amused at the "different circumstances" that would have brought them together, she laughs at how Ireland's circumstances would not have been different under France. The name of the general's ship, the *Fraternité*, is ironic since it disguises conquest as brotherhood and misrepresents Napoleon's imperial intentions with a revolutionary ideal. Though professing to help other nations, Napoleon would invade Ireland only to strengthen his empire at its expense. Freed from one empire, her country would simply be dominated by another.

In response, Wilmot establishes herself as a collector of curiosities through her journal. In the late eighteenth century, the travel journal acted as a cabinet by collecting and displaying objects in writing.[21] Benedict argues that literary cabinets, by describing museums and the works within them, represent the experience of looking as narrative, which becomes a means for ordering and collecting impressions.[22] Engaging in the Grand Tour, Wilmot's purpose is to gather objects for her literary cabinet. While she does not confiscate artwork, she does appropriate and display objects for consumption just as a collector would, so that her journal takes part in a practice that resembles Napoleon's curiosity collecting. As she states in a March 6, 1803, letter from Naples, the purpose of her travels is much like his, namely "going the rounds of visiting Curiosities" (141). Her journal therefore allows her to create a comparable collection of her tour and become a peer of her fellow collectors. However, her personal cabinet serves a different function from a public museum such as the Louvre. Benedict observes that private cabinets "challenge the authority of the state and . . . of professional institutions in regulating consumption and inquiry."[23] Unaffiliated with a dominant political structure, Wilmot's literary cabinet enables her to condemn imperial practices and subvert the political authority imposed by figures like Napoleon.

In contrast to Napoleon's collection, Wilmot's cabinet aims to undermine his imperial status. In her letter of December 13, 1801, she observes how "his image (in Plaster of Paris) reigns the Monarch of even every Gingerbread Stall" in the city (21). Unlike Canova's glorious presentation of Napoleon, she satirically shows him to her readers through the plaster bust,

an empty and inexpensively made imitation that cheapens his image. Her collecting of Napoleon's plaster bust allows her to disparage his unfulfilled promise of liberty. As she states in a letter of January 3, 1802, "While I was in England a Republican Egg was laid every day. But now that I am in the vitals of the Bird, I find no egg at all. You know 'tis only the cackling noise amongst Politicians" (30). Using the metaphor of a bird, she suggests that the political advances France has made are mere talk and that the British are deceived in believing them. Just as there is neither a "Republican Egg" inside the bird of France nor a democratic ruler inside the hollow plaster bust, so there is no democracy, she claims, within Napoleon's republic. Although he may reign over France, she deems him fit for commanding only a lowly food stall and insinuates that he rules merely in paste and water. Wondering whether he is anything more than an image, she prevents him from appearing as powerful as he seems.

Wilmot not only questions Napoleon's status but also deflects attention away from his designated tourist spot of the Louvre to the previously popular sites of the Revolution. As she states in her December 13 letter, "I had a particular curiosity to see the Champ de Mars, where eleven years before, Louis 16th exchanged fidelity with the Nation" (13). Through her interest in this Revolutionary tourist site, she turns it into a curious object for her cabinet. She also describes Revolutionary French society as a collection of curiosities. Recording a visit to Williams's Parisian salon in a letter of January 31, 1802, she notes, "We have a general permission to frequent these societies twice every week and they will, I dare say, present us with various specimens of natural curiosities" in the form of important literary and political figures (39). As opposed to Napoleon's false promises of democracy, which she feared Irish radicals were embracing, she collects Revolutionary sites to remind her readers of what true liberty looks like. Moreover, by referring to the French as "specimens" and "curiosities," she reverses Napoleon's threat to collect Ireland by turning France into an object for her literary cabinet. While he directs travelers on the Grand Tour toward the destination of his museum, she reprioritizes the British tourist agenda to help preserve her country.

When Wilmot does address the Louvre, she shows how artists break Napoleon's monopoly on its objects by reproducing them. Her letter of July 30, 1802, indicates that, while in Paris, she "got acquainted with Maria Cosway," a renowned Anglo-Italian artist, "who is drawing the Pictures in the Louvre, so as to give an idea of their subjects and arrangement, in small copperplates" (77). Cosway's copperplate drawings allow her to replicate the objects in miniature as well as in large numbers, rendering them easily

obtainable by others. The museum ceases to represent Napoleon's power fully if its objects are copied from him. Due to Cosway's national affiliation, the replicas also suggest Britain's possession of France's collection for its own. In her letter of December 13, 1801, Wilmot comments to her brother about the Louvre, "You have the merits and demerits of these antiquities, at your fingers ends" (11). He would not need to patronize Napoleon's museum to see the objects because artists like Cosway have portrayed them. In a letter of November 2, 1802, from Turin, she additionally observes that the city's school for sculpture "is full of excellent imitations of the Louvre" (108). While the French loot Italy, the Italians not only retrieve their stolen art but also appropriate French works through their high-quality reproductions. Even though Cosway's copperplates and Turin's replicas carry less prestige as mere copies of the originals, they possess value in allowing both Britain and Italy to prevent Napoleon from being the sole owner of these works.

Wilmot herself aids in protecting Britain's interests on the Continent by collecting curiosities in Italy in her journal. In a letter of January 1, 1803, she relates her viewing of art objects at a gallery in Rome:

> A troop of us went the next day to the Villa Borghese; the walks and improvements are extremely beautiful and the Palace fill'd with every curiosity in the line of Painting, Sculpture, fine Marbles, Mosaic &c. . . . Eight other rooms vie with one another in their treasures of taste; Daphne and Apollo, is the centre adornment of the third room . . . Seneca dying in the Bath, Castor and Pollux, Fighting Gladiators, Cupid and Psyche, Egyptian Idols, Satyrs, Centaurs, Sphinxes, Graces, Bacchanals, Narcissuses, Venuses, Sarcophagi, Roman Emperors, Aeneas with Anchises on his back, Vases, Idols, Crocodiles, Ganymedes, and so on. (137)

Her collecting of Roman antiquities aligns her not only with other Grand Tourists but also with Napoleon. By listing the contents of the palace and mapping out the arrangement of the art in rooms, her textual cabinet acts as a catalogue that enables readers to travel imaginatively through the gallery. The palace "fill'd with every curiosity" counters the Louvre that already seems to have it all. Meanwhile, her catalogue acts as a stockpiling of things against their loss to Napoleon. Much as the rooms "vie" for prestige in their collections, she and her "troop" fight for the objects in them, especially those associated with Greek and Roman mythology that Napoleon so greatly desired. As if at battle with the French emperor, she tells her readers in an April 17, 1803, letter, "Every moment is of consequence in seeing the curiosities" (182). Her collecting turns urgent because she is coming to the end

of her tour, but also because she worries that Napoleon might confiscate the objects, like those from Florence and Bologna. In constructing her literary cabinet from the curiosities in Italy, she claims to save them for Britain's benefit in the imperial struggle with France.

Besides viewing works that she fears Napoleon may take, Wilmot focuses on collecting objects that he has failed to obtain. In her letter of November 28, 1802, she records on a visit to Parma that the city is "seiz'd upon in the name of Bonaparte" (121). At her next stop in Modena, however, she sees "very valuable collections of Pictures rescued from the Ducal Palace at Parma" and observes that "being originals and masterpieces they were secreted with particular care to avoid the plunder of the French" (122). Napoleon may conquer the territory and take its famous pieces, but the Italians have kept some of their most valuable work, which she has the privilege to see. Even though he has secured the famous Venus de Medici, she declares that "Venuses of one sort or other are so abundant in these Galleries, that 'tis absolutely impossible to believe the number can be added to or, in many instances, the beauty made superior" (127). By focusing on the number and quality of the Venus statues, she makes the one that Napoleon owns seem almost insignificant. Benedict points out that while curiosity is often imperialistic, it also "resists control, both as an appetite and as a material object."[24] Wilmot's curiosity to see the Italian works that Napoleon has been unable to acquire is a way of opposing the force exerted by his museum. Ironically, one of the main methods that he uses to build his powerful empire is also beyond his power, as the objects he aims to collect elude him. Capitalizing upon the hidden Italian art, she creates a unique Grand Tour experience that the Louvre does not provide.

Wilmot further contests Napoleon's power by collecting statues of other leaders to enhance Britain's status. As she tells her brother about her visit to the Medici gallery in her letter of December 17, 1802, "What would have pleas'd you most of anything was an arrangement of Roman Emperors from Julius Caesar to Gallienus" (126–127). Noting that he would have liked to see the statues, she appeals to his fondness for antiquities. While Napoleon gains power by bringing art objects together in his museum, she gathers the most powerful leaders in Roman history in her cabinet for her brother. Collecting these pieces would endow him with prestige, much as Napoleon possesses through his collecting of ancient works. The "arrangement" of the museum also would allow him to feel powerful; as she acknowledges, "I know your passion for such sort of methodical things." Just as Napoleon has given the objects in the Louvre a "methodical arrangement," so Wilmot's brother longs to view the organization of the Medici's statues and

partake in the imperial project (12). Her comment functions on a national level as well; in collecting the statues for her Irish brother, she implies that Britain wants to compete with Napoleon for status. As if to counter the assemblage of French leaders' statues in Le Musée de Monuments François, her collection places a long list of Roman conquerors on Britain's side. With her assembly of Italian rulers, she adopts for Britain a history of leadership more extensive than that belonging to France.

In addition to constructing a literary cabinet in her journal, Wilmot allies herself with other British collectors who use their cabinets as a means of defying Napoleon's empire. In the journal's initial letter of November 29, 1801, she recounts how, "at 3 o'clock in the morning, we got on board the 'Countess of Elgin'" for passage across the Channel to France (3). Sailing on this ship, she associates herself with the countess's husband, Lord Elgin, known for collecting marble statues from the Parthenon's friezes in Greece. According to Judith Pascoe, Elgin's collecting of the marbles had several functions, one of which was "to create for England an art collection comparable to that of the Louvre," namely the British Museum. There was debate in Britain over Elgin's actions; detractors claimed his acquisitions were mere plunder, making him as bad as Napoleon. However, as Pascoe notes, those who supported his collecting believed that it was a way to forestall Napoleon's growing empire. "If Elgin had neglected to seize the marbles," supporters argued, "Bonaparte would have had them the moment he had the power." Moreover, they believed that if Napoleon could subdue Italy by taking its art objects, then Greece and other countries would be next.[25] The controversy over the Elgin marbles illuminates Wilmot's rationale in her Italian collecting. While it may seem contradictory for her to disparage Napoleon's imperial collecting when she supports a seemingly similar project, she believes that Britain's actions are essential in protecting her country from the French.

Despite associating herself with Britain, Wilmot endorses the cabinets of Irish collectors to contest England's imperial collecting of her country. On her return journey, she meets the Foster cousins, two other Irish travelers who are bringing back a cabinet, "Amongst Swedes, Germans, Scotch, English, and Welsh, they were the only specimens we had on board of Irish (I forgot myself), and my pride was perpetually tickled by having them, in our little Colony, as the representatives of my Country. Everybody admired and benefited really so much from their society; they most good-naturedly unpack'd all their trunks, and shew'd us all the curiosities they had pick'd up upon their travels; Turkish, Grecian, &c." (219–220). The Fosters follow England's lead in collecting from Greece, which aligns their country with Britain's empire. By engaging in this form of collecting, they help strengthen

the bond between England and Ireland as a means of exhibiting a more unified front in the face of French attacks. However, she appreciates the Irish cousins for their ability to "benefit" those on board with their entertaining and educational collection; they also inspire "pride" in Wilmot for helping to define Ireland as a major collector. Declaring them "the representatives of my Country," she indicates that they too collect to bolster national status. She even suggests that Ireland possesses the ability to gain power through cultural acquisition. Although recently colonized by England, her country is part of a "Colony" on the ship formed of many stronger nations, including England, against whom it holds its own. Wilmot thus undermines England's imperial attitudes toward its colony by upholding the Irish cousins' cabinet as superior. She further implies that Ireland's collecting practices are essential to Britain's attempt to control the Continent. In presenting the Fosters' cabinet for consumption at home, she not only aims to change views about Ireland's status as a subject nation but also hopes her readers can envision themselves a stronger force of resistance against Napoleon.

Wilmot brings back the Fosters, and even herself, to Ireland as objects of curiosity. She aligns herself with the cousins not only as fellow Irish but also as fellow collectors. Referring to them as "specimens," she turns them into valuable items to add to her cabinet. While this term categorizes them as samples for collection, it also singles them out as distinguished persons for their knowledge. Inserting the parenthetical note "I forgot myself," she indicates that she is an individual belonging to this group (219). "In visiting collections, gathering rarities, and publishing accounts of their visits," Swann explains, "travelers established their own credentials." Just as the cousins gain credibility as Irish collectors with their cabinet, Wilmot attains a viable reputation as a collector through her literary cabinet of Italian and French curiosities. Furthermore, notes Swann, collectors "sought to establish themselves as remarkable—that is, 'wonderful'—individuals in a social world which placed a premium on astonishing novelty."[26] Like the Fosters' cabinet, her journal transforms her into someone who not simply records but evokes curiosity or wonder. As a result, Benedict claims, "curiosity makes the curious themselves . . . phenomena in their own collections."[27] With her literary cabinet of curiosities, Wilmot transforms her shipmates as well as herself into rare, valuable persons for her audience to collect and "admire" (219).

The Miniature Portrait: Picturing an Alliance

Associated with the sentimental mode, portrait miniatures belonged to the booming business in personalized luxury commodities in the eighteenth

century; by the Napoleonic era, they had become standard tokens of exchange in relationships.[28] In her journals, Martha Wilmot collects portrait miniatures to memorialize her relationship with Princess Dashkova. In a journal entry of December 20, 1803, several months after her arrival in Russia, she recounts how Dashkova plans to give her one as a souvenir of their friendship:

> The Princess is preparing a Bracelet for me, her own picture; it is to be worn on the left arm, and is literally call'd a Sentiment. (Do not suppose I have lost my senses because I continue my plan of writing all sorts of little nothings as they occur; by the by I think such, trifles often let one into the manners of a place more than graver subjects, and I shall be so delighted if I can make you sensible of the manners and customs here.) You may be sure this same Bracelet is a more agreeable testimony of Princess Daschkaw's affection than anything else cou'd be.[29]

The circular or oval miniature portrait was small enough to fit on jewelry or a snuff box, and it was often worn as an ornament.[30] As Dashkova's "own" image, it closely connects to its painted subject, and Wilmot believes it represents her friend's "affection" for her (67). Being "literally call'd a Sentiment," the bracelet is the embodiment of emotion; assigned a proper name, its specific intent is to evoke feeling for the person pictured. The instructive phrase "it is to be worn" suggests that its correct display helps the viewer recognize its function. By wearing it on her arm as a bracelet, Wilmot attaches her friend to her body, while its placement on the left side closer to the heart heightens its sentimental value. The miniature portrait was also a memorial object used to commemorate personal associations between the sitter and the beholder. According to Amanda Herbert, gift exchange allowed women to create and maintain their relationships. When given as a gift, the portrait could demonstrate love and esteem, overcome absence, and stimulate memory.[31] The bracelet that Wilmot wears allows her to show in a lasting material way her connection with the princess.

Beyond personal remembrance, the miniature portrait on the bracelet signifies political affiliation. Featuring the image of Dashkova, a prominent Russian leader, the bracelet is a revealing testimony of Wilmot's feelings for her benefactor as well as her political sympathy. Wilmot observes a similar practice with Count Alexis Orlov, another leading figure under Catherine the Great's reign, who "wears the Empress's picture set in diamonds of enormous size" (68). The valuable diamonds reveal the degree to which the count values his connection to the former empress. His action is also a political gesture, as officers of state often honored royalty by wearing their

miniatures and displaying them for diplomatic purposes.[32] When decorating a sentimental object usually reserved for private viewing, explains Dyer, the presence of public figures signals its political meanings and could make them more personal and affecting.[33] Count Orlov's miniature proclaims both his private and public association with Catherine. As her signature stone, the diamonds help establish her identity, while their size reflects her momentous political importance. By displaying an image of a famous political figure, Wilmot's bracelet also acts as a declaration of her support for Russia and fashions her as its loyal subject.

In writing about the miniature portrait, Wilmot desires to generate sympathy for Russia at home. Recording "all sorts of little nothings" in her journal, she presents her readers with the insignificant incidents of her everyday life abroad but also discusses the "nothings," or small objects, that Dashkova gives her. Though seemingly worthless as "trifles," these everyday objects carry importance because they enable her readers to understand Russian culture and politics. She commands her readers to "not suppose I have lost my senses" for writing on souvenirs; far from irrational, she uses her senses to perceive the information afforded to her by such objects. In turn, Wilmot believes that the "bracelet is a more agreeable testimony of . . . affection than anything else cou'd be" because readers can envision Dashkova's love through this object. Reaching out to her audience through the souvenir, she desires to "make you sensible" and render her audience as receptive as she is to Russia. When she says "I continue my plan of writing" she means that she not only perseveres in her project of discussing miniatures but also uses them as part of her plan to establish national feelings for Russia in her home country (67). Rather than indicating a side issue, her digressive comment about the bracelet is a way to instruct her viewers on how to regard this seemingly foreign country.

Moreover, Wilmot hopes that the miniature portrait will solidify Britain's political relationship with Russia through personal friendship. In a journal entry of October 29, 1805, she writes of Dashkova, "She has given me this Eveg a gage d'amitie of high value indeed, her own Picture" (154). The portrait acts as a pledge of friendship between Wilmot and the princess, but as a gift from a high-ranking official, it also shows Russia's desire to ally with Britain. Despite the declared intent of feeling, Wilmot is aware that Russians employ these gifts for political ends: "I was often offer'd bribes . . . in the guise of proferr'd friendship" (298). The portrait is thereby a means by which Dashkova can convince her and the British to take Russia's side. Wilmot willingly accepts the gift in the interests of her country. In a September 17, 1803, journal entry, she expresses concern over the news

Figure 3.2. Joseph Etienne Blerzy, with miniature by Nicolas Soret, snuffbox with portrait of Catherine II, Empress of Russia, 1774–1775, c. 1786, French, gold, enamel, and diamonds, overall: 1 3/8 × 3 × 2 3/16 in. (3.5 × 7.6 × 5.6 cm), miniature: 1 1/8 × 15/16 in. (2.9 × 2.4 cm). The Metropolitan Museum of Art.

of "the dreadful convulsed state of Ireland & the threats of . . . French Invasion" (50); afterward, she writes to her mother to say, "You hope Russia will be our friend. How ardently do I hope it too" (60). Calling Russia by this intimate term, she shows that the desired connection is national as well as personal. Her journal entry of September 16, 1804, eventually brings "blessed intelligence respecting the Russians having avow'd their intentions of befriending England against the French" (128). In describing the alliance as "befriending," she suggests not only that it functions like a friendship but also that friendship helps foster an alliance. Intimate objects like the miniature portrait, she implies, play a key role in establishing international connections.

Miniature portrait boxes additionally indicate how Britain would benefit from this alliance. As Wilmot records in her journal on April 4, 1805, "The Princess rummaged her treasures today & gave me a magnificent snuffbox of gold. The Empress Katherine's likeness is most perfectly represented in profil at one side & at the other the Coronation or rather the famous 28th of June when she was chosen" (140). Dashkova employs her snuffbox of the empress, like the one in Figure 3.2, to manifest her feelings

for Wilmot, but by the early nineteenth century, portrait boxes were a standard aspect of diplomatic exchange.[34] The status of Dashkova's box as a luxury good heightens both its sentimental and political appeal. Portrait boxes were typically made of gold and embellished with diamonds, enameled decoration, lacquer, and other extravagant materials. As Berg explains, luxury goods, defined as elite in their association with rank and hierarchy, their link to the person, and their fine material, helped those who owned them rise in esteem.[35] Dashkova's box is similarly associated with a "famous" empress and clearly connected to her through the "likeness . . . perfectly represented" (140). The value of the box, one of the princess's "treasures," enhances its function as a precious memento, and its "magnificent" gold material signifies Catherine's importance as a ruler. By sharing with Wilmot an object of such luxury, Dashkova indicates Russia's wealth and power; in turn, the political alliance would appear to be equally worthy. The gift suggests that, as Russia's ally, Britain would rise in the world's esteem as a more global nation.

Wilmot further shows her bond with Dashkova by planning to exhibit her miniature gifts at home. In a December 1, 1805, journal entry, she relates her intent regarding a portrait fan:

> But a few days ago she gave me a gage d'amitie which she priz'd to such a degree that she told me she had intended to have it buried with her, and that in changing that intention in order to give it to me I might judge of her tenderness & affection. It was the first present She ever receiv'd from Katherine the Second, & certainly serv'd to recall the most interesting period of a friendship which then existed assuredly. . . . It is a beautiful fan which the Princess happening to admire in Katherine's hand was requested by the Empress to accept as a memorandum of her affection. . . . I think I shall get it elegantly framed, and consider it as one of the most valuable memorandums of friendship which I possess. (159)

A statement fashion accessory that women would have carried while socializing, the fan widely circulated the figures printed on it.[36] As a sentimental object, the portrait fan signifies Catherine the Great's select "request" of Dashkova as a friend and "serv'd to recall" this friendship in her memory (159). Just as the princess once accepted the fan from Catherine "as a memorandum of her affection," Wilmot now can "judge of her tenderness & affection" in receiving the fan from her. While Dashkova had considered interring the fan with her remains, Wilmot decides to turn it into a souvenir by framing it. Stewart contends that objects "placed under glass . . . eternalize an environment by closing it off from the possibility of living

experience" or change; framing an object thus turns "history into still life."[37] Far from moldering in the grave, the fan will live on when preserved behind glass. Wilmot suggests that the affection between her and Dashkova will be just as lasting and remain unaltered by time.

Wilmot's intended display of the fan indicates the merit of an alliance with Russia as well. By intending to have the fan "elegantly framed," she indicates the object's importance to her, much as the diamonds framing Count Orlov's miniature of Catherine reflect the value of that connection to him (159). As Pointon explains, "Visibility is a prime factor in the scale of values attached to ownership," and "the framing of particular portraits in elaborate and individually designed frames calls attention to their preeminence."[38] Gifts destined for display were especially instrumental in political exchanges. Displaying and arranging miniatures in domestic space transformed them from private possessions into visually public items that enabled the narration of relations.[39] The fan would assume importance for Britain when framed, as those featuring portraits of historical persons bore political significance and helped publicize images of national sovereignty.[40] Berg notes that such goods served as "cultural displays of power" for their collectors and that countries often imported them to bolster national identity.[41] By exhibiting the fan, Wilmot would provide a constant material reminder of the strength Britain could gain through an alliance with Russia. The fan carries such importance both personally and politically that it is no surprise she deems it one of her most valuable souvenirs.

While Wilmot collects miniatures to forge an alliance with Russia, Dashkova gives them as a means of guaranteeing both her own and imperial Russia's remembrance. At the time of Wilmot's visit, the princess was close to death and had no legal heirs; she may have loaded Wilmot with gifts to leave a history of herself and ensure a legacy.[42] Marcel Mauss points out that "exchanges and contracts take place in the form of presents; in theory these are voluntary, in reality they are given and reciprocated obligatorily."[43] In passing on her goods to Wilmot, Dashkova expects her friend to remember her in turn. During her visit to her sister, Catherine Wilmot notes in a letter of May 15, 1807, "The Princess has been acting of late precisely as if she was already Dead. Her Legacies to her friends She has already given in advance of those sort of memorandums which are to exist as monuments of her esteem."[44] As gifts by will, Dashkova distributes her goods in preparation for her death. "Given in advance," the gifts make her seem deceased already. Nevertheless, she uses her premature gifts to project her memory into the future. Though the objects are small, they function, like much larger "monuments," as lasting evidence of her notable person, memorializing her

and enabling her continued existence. A gift solidifies a connection with the receiver because it possesses something of the giver.[45] By gifting her possessions as souvenirs, Dashkova ensures that she, and by extension her empire, will be remembered after her death.

The miniature portrait not only memorializes Dashkova but also paradoxically keeps her alive. As Martha Wilmot notes in her journal on June 7, 1808, giving the miniature "awaken'd in Princess D's mind a hundred recollections of former times, but I think she is more animated in it than in any other."[46] For Dashkova, the miniature conjures up remembrances, so that previous events seem to continue in the present. As a result, she is more enlivened when thinking about the past than the present. While Wilmot's pronoun "it" could refer to "former times," it may also suggest that the princess appears more alive in the miniature. According to Stewart, "The miniature projects an eternalized future-past upon the subject; the miniature image consoles in its status as an 'always there.'"[47] By rendering the subject immortal, the portrait acts as a souvenir through the denial of death. When bequeathed as an heirloom, it carries a narrative of continuity. As a "cipher for memory," notes Pointon, the miniature both represents a person and stands in their place, securing a connection between the absent person and the viewer.[48] Wilmot recognizes that, even after Dashkova passes away, she will remain "animated" and seemingly alive in her portrait (347). The miniature, which captures her presence "more . . . than any other" state does, is the best way to ensure her existence.

In turn, Wilmot gives her own miniature portrait to Dashkova to solidify the alliance between their countries. In a January 24, 1804, letter to her sister-in-law, she writes of her plans to "sit for four Pictures. Only think, the Princess will have a Miniature of this ridiculous face of mine in a snuff Box" (79). While Wilmot herself is not a political figure, her portrait, featured on a box like that of Catherine the Great, plays a political as well as a sentimental role by visually linking her country with Russia. Her emphasis on the number of portraits indicates not only Dashkova's love for her but also her desire to make the alliance. In addition to the portraits that Dashkova wants for herself, Wilmot notes a "second Miniature she intends to send to my Mother." When painted abroad, miniature portraits could be transported home as mementos of travel.[49] By sending one to Wilmot's family and mother country, Dashkova encourages Britain to remember Martha's connection to Russia. The miniature's appearance evinces its purpose of establishing a political alliance. According to Pointon, political art plays a more symbolic than representative role, so that the identity of the subject portrayed is less important than the material claims made upon

the subject.[50] Following the progress of the portrait in a letter sent to her mother the next month, Wilmot asserts, "As to likeness I fear that will be left out of the question," yet "your miniature shall be just like it" (83–84). Just as the pictures of Wilmot must match, so Britain and Russia should comply in their political views.

The exchange of miniature portraits further enables Wilmot to assume a political role in facilitating international relations. In her July 18, 1807, journal entry, she recounts, "Every description of Society that I have ever seen here has been the faithful Miniature of a Court. I am myself Prime Minister of one of the greatest in Moscow" (298). When she calls Russian society a miniature court, she means that each aristocratic group to which Dashkova introduced her acts like a small-scale replica of the ruling class. By deeming herself its prime minister, she suggests that she plays the equivalent of this political position in Russian society as Dashkova's friend. She also uses the term to designate herself the diplomatic representative of Britain. While her position may not appear politically serious, the Russians hold her accountable for Britain's political moves. As she notes in her entry of July 21, 1807, "King George & his two parliaments are sometimes brought to me to answer for their proceedings (for which I am made responsible) with as much gravity as if the thing was not absurd" (301). Though the Russians' behavior may seem overly intense to Wilmot, who has no direct influence in the British government, it shows that they view her as politically important partially because of her national affiliation. The role she plays in Russia's miniature social court thus carries great symbolic significance.

Wilmot not only writes about miniature portraits but also turns Russia into a miniature for her British readers. Her "description of Society" in her journal provides miniature pictures of the Russian court, and she even turns Dashkova, her superior in political and social rank, into a miniature through her writing (298). She describes her favorite room at Dashkova's estate as containing "a most elegant Bureau where all my writing impliments are arranged in the compleatest order. Over the Bureau hangs the Princess' picture" (64). Due to the placement of the portrait, Wilmot sees her friend before her as she writes. Having her writing tools perfectly gathered on her desk, she is prepared to carry out her memorial task. The portrait above the desk is most likely the 1784 painting she received from Dashkova as a token of friendship; as Figure 3.3 indicates, it shows the princess in her court dress wearing the red sash and star of the Order of Saint Catherine as well as a diamond-studded lady-in-waiting pin set with a miniature portrait of the empress.[51] When reinscribed in large-scale portraits, miniatures suggest

Figure 3.3. Dimitrii Grigorievich Levitskii, *Portrait of Princess Dashkova*, 1784, Saint Petersburg, Russia, oil on canvas, 23 1/2 × 19 1/2 in. (59.7 × 49.5 cm). Hillwood Estate, Museum, and Gardens. Photograph courtesy of Edward Owen.

allegiance to the persons featured.[52] While all the objects that Dashkova wears indicate her position of power and leadership, the miniature indicates the importance of personal connection. By creating her own miniature portrait of Dashkova in her journal, Wilmot captures this image and encourages her readers' love for her friend. Although her literary portrait renders Russia small, she hopes that it will convey to her British audience the benefits of establishing an alliance with a nation as large and powerful as Russia.

The Masquerade Costume: Union in Disguise

Attending masquerade balls was an eighteenth-century tourist phenomenon, and costumes often became travel souvenirs; at the end of the century, their popularity coincided with the expansion of imperialism.[53] In a letter written to her mother on April 28, 1804, from Dashkova's estate in Troitskoe, Wilmot recounts how her servant sews her such a costume: "My little Sophia is at present hard at work, and guess the employment. She is making me a dress, according to the costume of the Peasants of this part of the country, of glowing red nankeen. If an opportunity offers I intend sending it home. It wou'd be a fine dress in case of a Masquerade frolick. The singularity of the fashion wou'd be a delightful puzzle" (96). Fashioned according to traditional Russian clothing, the peasant dress, like that in Figure 3.4, is an authentic souvenir of its place of origin, and Wilmot signals her intention of wearing it to a masquerade. Meghan Kobza states that costumes exhibiting themes of exoticism and empire were popular at masquerades, as they afforded participants the opportunity to engage with conceptions of the Other.[54] By promising to send the dress to Ireland, Wilmot engages Britain's oriental fascination to heighten readers' interest in Russia. Under Catherine the Great, Russia had started to Westernize, but the West still viewed it as essentially Asiatic.[55] The dress, crafted from the Chinese fabric nankeen, connects Russia to its oriental past rather than its more Westernized present. Textiles became commodities holding global appeal in the eighteenth century, with fabrics from the East being the most fashionable.[56] By dressing Russia up in this Eastern costume, she purposely emphasizes the country's foreign nature to increase its appeal in Britain. She understands that the Russian dress would be valued for its "singularity" in a Western context (96). In bringing back a costume that will impress her viewers, she hopes to convince them to share her feelings about Russia as well.

While Wilmot builds on the exotic appeal of the Russian dress, she also renders it safe through the mediating presence of the masquerade. Worn as a fun disguise for a "frolick," the dress would be less likely to intimidate a British audience (96). As a "delightful puzzle," it would entice them into a game that would simultaneously entertain and test their knowledge of this unfamiliar national identity. Taking the dress out of its native setting and "sending it home" would further enhance its effect. As Stewart observes, "The exotic object represents distance appropriated . . . on the one hand, the object must be marked as exterior and foreign, on the other it must be marked as arising directly out of an immediate experience of its possessor." By donning the costume, Wilmot would become the intermediary providing

Figure 3.4. Ensemble, nineteenth century, Russian, silk, metal, and cotton. Brooklyn Museum Costume Collection at The Metropolitan Museum of Art.

firsthand knowledge of the country. With her assistance, the costume would create what Stewart calls an "intimate distance" between Russia and Britain. Although the purpose of the masquerade was to render the familiar strange, the unfamiliar dress would also be more approachable when exhibited "within the context of the familiar, the home."[57] Wilmot's strategy of presenting an unknown souvenir that inhabits a known space would help Britain to imagine forming an alliance with a nation so different from its own.

The masquerade costume further functions as a disguise for Wilmot's political intentions. Kobza explains that masquerades were frequently aligned with politics, since a column dedicated to them was placed alongside reports of wars and government sessions in newspapers. As spaces of elite sociability, masquerades provided women with a large, visible stage on which to exhibit their views.[58] Wearing the peasant dress to a masquerade in Britain would transform it into a political statement about Wilmot's support for Russia during a time of public debate over the alliance. Furthermore, the costume would enable her to gauge the possibility of this connection. In a July 5, 1804, letter to her mother, she emphasizes her desire for the costume's safe arrival by writing, "I am going to ask you whether you have had any tydings of the Russ Peasant's dress which I sent to Moscow to be forwarded to St Petersburgh the day before we quitted Troitska" (112). By inquiring whether her mother has "tydings" of the dress, Wilmot is asking whether the dress has arrived while simultaneously inquiring about news on the political status between the two countries. If the costume has successfully traveled through the major cities in Russia and onto Ireland, this means that the routes of trade are open between them and that the relations between Britain and Russia are assumedly friendly.

Although Wilmot presents Russia as Eastern, she employs costume to break the stereotype of it as a less modern nation and reveal its power. In a December 13, 1806, letter, she notes that Dashkova gave her several costume books, which she describes as "three most interesting Volumes of' 'a Description of all the Nations submitted to Russia' full of colour'd Prints of the Costumes of Each" (274). By documenting countries conquered by or associated with Russia, the costume books act as evidence of the country's strength. The prints of each country would allow readers to see over whom Russia exerts power, while the books collect the dresses of different nations and turn them into Russian souvenirs. In giving the books to Wilmot, Dashkova hopes to prove Russia's might to Britain through the documentation of dress. As Douglas Fordham observes, visual representations of exotic costumes showed a country's imperial power and exhibiting

them "became a matter of national pride and significance." He further notes that costume had the ability to affect political decisions.[59] Wilmot hopes that the book will convince readers that Russia could be a valuable ally. Although she initially presents Russia to Britain in peasant dress, she removes the disguise to show that it is a strong and formidable country, with the costume books providing evidence of its power over those nations incorporated into its empire.

Costume enables Wilmot not only to cultivate a partnership between Britain and Russia but also to warn Britain that it could lose the alliance to France. In its attempts to modernize, Russia embraced Western cultural habits, such as fashions in clothes.[60] In her December 13 letter, Wilmot notes the emulation of the French by the Russians when she states, "Profession & trade of the domestic kind (I mean taylors, Mantuamakers, Miliners . . .) swarm with french" (275). Through her parenthetical list of clothiers, she emphasizes that those who make clothes in Russia are French and that French fashions are popular in the country. Her use of the term "swarm" suggests that the French occupy jobs in Russia in large numbers, which conveys to Britain how widespread French influence is across the nation. The term further evokes the state of being surrounded, reflecting the encroaching invasion of Russia that Napoleon was planning. Wilmot reveals the extent to which French dress has overtaken the country when she tries unsuccessfully to obtain Russian clothing at a store before leaving for Ireland. As she recounts in her journal on September 28, 1808, "I went this Eveg to the Russ shop to buy a russ manufacture gown, but found nothing" (382). Russian clothes, replaced by French ones, have become impossible to find. Using clothing to show national sympathy, she reflects that if Russia were to adopt French dress and other customs, it might ally with France politically as well.

By sending traditional peasant clothing to Britain, Wilmot symbolically shows Russia's growing political servility to the French Empire. In her December 13, 1806, letter, she calls Napoleon's France "the Silken Yoke of the World's Tyrant" (275). As French fashions enter Russia, they unite the two countries in a commercial alliance; according to Wilmot, however, France's yoke is also an oppressive agency that renders Russia subservient. Throughout early nineteenth-century Europe, France was the main purveyor of fashion for European elites, and Russian fashion journals record the business of importing Parisian fashion into the country.[61] Not only does Napoleon use actual luxury textiles like silk, which suggest wealth and status, to compete with Russia's nobility, but his rule is also silken in its suave and ingratiating means of establishing power through fashion. Wilmot

consequently views him as a tyrant who employs dress to exercise complete power over Russia. In turn, she sees the Russians who submit to French fashion as no more than potential subjects. Through clothing, she shows that Russia could become, like the "Nations submitted" in the costume books, a souvenir of Napoleon's empire (274). The peasant dress thus sends an allegorical message to Britain regarding Russia's growing subservience to Napoleon's regime.

To counteract French influence, Wilmot circulates English clothing in Russia. She writes in an August 1, 1803, letter to her mother, "The examination of my Wardrobe wou'd have made you laugh, and the admiration for everything English. I mention these trifles because I think they are very characteristic" (31). England was a close competitor with France in exporting fashion to Russia.[62] The Russian women who are fascinated with her clothes imbibe through them an understanding of English culture; the clothes are a way for her to spread ideas about Britain in Russia. While it may seem humorous to her mother that fashions so commonplace at home are unfamiliar in Russia, Wilmot suggests that this very exoticism in dress makes the British popular there. Employing the same term that she uses to describe the miniature portraits, she observes that clothes are "trifles" whose fashionable status belies their political impact (31). By describing this "characteristic" Russian quality, she gives her mother an impression of the country while asserting how much dress defines national character. Eventually, in a letter of July 9, 1804, she informs her mother that Dashkova requests that she stop sending her daughter clothes of "English Museline" from home because "when she gets them she gives the half away" (116). Although this practice seems unnecessary to Dashkova, it constitutes for Wilmot an attempt to make national connections through dress.

Wilmot additionally encourages an alliance between Britain and Russia by dressing up as a peasant for Dashkova. In an August 23, 1808, journal entry, she recounts, "Yesterday I receiv'd a present . . . which delighted me, a Peasant's dress in the true fashion of the Married Women. I put it on immediately & went with bread & salt to shew myself to the Princess" (369). By donning the costume to exhibit herself before her friend, she engages in a form of masquerade. Much as the Russian peasant costume will be "delightful" to those in Ireland, she is "delighted" to dress up as a figure that is the opposite of who she really is to entertain Dashkova (96, 369). Although she wears an authentic peasant dress, she is neither a Russian peasant nor a married woman. However, this "true fashion" reveals the truth about her status. Dressed as a young woman in national costume presenting a loaf of bread topped with a salt cellar, she partakes in a

traditional Russian ritual that allows her to express gratitude for Dash-kova's hospitality and friendship.[63] The peasant dress also suggests that she is the princess's servant. Despite her relatively high rank as a member of the Irish gentry at home, in Russia she stands in relation to Dashkova, an aristocratic figure heading a great empire, much as a Russian peasant does. Far from denigrating her, though, the costume allows her to suggest the union she desires between Britain and Russia. As the dress of married women, it implies that she is also wedded to the princess, becoming a means of appeasing her friend and winning Russia's favor.

Through these peasant costumes, Wilmot expresses her desire to unite not only Russia and Britain but also Ireland and England. Bohls points to the phenomenon of middle-class women tourists who identified with the lower classes as a means of commenting upon their own situations: "British women carried with them into unfamiliar terrain their subordinate position in their own society." Consequently, "women travelers recognized analogies between their own position and that of women in Middle-Eastern cultures" or, more generally, cultures foreign to their own, which "sometimes resulted in an identification with the Other that cut across the barriers of religion, culture and ethnicity" as well as class. Bohls calls this practice "projection or displacement," in which women write "their own cultural exclusion through that of these other Others."[64] The acts of sending, wearing, and invoking Russian peasant costumes allow Wilmot to displace and thereby address her own country's lack of political representation within Britain. In receiving a peasant dress from her servant, she shows that she identifies with Sophia as a subject under empire. The costume suggests that, to England, the Irish are the equivalent of peasants and just as foreign as Russians are. By dressing as a peasant, she comments upon her low status as a member of the British Empire and signals her desire to be as unified with England as she has become with Russia.

Costume allows Wilmot to encourage further unity by challenging hierarchies of class and nation. In a letter of February 18, 1804, she describes a masquerade held by Dashkova: "The best thing I saw there was my own little pretty femme de Chambre Sophia. I dress'd her out in every finery I could collect and she look'd uncommonly pretty" (83). By putting Sophia in luxurious clothing, she symbolically moves her out of the peasant class and into the privileged nobility. While masks were often used to reinforce status, notes Kobza, character costumes served a different function, allowing the wearer to dress either above or below their station and transgress their social rank or nationality. As a result, the distinctions of nobility and servantry, or domination and powerlessness, can disappear in the inversions

of the masquerade.[65] In dressing Sophia as a woman of status and herself as a peasant, Wilmot questions such categories of self and other by showing that the roles are reversible. The clothes that render Sophia "uncommonly pretty" imply not only that she is striking in them but also that she is far from common, despite her subject position (83). For Wilmot, this message is resonant on a national level as well. Identifying closely with her own servant, she dresses up Sophia to imply that Ireland, seen as lower in rank under Britain's empire, is as good as England. By crossing class boundaries with costume, she suggests the possibility of breaching the divisions between nations.

Catherine Wilmot hopes that the exchange of dress with Dashkova will also increase Ireland's national status at home. In a letter of September 24, 1805, she lists the numerous gifts that her sister Martha receives, which include "a full suit of Russian Costume worn at Court by Princess Daschkaw."[66] The princess's royal clothing is a souvenir of her life at court and of Russia's power; like masquerade dress, it functions as a costume that renders its wearer an imperial figure. Kobza states that costumes could signify a range of meanings, including social connections, and that those given by fashionable figures reinforced social ties and rank.[67] By giving her royal dress to Martha, Dashkova implies that she considers her as good as the nobility in Russia. In turn, she dresses down as an Irishwoman. As Catherine states in an October 1, 1805, letter, "In the center of riches and honours I wish you were to see the Princess. . . . An old brown great coat and a silk handkerchief about her neck worn to rags is her dress, & well may it be worn to rags for she has worn it 18 years and will continue to do so as long as she lives because it belong'd to Mrs Hamilton" (200–201). By masquerading in her Irish friend's clothes, which function as symbols of their attachment, Dashkova displays her sentimental bond with Catherine Hamilton. Dressing in "rags" amid her "riches" further suggests her sympathy with Ireland as a subject nation. As Catherine Wilmot's letters show, Dashkova's actions place Ireland on an equal level with Russia, thereby raising the country's importance.

The masquerade costume's subversion of boundaries enables Martha Wilmot to express her desire for political union between Ireland and England. She recounts the following conversation with Dashkova in a September 9, 1803, letter: "This Evening she suggested an idea which I really think excellent, that the most perfect union wou'd be establish'd between England and Ireland were the King to reside and even call his Parliament in the latter Kingdom at Stated periods—thus becoming acquainted with Ireland and blending the interests of both Countrys by raising the

consequence of the little Green Island and exciting the affections of his Irish subjects."[68] As Dashkova's suggestion shows, the way to establish union would be for England to do a little masquerading of its own, in which Britain's king would live and set political meetings in Ireland part of the time. By getting to know the colony, he would no longer see it as foreign. Like Dashkova's gift of royal costume and her dressing in Irish clothes, the king's political actions, Wilmot believes, would "rais[e] the consequence" of her country in England's eyes. While the Irish would remain subjects, like the peasants that she represents in masquerade costume, she imagines a union in which Ireland would be as important as England and enjoy political representation within the empire. Just as costume helps to establish connections, Wilmot hopes the two countries could share similar interests that would break down the divide between them. With Napoleon threatening invasion of Britain and radical groups attempting to stage rebellions in Ireland, she suggests that it is in both nations' best interest to facilitate strong relations.

While the Wilmots' work is only beginning to receive critical attention, it remains important for its record of collecting during the Napoleonic era. By documenting how Napoleon used the museum to dominate the Continent and how the British created idiosyncratic cabinets of curiosities to resist French control, Catherine's journal sheds light on the role that collecting played in the formation of empire. Recording her exchange of objects of sociability with Princess Dashkova, Martha's journals reveal how Russia and Britain forged cultural and political connections against Napoleon as well as how national identities were redefined on a more global scale. The Wilmots' criticism of Napoleon and his empire, however, led them to resist publication. Despite receiving offers from Williams to print her work, Catherine remained cautious about the repercussions of political critique, which had led to her friend's imprisonment and censorship.[69] Martha similarly feared a negative reception due to her political views. As she states upon arriving in England on December 26, 1808, "I was on a sort of theatre; a great public witnessed my acts; they judg'd them too."[70] Regardless of their reticence, writing and circulating the journals within their social circles enabled them to partake in the major political debates of the time and assume roles of public consequence. The journals themselves thus stand as souvenirs, reminding us to align Catherine and Martha Wilmot with other revolutionary women writers.

4

Charlotte Eaton's Battlefield Relics in *Narrative of a Residence in Belgium*

On June 18, 1815, the Duke of Wellington sent to Britain two bronze French eagles, captured at the Battle of Waterloo by Scottish regiments, to announce the allied forces' victory over the French and the end of the Napoleonic Wars. Arriving before the news was officially announced, the eagles represented the crucial role of the souvenir in circulating information and allowing the public to visualize their nation's triumph.[1] Soon, various objects from the battle went on display around London, including weapons, armor, Napoleon's carriage, and even his horse Marengo.[2] The victory at Waterloo also prompted the development of an entirely new phenomenon: battlefield tourism. Thousands of Britons visited Waterloo after Napoleon's defeat opened the Continent to travelers. Seeking a tangible experience of the battle, they collected souvenirs, ranging from military relics like swords and bullets to soldiers' personal items such as clothing, papers, and teeth.[3] As the field quickly turned into a tourist attraction, organized tours and guidebooks instructed travelers on the significance of the site and helped shape their experience. By purchasing or collecting souvenirs from the field, tourists took part in the national victory and exhibited their patriotism. As a result, Waterloo became instrumental in the construction of British identity throughout the nineteenth century.[4]

A Scottish travel writer and novelist, Charlotte Anne Eaton was touring Belgium with her brother John and younger sister Jane Waldie Watts, a writer and artist, when the fighting at Waterloo broke out. After temporarily evacuating from Brussels to Antwerp for safety, she visited the battlefield on July 15, almost a month after the defeat of Napoleon's army. She wrote an account of her experiences, published by John Murray in 1817 and titled *Narrative of a Residence in Belgium during the Campaign of 1815 and of a Visit to the Field of Waterloo*. It describes the panic and chaos leading up to the battle, the arrival of the injured in Brussels afterward,

and her collecting of souvenirs during her visit to the site; it also contains a panoramic sketch of the battlefield drawn by Jane. Subtitled *By an Englishwoman*, Eaton's account was published anonymously but emphasizes national identity, a key decision for a work that engages with Britain's victory. Her travel journal was highly successful; ten editions were released within a few months, and her contemporaries acknowledged it as the best account by a nonmilitary writer. She published a second travel account, *Rome in the Nineteenth Century*, in 1820; she also wrote two novels, *Continental Adventures* in 1826 and *At Home and Abroad* in 1831. However, *Narrative of a Residence in Belgium* remained her most influential book, and subsequent British tourists arrived at Waterloo with a copy of it as their guide to the battle.[5]

In this chapter, I argue that Eaton uses Waterloo souvenirs in her writing to redefine patriotism and advocate for a more inclusive national identity. Britain emerged as the most powerful nation in Europe after Waterloo, but the end of the Napoleonic Wars also precipitated political division, financial upheaval, and growing popular protests and social unrest at home. Patriotic accounts of Waterloo helped the British revisit their victory and reestablish their identity at a time of crisis and change.[6] Eaton adopts the popular entertainment of the panorama and its souvenir key to participate in the patriotic celebration of the battle and collects military relics to strengthen a sense of national identity. However, her account also challenges the predominant narrative by focusing on those omitted from records of the national victory. She uses relics of the Scottish Highland regiments to highlight their contributions to the battle and incorporate them more fully into the British nation. Unlike travelers who sought war souvenirs as symbols of Britain's power, she describes collecting tragedy souvenirs to honor the sacrifices made by soldiers and reveal the impact of their loss on the women and families left behind. Her souvenirs simultaneously make patriotism visible while exposing its gaps, revealing how Britain's issues after the wars are rooted in the exclusion of the very citizens on whom their victory depended. At a time when Waterloo was quickly becoming a memorable event in British history, her collecting encourages remembrance of all who fought for the nation.

Eaton's Waterloo souvenirs in the *Narrative* are significant for showing the role of women in constructing and circulating ideas about patriotism, sentiment, and nation. Most early literary responses by renowned poets like Walter Scott, William Wordsworth, and Robert Southey focused on the battlefield as a site of victory and national pride. While the experience of middle-class female tourists like Eaton has received less critical attention than that of elite male writers, their accounts are important for raising

questions about who Waterloo belonged to and how to experience it properly.[7] In bringing attention to women, common soldiers, and the Scottish, Eaton's souvenirs provided a wider audience with a sense of ownership in the battle and enlarged what it meant to be British. She further employed feminine sentiment in her reconstruction of the nation. War, coded as male, was seen as an inappropriate space for women; they belonged in the domestic sphere, not on the battlefield.[8] Using souvenirs to evoke feeling and encourage remembrance of the dead, she merged the domestic with the public space of war to transform the battlefield into a site of pride as well as sympathy and commemoration. By providing readers with access to and understanding of the battle, her account helped forge a new and more comprehensive sense of Britishness.

The Panorama Key: Picturing Patriotism

In 1816, artist Henry Aston Barker exhibited his Waterloo panorama for the first time at the Strand in London. A popular visual and commercial entertainment invented by his father Robert Barker in 1793, the panorama was in effect a large-scale peep show. Rather than looking into a box at miniaturized sights as in Wollstonecraft's rare-show, panorama viewers entered a rotunda where they were surrounded by vast, 360-degree canvas representations of exotic landscapes or famous battles.[9] The younger Barker's depiction of the defeat of Napoleon's army was an instant success, transforming Waterloo into one of the most important events of its time and marking the site as instrumental in the construction of British national identity.[10] The panorama served as a middle-class substitution for the Grand Tour, allowing those who could not travel to experience the event virtually.[11] A small printed guide called a key that described the visual representations and shaped viewers' responses to the battle accompanied the panorama.[12] Initially a fold-out plan circular in design, as Figure 4.1 shows, it evolved into an explanatory leaflet with a small map of the paintings at the end. The key acted as a souvenir by commemorating Waterloo, preserving the ephemeral battle as a historic and memorable occasion; purchased at the panorama, it became a reminder of visitors' viewing experience as well. Those who could travel to Waterloo frequently adopted the format of the panorama key to illustrate what they had seen. Eaton's text, which includes her sister's drawing of the battlefield, functions like this souvenir. As she states in her preface, her narrative evolved out of a "brief and imperfect account . . . hastily composed at a few days' notice, for the sole purpose of illustrating the panoramic sketch of the field which accompanies it."[13]

Figure 4.1. Panorama of the Battle of Waterloo, lithograph. © J.L. Walton 1885. Library of Congress.

Eaton creates a panorama key in her text to define the Battle of Waterloo as an unforgettable national event. Focused on realistic and accurate depictions, panoramas promised to offer viewers an authentic experience of events. Painters usually made sketches on site, and Barker visited Waterloo to make drawings and collect information soon after the battle.[14] Similarly, Eaton emphasizes her firsthand knowledge of the battle's aftermath to guarantee the veracity of her account. Acknowledging the large number of travel accounts on Waterloo in her preface, she states, "This little Narrative has, however, one claim on its attention which no other possesses,—in being the simple and faithful account of one who was herself a spectator of the scenes she describes, and a witness of the events she relates, during those days of desperate conflict and unparalleled victory, which must be for ever memorable in British history, and for ever interesting to every British heart" (iv). While those who arrived later "related the past,—she describes the present" (vi). Through the souvenir of her panorama key, she promises to bring the events of Waterloo into the current time. As Neil Ramsey and Gillian Russell explain, new media technologies like the panorama endeavored to bring the past to life in their reenactment of the war.[15] Repeating the phrase "for ever," Eaton emphasizes that her work will enable these events to remain present for her audience (iv). Exhibited for several weeks or months at a time, the Waterloo panorama maintained British interest in the war and the struggle against the French by which the nation defined

itself.[16] Her repetition of "British" and use of the term "victory" likewise heighten readers' patriotism by reminding them of their country's success in battle (iv).

By providing a comprehensive view of the battlefield, Eaton's panorama key helps readers visualize the event. Once at the site, she describes how she and her companions seek a high position from which to look at the field:

> On the opposite side of the road we scrambled up a perpendicular bank, through which the road had evidently been cut. It was upon this eminence that the Duke of Wellington stood at the commencement of the action, surrounded by his staff. It was here, we were told, that in the most critical part of it, he rallied the different regiments, and led them on again in person to renew the shock of battle. Here we stood some time to survey the field. Immediately before us, nearly in the hollow, was the farm-house of La Haye Sainte . . . it was occupied by the British, and it formed the most advanced post of the left centre of our army. . . . On the right stood the ruins of Château Hougoumont. . . . It formed the most advanced post of the right centre of our army. (271–274)

Typically taken from a natural elevation, panorama sketches allowed artists to determine the height and condition of the ground and deduce military action.[17] Travel texts on Waterloo adopted this perspective, providing panoramic overviews of the field's topography and explaining the positions of troops and their movements. Eaton's elevated location enables her to give a "survey" of the battlefield, both as a general overview of the space and as a detailed map of landmarks where British troops had been stationed (271–274). According to Philip Shaw, tourists positioned themselves above the battlefield to escape its confusion and chaos, which afforded them a sense of visual unity. A comprehensive view also provided control, allowing them to consume the field as an object of knowledge and power and exercise symbolic command.[18] Taken from the Duke of Wellington's station, Eaton's panoramic view encourages her readers to imagine themselves in a similar position of power over the French to heighten their sense of national unity.

Eaton's panorama key focuses on the field as a national memorial. Stuart Semmel remarks that British visitors often found their understanding of Waterloo frustrated by the lack of visible markers, such as monuments to their nation's victory, on the field.[19] However, Eaton defines the field itself as a monument. Directing attention to the field of Mont-Saint-Jean where the battle was fought, she notes how "the rich harvests of standing corn, which had covered the scene of action we were contemplating, had been

beaten into the earth, and the withered and broken stalks, dried in the sun, now presented the appearance of stubble, though blacker and far more bare than any stubble land" (279). She traces the battle through the decimated crops, which symbolize the destruction of war. Unlike fields that would have been burnt after harvesting, the battlefield shows a greater degree of damage. She also sees the war reflected in marks left on the field: "In many places the excavations made by the shells had thrown up the earth all around them; the marks of horses' hoofs, hat had plunged ankle deep in clay, were hardened in the sun; and the feet of men, deeply stamped into the ground, left traces where many a deadly struggle had been. The ground was ploughed up in several places with the charge of cavalry" (279–280). As Semmel explains, the field memorialized the event through the marks inscribed on its surface.[20] By pointing to these features, Eaton's key transforms the site into a memorial for her readers.

Eaton also charts national alliances through the field's landmarks with her panoramic key. Of the farmhouse at La Haye Sainte, she notes, "Its walls and slated roofs were shattered and pierced through in every direction with cannon shot" (281–282). The damage done to the building reveals the attacks launched by the French against the British. At the Château d'Hougoumont, she laments, "Its broken walls and falling roofs presented a most melancholy spectacle: not melancholy merely from its being a pile of ruins, but from the vestiges it presented of that tremendous and recent warfare by which those ruins had been caused" (288). She is saddened not so much by the deterioration of the building as by what it reveals about the harm suffered by the British troops. However, she expresses a different view regarding a structure near La Belle Alliance, where the French were stationed: "The principal house on the left side of the road was pierced through and through with cannon balls, and the offices behind it wore a heap of dust from the fire of the British artillery. Notwithstanding the ruinous state of the house, it was filled with inhabitants. Its broken walls . . . would afford them but a sorry shelter. It was immediately to be repaired; but I rejoiced that it yet remained in its dilapidated state" (282–283). While her desire for the occupied house to remain damaged may seem inhumane, Semmel explains that tourists often expressed the wish for ruins at Waterloo to stay untouched because they served as memorials of the battle.[21] For Eaton, the destruction of property occupied by the French allows her to see Britain's success.

Eaton's focus on the Duke of Wellington further defines the battle as a British victory. In her description of the panoramic view of the field, the term "eminence" not only indicates the piece of rising ground on which he stood but also recognizes his fame and distinction as the commander

of the British army (271). Wellington was immortalized by the panorama, whose outsized representations helped to facilitate the celebrity status he gained from Waterloo. In its paintings, he occupied the center, so that viewers were encouraged to see the events of the battle from his perspective, whereas the appearance of his opponent, Napoleon, was minimized. In reality, his victory was largely a construct, as the battle ended in a draw. After his return from exile, Napoleon found his army greatly reduced in size as he lost political support, and his defeat was unsurprising. Britain's contributions to the battle were also modest in scale, as more European armies allied against the French. Despite its realistic depictions, the panorama was therefore more important as a tool of British propaganda. It reinforced patriotic feelings through identification with a painted scene that celebrated victory.[22] Ironically, Napoleon was the first to notice, and he had made plans to construct rotundas on the Champs-Élysées to exhibit scenes of his imperial battles. While they were never completed, the British capitalized on his idea with the Waterloo panorama; as Shaw notes, it was "designed for the sole purpose of pleasing and instructing the public in the truth of Wellington's great victory."[23] Eaton's text similarly magnifies British readers' perception of Wellington to help them view Waterloo as a national success.

Wellington served as a useful foil to Napoleon in the construction of national identity, and Eaton uses her panoramic scene of the battle to differentiate the two leaders. She indicates that opposite to Wellington's hill "were the heights occupied by the French, upon which, at some distance, and secure from the storm of war, stands the Observatory, where Buonaparte stationed himself at the beginning of the action, and whence he issued his orders, and commanded column after column to advance to the charge, and rush upon destruction" (277). She imagines how Napoleon, positioned on an elevation like Wellington's, battled with him for control of the field. However, Napoleon "never led them on to battle himself—he never once braved the shock of British arms. It is not true that he was ever . . . in any danger of being taken prisoner by the English. Indeed he exposed himself to very little personal risk" (301). As her term "braved" suggests, Napoleon not only failed to engage in the battle directly but also lacked the courage to do so. In contrast, "Lord Wellington exposed himself to the hottest fire, threw himself into the thickest of the fight, and braved every danger of the battle. He issued every order, he directed every movement, he seemed to be every where present, he encouraged his troops, he rallied his regiments, he led them on against the tremendous forces of the enemy, charged at their head, and defeated their most formidable attacks"

(305–306). By picturing Wellington's involvement in the battle, she designates him the leader Napoleon fails to be. Enabling British readers to partake in Wellington's heroism, her souvenir key would bolster their sense of patriotism.

Through identification with Wellington, Eaton scripts for readers how to feel about Britain's losses as well. Recounting a moment when the commander returned to the field after battle, she acknowledges the emotion and humanity of his response:

> As he crossed again the fatal field, on which the silence of death had now succeeded to the storm of battle. . . . He saw himself surrounded by the bloody corpses of his veteran soldiers, who had followed him through distant lands, of his friends, his associates in arms, his companions through many an eventful year of danger and of glory: in that awful pause, which follows the mortal conflict of man with man, emotions, unknown or stifled in the heat of battle, forced their way—the feelings of the man triumphed over those of the general, and in the very hour of victory Lord Wellington burst into tears. (310–311)

Shaw argues that the panorama key, which encouraged viewers to match the sketch with historical annotations and official knowledge about the conflict, trained them to look at the field in a detached, objective way. As "the ground is purged of its connections with arresting images of pain and suffering," he explains, it "is transformed into a site of . . . national resubstantiation." By filtering out the horrors of war, the key "shuts off the potential for dissident readings of the field."[24] However, Eaton's description of Wellington's emotional response to his slain soldiers puts the horror in front of readers' eyes, as they see along with him once loyal supporters and friends rendered "bloody" bodies on the field (310–311). By depicting Wellington openly expressing emotion over their deaths, she not only indicates the gravity of the situation but also designates him as heroic for showing compassion apart from his role as a military commander. Focusing on the battle's destruction could disturb readers and possibly diminish their patriotism, but in Eaton's text, it facilitates a connection with the suffering and emotional weight of the national sacrifice.[25] Far from distancing readers with her key, she suggests that experiencing pain and loss amid victory is an integral part of fashioning national identity.

Despite the losses, Eaton argues that Britain's involvement in Waterloo was justified for ending Napoleon's empire. Barker's panorama key closed with a patriotic message intended to guide a communal viewing experience.[26] As Favret states, the panorama was less about participation and more

about the lesson it conveyed about war.[27] Near the end of her account, Eaton likewise makes a nationalistic statement regarding Britain's victory:

> Yet it has been asked—and I have often heard the question slightingly repeated by my own countrymen,—"And what, after all, has England gained for years of war and bloodshed but glory?" And what, I ask in return, could she gain that is equivalent to it? What is there on earth to be compared to it? Glory is the highest, the most lasting good. Without it, extent of empire, political greatness, and national prosperity, are but a name; without it, they can have no security, and can command no respect . . . wealth and power and dominion and greatness may pass away,—but glory is immortal and indestructible, and will last when empires and dynasties are no more. What gives nations honour and renown in future times but the glory they have acquired? (346–347)

She counters those who criticize the sacrifice of human life for an intangible national ideal like "glory" by expressing surprise that her "own countrymen" would hold such unpatriotic sentiments. She retorts that, when defining a nation, the ideals it embodies are more important and lasting than simply the extension of empire. In her view, this is why France failed: "Napoleon Buonaparte had indeed ambition—but it was for power, not for glory; for unbounded empire and unlimited dominion, not for the welfare of his subjects and the prosperity of his country.—He used the talents, the opportunities, and the power, with which he was gifted . . . not to save, but to destroy, not to bless, but to desolate, the world" (305). Although acknowledging Napoleon's abilities, she contends that he used them for dishonorable ends by exerting control over and damaging other nations; in contrast, Britain deserves "honour" for the achievement of defeating him. She further claims that, unlike the devastation caused by war, ideals are "indestructible" (347); while Napoleon's empire will be forgotten, Britain's triumph will define its national legacy.

Eaton additionally defends Waterloo by arguing that Britain played an essential role in securing European freedom. As the battle became symbolic of the defeat of French tyranny, Britain was seen as a savior from Napoleon's despotism.[28] During her journey, she notes, "Wherever we had gone before, and wherever we afterwards went, we heard the same sentiments from every tongue, and we saw the most unequivocal signs of the inveterate hatred of the whole Belgic people towards their former rulers" (17). Playing on Britain's rivalry with France, she stresses that "it is the *English*, not the French, who are popular, in Belgium; and it was far more gratifying than any individual distinction could have been, to find that we were every where

received with marked attention and respect for the sake of our country, and that the name of England is every where beloved and honoured." In addition to improving Britain's standing, the battle also helped Belgium, dubbed "Little Britain" because of its shared support for liberalism.[29] Observing a group of peasants, she notes, "it was with a feeling of pride for our country we indulged the thought that it was to England they owed their security; that it was her protecting arm which interposed the impenetrable shield of her armies between them and the tyranny and usurpation of France" (21). To justify war's destruction, she poses it as a safeguard from worse harm under Napoleon. Calling the British "the champions, the conquerors, and the deliverers of the world," she underscores a new awareness that the fate of Europe depends on her nation (vi).

Eaton's panorama key functions as a souvenir by not only keeping Britain's victory alive in the present but also projecting it into the future. According to Semmel, Waterloo was hailed as one of history's greatest events, but to remain historic, it had to be viewed from a future perspective. Writers therefore adopted a technique in which they imagined a time when the battle would be recalled before other famous events in the country's history.[30] Eaton uses this approach when stating, "Highly as the fame of England had stood in all ages, she had now attained an unparalleled height of greatness and glory; that the ancient triumphs of Cressy, Poictiers, and Agincourt, in one age,—of Ramillies, Malplaquet, and Blenheim, in another,—had been surpassed in those of Salamanca, Vittoria, and Waterloo, in our own" (350). Comparing decisive battles from Britain's three major wars against France, she claims that the Napoleonic Wars are as exceptional and enduring as previous conflicts. Listing the battles in groups of three, she points to their similarities. During the Hundred Years' War, King Henry V achieved victory despite the opponent's greater number of troops, just as Wellington defeated Napoleon with a smaller allied army, while in the War of the Spanish Succession, the English allied with the Dutch Republic against France, much as Belgium sided with Britain at Waterloo. However, calling the earlier wars "ancient triumphs" also allows Eaton to deem them obsolete. In designating the Napoleonic Wars as "unparalleled," she suggests that they are exceptional in comparison to former conflicts and cannot be replaced or forgotten.

By envisioning Waterloo's future fame, Eaton facilitates the construction of British national identity. The British came to see Waterloo as a sacred place and considered it a patriotic duty to visit the field.[31] The panorama heightened this patriotism by allowing viewers to continue to celebrate and take part in the nation's success. As she states, "Generations yet unborn shall pride

themselves on being the descendants of those who fought and conquered in the righteous cause of Justice, Honour, and Independence . . . on the glorious field of Waterloo; and feel the throb of generous enthusiasm and of virtuous patriotism, when they retrace the bright history of their country's achievements" (349–350). Imagining future citizens who will feel honored to be connected to those who fought at Waterloo, she believes that the battle offers a common inheritance that can unify the nation. Providing herself as an example, she claims that her tour of the site has already changed her. She ends her account by stating, "I returned to my country, after all the varying and eventful scenes through which it had been my lot to pass,—more proud than when I left it, of the name of AN ENGLISHWOMAN" (350–351). Although she is Scottish, she adopts an English national persona to weave her personal experience into a broader collective identity.[32] By emphasizing her gender, she also includes women in this new idea of the nation. In giving a glimpse of the "glorious field," her panorama key will similarly transform readers as they "retrace" and relive the experience of Waterloo (350).

Military Relics: Becoming British

In his 1821 painting *The Village of Waterloo*, British artist George Jones returns his viewers to 1815, just after the battle, when bodies were still being buried and military debris lay scattered across the field. One of the most prolific battle painters of the nineteenth century, Jones visited Waterloo immediately after the event and, like the panorama painters, made drawings on the spot. In this work, represented in Figure 4.2, a group of sightseers prepares to leave in a coach, while several others inspect battlefield memorabilia sold by a Belgian woman. The scene depicted is an eyewitness record of the trade in small military relics collected from the field and sold as souvenirs. By the time Eaton arrived, local citizens had begun to peddle items like weapons, bullets, and armor to tourists who took them home as keepsakes of their visit. Jones's painting is simultaneously a reflection on those who served in the battle. He illustrates the international nature of the Allied army by including British, Prussian, and Scottish Highland officers alongside the party of tourists. He also recognizes the injured by featuring a soldier on crutches hobbling toward the group. The painting points to the connections between the trade in military relics and the construction of British national identity after the wars.[33] Like Jones's tourists, Eaton purchased and collected these relics as souvenirs to celebrate Britain's victory while honoring fellow Scottish citizens and arguing for their inclusion in the nation.

Figure 4.2. George Jones, *The Village of Waterloo, with Travellers Purchasing the Relics That Were Found in the Field of Battle, 1815*, c. 1821, oil on panel. Image courtesy of the Council of the National Army Museum, London.

Eaton's narrative provides a close-up look at the military relic trade at Waterloo. As she observes, "Numbers of country-people were employed in what might be called the gleanings of the harvest of spoil. The muskets, the swords, the helmets, the cuirasses,—all the large and unbroken arms, had been immediately carried off; and now the eagles that had emblazoned the caps of the French infantry,—the fragments of broken swords, &c. were rarely to be found; though there was great abundance upon sale" (315–316). Using Waterloo's designation as an agricultural area as a metaphor, she calls the collecting of relics left behind after the battle the "gleaning" of the "harvest" of war. Her term "spoil" suggests that the relics are mere waste, yet the large number of them for sale indicates their popularity with tourists. At a time when Britain's military prowess was the most important component of its national identity, these objects allowed visitors to connect with the event that had solidified their nation's preeminence. They also operated as status symbols, giving their owners the opportunity to exhibit their patriotism.[34] Eaton marvels that after the intact relics had been collected and sold, even damaged ones are on offer. Regardless of the state of the object,

its significance as a souvenir lay in its physical presence at the battlefield, which Britons could possess only by going there.[35]

Eaton shows how collecting military relics enables the British to participate in their nation's victory over the French more effectively. Visiting La Belle Alliance, the former French stronghold, she relates, "The house was filled with vestiges of the battle. Cuirasses, helmets, swords, bayonets, feathers, brass eagles, and crosses of the Legion of Honour, were to be purchased here" (283). The cross of the Legion of Honour was the highest order of merit in the French army under Napoleon. Composed of a red ribbon and a five-point cross to reflect the number of ranks, it replaced the orders of nobility with awards for civic and military merit. During the Revolution, Napoleon gave the decoration as a favor or gift to ensure political loyalty. He also wore it himself, so that it became a prominent and visible object of the French Empire.[36] Defending the awarding of the medals, he reputedly declared, "You call these baubles, well, it is with baubles that men are led. . . . The soldier needs glory, distinctions, and rewards."[37] He recognized the power that seemingly simple trinkets held in providing incentives for men to fight. As a highly prized possession, the cross became a popular item for souvenir hunters to collect from the battlefield. Semmel points out that the French crosses were in high demand by both Napoleon's supporters as well as those who opposed him.[38] While ownership of the medal could indicate political sympathy with the fallen emperor, it would also allow the British to take distinction away from the French and redirect it toward their own nation.

The souvenirs for sale at La Belle Alliance further signify Britain's military superiority over France. The "brass eagles" that Eaton refers to were imperial symbols that crowned the staffs carried into battle by Napoleon's armies (283). Like the cross, the eagle, shown in Figure 4.3, was intended to institute feelings of pride and honor among the troops. Napoleon had designed the eagles himself, in emulation of ancient Roman symbols, and presented them personally to his regiments; consequently, losing one was seen as a disgrace, and soldiers pledged to defend them to the death. Eaton also notes the presence of cuirasses, or breastplates that France's heavy cavalry wore as body armor, as seen in Figure 4.4. The cuirassiers had an imposing appearance meant to intimidate the enemy; due to their sheer weight and brute strength, they were valued by Napoleon as a striking force during the wars.[39] While it might seem surprising that the British favored items of the battle's losers, Eaton's account suggests that they desired to possess trophies of the enemy as a way to heighten their own military prominence.[40] Captured eagles

Figure 4.3. Eagle color finial, French 105th Infantry Regiment, Battle of Waterloo, 1815, gilded bronze, 12 × 10 in. © National Army Museum. Image courtesy of the Council of the National Army Museum, London.

became war prizes that British soldiers would display as souvenirs; to show their defeat of Napoleon's toughest fighters, the great object of ambition was to possess the armor of a cuirassier. Tellingly, Wellington requested that all his battle trophies, which shaped his identity as a commander and served as reminders of his success, be carried at his funeral.

Figure 4.4. Cuirass of carabinier Fauveau, c. 1810–1815, French, brass, iron, and leather, 38 × 34.5 cm. © Musée de l'Armée, Dist. RMN-Grand Palais / Art Resource, NY.

In purchasing French military relics, British tourists could participate in this sense of national supremacy.

For Eaton, possessing military relics provides a sense of ownership in Britain's victory. During her tour of Waterloo, she records several places at which the British army trounced Napoleon's elite fighters. Behind the British post of La Haye Sainte, "A body of French cuirassiers were completely overthrown into this quarry, by a furious charge of the British" (273). On the battlefield, "His 'invincible' legions, his invulnerable Cuirassiers, in vain assaulted the position of the British, with the most furious and undaunted resolution" (277). Despite the cuirassiers' fearless and intense attacks, she

notes, the British troops defeated the soldiers considered too powerful to be beaten. While at La Belle Alliance, she secures souvenirs of this conquest, stating, "I bought from the people of the house the feather of a French officer, and a cuirass which had belonged to a French cuirassier, who, they said, had died here the day after the battle" (313). Weighing twenty-eight pounds, the cuirass would not have been a small, easily transportable object; however, its value as a relic outweighed its practicality as a collectible. Connected with the French soldier's death, the cuirass allows Eaton to triumph over the French much as the British army did. She considers her purchase a further win due to her gender, stating "that the poor man to whom it had belonged, when he brought it into the field, in all the pride of martial ardour, and all the confidence of victory, little dreamed who would carry it off. If he had known that it was to be an English lady, he would have been more surprized than pleased." Being doubly defeated by the British and a woman demoralizes the French even more. Obtaining armor from a battle that would otherwise have been inaccessible involves her in Britain's success and more strongly unifies her with the nation.

Despite the connection to the wars that military souvenirs offered, tourists like Eaton faced the issue of encountering inauthentic objects in the relic trade. The locals of Waterloo continued for decades to hawk souvenirs that they claimed to be genuine battlefield artifacts.[41] Soon, demand outstripped supply, and fabricated objects replaced authentic ones.[42] As a result, tourists often had little idea to whom the objects had belonged or if they had ever been owned by a soldier at all. As "the line between genuine artifact and manufactured souvenir was blurring," Semmel states, souvenirs began to pose an obstacle to historical understanding.[43] This may explain why Eaton focuses so extensively on verifying the authenticity of the objects she collects. While visiting the British post at the Château d'Hougoumont, she relates, "At the garden gate I found the holster of a British officer, entire, but deluged with blood. In the inside was the maker's name, Beazley and Hetse, No. 4, Parliament-street" (290). Knowing that the most intact souvenirs had already been sold, she may find value in the holster partly for being "entire," despite the absence of a weapon. Although the bloodstain would seem to mar its desirability, it intimately links her to the soldier's fate in battle. The holster's label authenticates it by tying it to a specific manufacturer in London, while retrieving it directly from a battle site instead of a souvenir shop guarantees it is not fraudulent. As a decidedly English object, the holster serves as a reminder of those who fought for the British nation.

While military relics allow Eaton to feel a sense of connection with Britain, they also enable her to celebrate her own country's involvement in the

wars. At a parade in Brussels, she draws attention to the regiments of Scottish Highlanders:

> Soon afterwards the 42d and 92d Highland regiments marched through the Place Royale and the Parc, with their bagpipes playing before them, while the bright beams of the rising sun shone full on their polished muskets, and on the dark waving plumes of their tartan bonnets. We admired their fine athletic forms, their firm erect military demeanour and undaunted mien. We felt proud that they were our countrymen: in their gallant bearing we recognised the true hardy sons of Caledon, men who would conquer or die; and we could not restrain a tear at the reflexion, how few of that warlike band who now marched out so proudly to battle might ever live to return. (45)

The British army's Irish, Scottish, and Welsh regiments reflected the ethnic diversity of those who fought in the Napoleonic Wars.[44] Although Scotland and England had been unified for over a century, the former was still considered a minor nationality within Britain. The English saw the Highlands as an exotic region, possessing a sense of otherness within the nation.[45] Pointing to the regiments' distinctively Scottish costume of bagpipes and plaid caps, Eaton expresses admiration for their cultural singularity and uses their material adornments to transform them into heroic soldiers. Her designation "hardy sons of Caledon," borrowed from Walter Scott, indicates her participation in creating a Romantic myth of Scotland; adopting the ancient name for the country, she associates the soldiers with a long history of national warriors (45). While retaining their unique qualities, she works to identify them as British. The Highland regiments' inclusion in the army helped forge a new sense of Britishness, uniting these groups against the common enemy of France. Evan Gottlieb explains that Scottish writers played a vital role in the development and promotion of a comprehensive British national identity by using the eighteenth-century device of sympathy.[46] Eaton expresses such emotion toward the soldiers, shedding a sentimental "tear" over their sacrifices and claiming that their role in the wars gives her a sense of national pride (45).

Eaton attempts to integrate the Scottish Highlanders into the nation by crediting their victories in the wars. Using the battle of Quatre Bras as an example, she asserts that their contributions have been overlooked:

> It is a perversion of words to call the troops engaged in the battle of Quatre Bras the English army. During the greater part of the day a few regiments only, a mere handful of men, were opposed to the immense masses

the French continually poured down against them: but they formed impenetrable squares, which were in vain attacked by the French cavalry, "steel clad cuirassiers," and infantry; and against which tremendous showers of shot and shell descended in vain. The 92d, 42d, 79th, the 28th, the 95th, and the Royal Scots, were the first and most hotly engaged. For several hours these brave troops alone maintained tremendous onset and the shock of the whole French army, and to their determined valour, Belgium owes her independence, and England her glory. . . . Let England be sensible of the vast debt of gratitude she owes them. (63–64)

Deeming it a misrepresentation to call Wellington's army English, she lists all the Scottish regiments involved, bringing attention to the fact that thousands of the British soldiers who fought in the wars were of this nationality. Juxtaposing the Highland regiments with Napoleon's cuirassiers, she suggests that the Scottish possess the same ferocity; she also points out that the Highland regiments successfully resist the cuirassiers, lending them an even higher status. She magnifies their success by naming the various obstacles they overcome, such as facing the French on their own, fighting them while outnumbered, and assuming the most dangerous position on the field. She further reminds her readers that the cuirassiers are "steel clad," yet the Highlanders remain invincible. While the Scottish may exist as a minority within the British nation, she redefines them as a major faction in the army. Attributing to them numerous accomplishments in the wars, she calls on England to acknowledge their role in Britain's success and their place in the larger nation.

By memorializing the Highland regiments' sacrifices in the wars, Eaton further shows their national importance. When the bodies of those killed at the battle of Quatre Bras arrive in Brussels, she remarks, "They fought like heroes, and like heroes they fell—an honour to their country: and on many a Highland hill, and through many a Lowland valley, long will the deeds of these brave men be fondly remembered, and their fate deeply deplored!" (92). Casting them as "heroes" and linking their remembrance to the iconic geography of Scotland, she ensconces them in national myth. She also recounts the stories of those involved at Waterloo: "In vain the French returned . . . and when they retired from the ineffectual attack, the brave Highlanders, with loud cries of 'Scotland for ever!' rushed among them, bore down all resistance, and scattered their legions" (163–164). The regiments' battle cry, used to express loyalty to Scotland, associates them with the nation while also suggesting that their victory will be eternally memorable. Eaton also marks the extent of their heroism in the

horror of their deaths. She observes that the road to Waterloo "was marked with vestiges of the dreadful scenes which had recently taken place upon it. . . . At every step we met with the remains of some tattered clothes, which had once been a soldier's. . . . Highland bonnets covered with mud were strewn along the road-side, or thrown among the trees" (255). The dirty remnants of the regiment's uniforms, which correspond to the slaughter, help her trace their fate. As "remains," the relics are mere scraps, yet they allow the soldiers to "remain" or endure in the nation's memory.

While Eaton largely focuses on the heroism of the Highland regiments, she also draws attention to their situation as veterans. At La Haye Sainte, she notes, "Three wounded officers of the 42d and 92d regiments were standing here to survey the scene: they had all of them been wounded in the battle of the 16th. One of them had lost an arm, another was on crutches, and the third seemed to be very ill. Their carriage waited for them, as they were unable to walk" (282). Each injured in a different way, the men manifest the variety of casualties that soldiers faced in the wars. Gunshot and saber wounds were most common, while some men lost limbs due to cannon shot. Dysentery, typhoid, malaria, and viral infections immobilized nearly a third of the battle's survivors.[47] Eaton's comment regarding the soldiers' need for transportation highlights the severity of their condition. According to Shaw, the media attempted to shift attention away from veterans and wounded soldiers, whose presence served as a visual reminder of the devastating effects of war.[48] Regardless, note Ramsey and Russell, evidence of the Napoleonic Wars' painful impact pervaded British culture.[49] Writers like Eaton not only brought war close but also bound the public's sympathies to soldiers. By showing common people as important actors in war, she demands political recognition of those who fought in the name of their country. In depicting the wounded Highland soldiers, she encourages remembrance of the Scottish to connect them more closely to the nation.

Eaton's most powerful argument on behalf of the Scottish regiments is that Britain would not have won Waterloo without them. At the Château d'Hougoumont, a Belgian woman "gave me the broken sword of a British officer of infantry (most probably of the Guards) which was the only thing she had left; and which, with some other relics before collected, I preserved as carefully as if they had been the most valuable treasures" (291–292). The officer to whom the broken sword belonged was most likely a member of the Coldstream Guards, a regiment of Scottish origin who played an essential role in protecting the site. As Eaton explains, Hougoumont "formed what is called the key of the position . . . and had it been lost, the victory to

the French would scarcely have been doubtful" (276–277). However, the French "were driven out of the wood again by the Coldstream and the third regiment of Guards and never afterwards were able to regain possession of it" (275). Wellington declared that the success of the battle depended upon Hougoumont, and the regiment's defense was considered one of their greatest achievements.[50] Eaton may regard the sword, despite its shattered state, as one of her "most valuable treasures" due to its connection with the Coldstream Guards and their achievement during the pivotal moment of the battle (292); it may hold even more significance as a fragment for the intensity of the fighting that it represents. The souvenir allows her to suggest that just as Waterloo would not have been a victory without the regiment, so Britain cannot be complete as a nation without acknowledging Scotland and its contributions to the wars.

Tragedy Souvenirs: "The Price of Victory"

When writer Walter Scott traveled to Waterloo, one of the souvenirs he obtained was the skull of a legendary British boxer and soldier, Corporal John Shaw of the Second Life Guards. While Shaw's body was already buried near La Haye Sainte, Scott was so fascinated with him that he arranged for the exhumation and return of his remains to Britain. He was not the only one to seek a war souvenir on the battlefield. Poet Eaton Stannard Barrett claimed to know someone who had brought back a thumb preserved in a bottle of gin; meanwhile, on a trip to the dentist, Henry Crabb Robinson received a replacement tooth plundered from the mouth of a dead soldier.[51] According to Kate Hill, men's collecting of body parts signified their association of war with conflict, aggression, power, and control.[52] Luke Reynolds argues that such collecting was imperialistic, as it allowed tourists to claim and take ownership of the field.[53] In contrast, women travelers more frequently linked military conquest to family, emotion, and memory, removing the unsettling violence inherent in the objects they collected. Their tragedy souvenirs showed an important shift in emphasis, from the exhibition of dominance to the exploration of the disturbing cost of war. With their ability to carry meaning and feeling, souvenirs became for women an ideal way to manage the complex emotional territory of the battlefield. As Maureen Daly Goggin and Beth Fowkes Tobin explain, women played the role of "memory-keepers" in their nations during conflicts. Through their mourning artifacts, which called to mind the touch, sight, and smell of the dead, women set the tone for national forms of commemoration.[54] Eaton similarly discusses tragedy souvenirs from Waterloo to

consider both the personal and national consequences of war and its effects on those left behind.

In determining how to view the lives lost in battle, Eaton criticizes travelers who seek out human carnage at Waterloo. After witnessing injured soldiers brought to Brussels, she relates that she initially hesitated to visit the site: "If such were the horrors of the scene here, what must they be on the field of battle, covered with thousands of the dead, the wounded and the dying! The idea was almost too dreadful for human endurance; and yet there were those of my own country, and even of my own sex, whom I heard express a longing wish to visit this very morning the fatal field of Waterloo!" (160). A desire to rush to the site was a common tourist impulse after the battle, with visitors hoping to enhance their social status by being the first to witness its aftermath.[55] She voices shock over such behavior, contesting that the grisly scene would be too unpleasant to experience. Visitors would have faced an overwhelming number of casualties on the field, as approximately fifty thousand soldiers had been killed or wounded during the battle. In criticizing those of "my own country, and even of my own sex" for wishing to go so soon, she suggests that the practice is neither patriotic nor appropriate for women (160). Condemning those who would visit "for the gratification of an idle, a barbarous curiosity," she deems them cruel in their lack of respect for the deceased and frivolous for treating death as no more than a commodified tourist experience.

In contrast, Eaton models a response that recognizes the pain and sorrow of the nation's loss during her visit to Waterloo. On the field of Mont-Saint-Jean, where the battle was primarily fought, she records one of her companion's reactions to its open mass graves:

> On the top of the ridge in front of the British position, on the left of the road, we traced a long line of tremendous graves, or rather pits, into which hundreds of dead had been thrown as they had fallen in their ranks, without yielding an inch of ground. . . . "And these then are the graves of the brave!" at length mournfully exclaimed one of the party, after a silence of some minutes, hastily wiping away some "natural tears." "Look how they extend all along in front of this broken beaten down hedge—what tremendous slaughter!" (263–270)

Eaton's companion conveys grief at the large number killed with the term "slaughter" as well as at the mass graves, which are no more than "pits" into which the dead have been thrown unceremoniously. As her companion indignantly exclaims, this fate hardly seems fitting for "brave" soldiers. The imperative command to "look" directs attention toward the situation of

the dead; left where they fell along the side of the road by a row of dilapidated bushes, the soldiers did not receive an honorable burial. Eaton stresses the genuine nature of her companion's emotional response by enclosing "natural tears" in quotation marks, a form of punctuation she frequently uses to add emphasis to her ideas. By focusing on the solemnity and sadness of the scene, she enlarges the reader's sympathy for the dead. Beyond mere tourism, the field becomes a site for expressing emotion over those who died in battle. As Susan Matthews explains, women who traveled to Waterloo saw mourning as part of the project of forming and reshaping national culture.[56] By grieving the loss of Britain's soldiers, Eaton turns the tourist practice of visiting Waterloo into a collective moment of suffering that heightens national identity.

Eaton also counters masculine forms of collecting by evoking the horror of the human remains on the battlefield. At Waterloo, the confrontation with traces of death and destruction provoked physical as well as emotional reactions in visitors.[57] As Eaton describes of the graves, "The effluvia which arose from them, even beneath the open canopy of heaven, was horrible; and the pure west wind of summer, as it passed us, seemed pestiferous, so deadly was the smell that in many places pervaded the field" (270–271). Left to decompose, the bodies would have begun to stink as they rotted in the summer heat. Her terms "effluvia" and "pestiferous" point to not only the stench but also the degree to which it makes her feel sick. Contrasting the "pure" wind with the foul odor and the hellish scene on the field with "heaven" overhead, she heightens the visceral and inhumane aspects of the battle. While looking at the graves, she notes how "from one of them the scanty clods of earth which had covered it, had in one place fallen, and the skeleton of a human face was visible. I turned from the spot in indescribable horror, and with a sensation of deadly faintness which I could scarcely overcome." Made ill once again by the sight of the skeleton, she shows how bodily remains allow her to experience the frightfulness of war. Unlike the skull that Scott collected, which represented his admiration of its warlike owner, Eaton expresses revulsion over the sight of it; in physically turning away from the skeleton, she rejects the violence that it represents.

In opposition to collectors who use war souvenirs to establish ownership of the battlefield, Eaton employs human remains as tragedy souvenirs to encourage remembrance of the nation's sacrifice. In a cornfield near the Château d'Hougoumont, she notices another gory remnant: "While I loitered behind the rest of the party, searching among the corn for some relics worthy of preservation, I beheld a human hand, almost reduced to a

skeleton, outstretched above the ground, as if it had raised itself from the grave. My blood ran cold with horror, and for some moments I stood rooted to the spot, unable to take my eyes from this dreadful object, or to move away. . . . Never shall I forget the dreadful scene of death and destruction which it presented" (285). While Shaw argues that these gruesome aspects of the site remain resistant to aesthetic appropriation, Catriona Kennedy proposes that Eaton is embracing a different kind of aesthetic, which she calls the "battlefield gothic."[58] A genre that emerged during the Napoleonic Wars, the war gothic represented extreme emotion and terror in military situations. One common scenario involved the disturbing threat of the dead awakening if forgotten, rising from their graves to check that the living continue to honor their sacrifice.[59] Eaton's observation that the hand appears "as if it had raised itself" suggests a similar reanimation (285). As Goggin and Tobin suggest, bodily parts challenge the binaries of life and death, or subject and object, as they survive beyond the body.[60] The power of objects to recall the presence of the missing dead lends them a form of animation and subjectivity. Like the skull that peeks from the earth, the hand reaches out, seeking to be remembered. Eaton's statement "never shall I forget" acknowledges the scene's horror but also promises to keep the dead in mind; the skull and hand thus become "relics" worth remembering (285).

Eaton also supports the recollection of the dead through the flowers that grow on soldiers' graves. Unlike human remains, the flowers help connect her with those buried on the field. After walking through the wood of Hougoumont, she relates, "I was struck with the sight of the scarlet poppy flaunting in full bloom upon some new-made graves, as if in mockery of the dead. In many parts of the field these flowers were growing in profusion . . . and their slender roots had adhered to the clods of clay which had been carelessly thrown upon the graves. From one of these graves I gathered the little wild blue flower known by the sentimental name of 'Forget me not!'" (296–297). A common European plant often found in Belgium, the poppy grows from disturbed ground; it is therefore unsurprising that Eaton would find it blooming on the recently dug graves. The flower has long been a symbol of sleep due to the sedative quality of the opium extracted from it, as well as of death because of its blood-red color.[61] Her objection to the poppy and its relevant symbolism might seem unexpected, yet the showy "flaunting" of its bright, cheerful color contrasts starkly with the gloom of the field (296–297). Since this term also suggests defiance, the flower may offend her for thriving on the site of death; "in full bloom," it enjoys the height of life, while the soldiers no longer will. As a "mockery," the poppy misrepresents, and even seems to ridicule, the tragedy of the battle. Eaton

bypasses the poppy to collect a forget-me-not that is growing from the graves instead. Symbolic of long-lasting connection, this flower indicates her intention not to forget those who fought. Putting its name in quotation marks makes it sound as if the flower is speaking these words and, like the animated hand, demanding remembrance. By choosing one flower over the other, she advocates for recalling the dead rather than letting them sleep and their memory fade. She also makes a statement about how they should be commemorated respectfully with her more feminine, sentimental souvenir.

Although Eaton focuses largely on the remembrance of British soldiers, she expresses sympathy for the French through tragedy souvenirs as well. At Mont-Saint-Jean, she notes the wide variety of debris left after the battle:

> The whole field was literally covered with soldiers' caps, shoes, gloves belts, and scabbards, broken feathers battered into the mud, remnants of tattered scarlet cloth, bits of fur and leather, black stocks and haversacks, belonging to the French soldiers, buckles, packs of cards, books, and innumerable papers of every description . . . printed French military returns, muster rolls, love letters and washing bills; illegible songs, scattered sheets of military music, epistles without number in praise of "l'Empereur, le Grand Napoléon," and filled with the most confident anticipations of victory under his command, were strewed over the field which had been the scene of his defeat. The quantities of letters and of blank sheets of dirty writing paper were so great that they literally whitened the surface of the earth. (280–281)

The long list of objects mimics the chaos and fast-moving pace of the battle, while the objects themselves, reduced to "bits" and "tattered" "remnants," reflect its destruction. The bills, receipts, and sheets of music are ephemera, or trivial, disposable pieces of printed matter not made to last; despite this, argues Russell, ephemera is crucial to the shaping of human relationships.[62] In Eaton's text, such objects help her connect to those who fought the battle. The personal, intimate nature of items like clothing and love letters humanizes the soldiers. Everyday things such as packs of cards and books show the desire for entertainment and relaxation during the stress or monotony of war, giving the troops an identity beyond their military role. These objects notably "belong to the French" (280–281). Even if a war gothic writer begins with sympathy for one side, their representations may become ambiguous as both sides begin to look equally vulnerable to the cruelty of war and consequently more human.[63] Rather than gloating over France's loss, Eaton acknowledges the sad irony posed by the patriotic military music

and letters that express certainty of Napoleon's triumph. Lumped in with mundane scripts like laundry receipts, they seem just as meaningless. The profusion of blank paper may suggest that Waterloo ends France's opportunity to write its victory into the history books. Despite national differences, the soldiers' remains allow Eaton to show that they shared with the British a love for their country and a longing for remembrance.

Eaton restores humanity to all the soldiers who fought at Waterloo by emphasizing their connections to family. Illustrating the love letters from the field with real-life examples, she observes the troops leaving Brussels for battle after Wellington issues their mobilization orders: "Numbers were taking leave of their wives and children, perhaps for the last time, and many a veteran's rough cheek was wet with the tears of sorrow. One poor fellow, immediately under our windows, turned back again and again to bid his wife farewell, and take his baby once more in his arms; and I saw him hastily brush away a tear with the sleeve of his coat, as he gave her back the child for the last time, wrung her hand, and ran off to join his company" (42–43). By capturing the sense of urgency, apprehension, and pain of separation, she creates awareness of the soldiers' relationships with their families and loved ones.[64] Through repetition of the phrase "for the last time," she evokes the gravity of the situation and the ever-present reality that the soldiers might not return (42–43). She notes that even veterans who have undergone such separation before are affected, contrasting the masculine "rough cheek" with their more feminine tears. She engages sympathy for the soldier who repeatedly says goodbye to his wife and child by calling him a "poor fellow" and highlighting his distress. She also tells the story of William Ponsonby, a British officer who before being killed "was in the act of giving [his aide-de-camp] a picture and a last message to his wife. . . . He was deservedly beloved by his friends and companions, adored by his family, and lamented and honoured by his country" (315). As a sentimental souvenir, the miniature portrait would allow Ponsonby's wife to keep his memory alive, while Eaton's eulogy emphasizes his importance to both the nation and his personal relations. Through her depictions of the soldiers' separations and deaths, she reveals their human side and the emotional repercussions of war.

Eaton emphasizes the effects of the battle not only on soldiers but also on women. Nearly four thousand women accompanied the British army, following the men and providing them with food and sustenance; however, their presence is barely visible in most accounts of Waterloo.[65] She recognizes them: "Many of the soldiers' wives marched out with their husbands to the field, and I saw one young English lady mounted on horseback,

slowly riding out of town along with an officer, who, no doubt, was her husband" (43). She also differentiates them from the women who plunder the bodies on the field: "Those hardened and abandoned wretches who follow the camp, like vultures, to prey upon the corpses of the dead, had the temerity . . . to rifle the pockets of the officers who fell, of their watches and money. The most daring and atrocious of these marauders were women" (316–317). While the scavengers, whom she compares to birds of prey, act for profit, she notes that for many women such actions were often a matter of survival.[66] As the "muster rolls" or records of soldiers' pay left on the field indicate, women relied on their husbands' military wages for support (281). The female looters are likely desperate; as she points out, some are "actuated by better motives, and, like the matrons of Hensberg, in times of old, seemed to think their best treasures were their husbands" (317). Referencing the siege of Weinsberg in 1140, when King Conrad III granted women the right to escape with whatever they could carry on their backs and they surprised him by taking their spouses, she suggests that women's plunder at Waterloo reveals the extent to which they depend on their husbands and their remains.

For women, Eaton notes, the cost of war is emotional as well as economic. After the battle, it was customary for women to search among the corpses for their men to bury them. Having observed this practice, she relates the following story:

> An officer, with whom I am acquainted, went over the field on the morning of the battle, and examined the ghastly heaps of dead in search of the body of a near relation; and . . . in the same melancholy and fruitless search, many an English woman, whom this day of glory had bereft of husband or son, wandered over this fatal field, wildly calling upon the names of those who were now no more. The very day before we visited it, the widow and the sister of a brave and lamented British officer had been here . . . accusing heaven for denying them the consolation of weeping over his grave. I was myself, afterwards, a sorrowful witness of the dreadful effects of the unrestrained indulgence of this passionate and heartbreaking grief. In the instance to which I allude, sorrow had nearly driven reason from her seat, and melancholy verged upon madness. (320–321)

While both fellow soldiers and women search the field for their loved ones, Eaton highlights women's expressive response to loss. Juxtaposing the "day of glory" with their suffering, she brings attention to an issue overlooked in the patriotic celebrations after the battle. By noting that the women who search the field for their "husband or son" are "English," she stresses both

their family and national connections to encourage sympathy for their plight. The terms "wild" and "madness" show the extremity of their emotions, while their inability to find the remains prevents solace, suggesting the importance of the body to the process of mourning and remembrance. Human remains refer to those left behind after the wars as well. Destitute widows, who were a prevalent sight in Britain, best rendered the suffering caused to civilians.[67] Due to the largely absent bodies of male soldiers, women's bodies became the primary mode of visualizing the pain and destruction of war.[68] Depicting the grief of the women on the field allows her to convey more effectively the consequences of Waterloo. As "a sorrowful witness" of such loss, she verifies the reality of the scene and scripts for her readers the appropriate emotional reaction (320–321).

Despite Eaton's opposition to confiscating human remains as war souvenirs, she collects some for the purpose of commemoration. At Hougoumont, she notices how "huge piles of human ashes were heaped up, some of which were still smoking. The countrymen told us, that so great were the numbers of the slain, that it was impossible entirely to consume them" (287). As English artist Denis Dighton's painting *Château de Hougoumont* in Figure 4.5 shows, the task of disposing of the thousands of dead bodies fell to the local peasants, who cremated them due to lack of time and space for burial. On her tour of the site, Eaton recounts,

> The countryman led me to one of these piles within the gates of the court belonging to the Château, where, he said, the bodies of the British Guardsmen who had so gallantly defended it had been burnt as they had been found, heaped in death. I took some of the ashes and wrapped them up in one of the many sheets of paper that were strewed around me; perhaps those heaps that then blackened the surface of this scene of desolation are already scattered by the winds of winter, and mingled unnoticed with the dust of the field; perhaps the few sacred ashes which I then gathered at Château Hougoumont are all that is now to be found upon earth of the thousands who fell upon this fatal field! (293–294)

The ashes she collects function as a tragedy souvenir by providing her with a tangible means of remembering the deceased soldiers; touching their remains allows her to feel connected to them. Although the ashes are impersonal in nature, their specific location links her to the troops who defended the château. Referring to them as "sacred ashes," she indicates that this souvenir allows her to honor the dead; as the remains of "British Guardsmen," it also enables her to pay tribute to the nation. Wrapping the ashes in the paper she finds on the field, she packages them safely for

Figure 4.5. Denis Dighton, *Château de Hougoumont. Field of Waterloo, 1815*, 1815, watercolor, 30 × 44 cm. Royal Collection Trust / © His Majesty King Charles III 2023.

transport. Considering that much of the paper is blank, her act of placing the "blackened" ashes upon it suggests that she metaphorically uses them to write her own version of Waterloo and shape how Britain's contributions are remembered. By imagining the ashes to have blown away or become indistinguishable from dirt, she implies how easily the deceased could disappear; preserving their ashes as a souvenir ensures that they will not go "unnoticed" or unremembered.

Ultimately, Eaton uses tragedy souvenirs to encourage awareness and remembrance of the sacrifices that made Britain's victory possible:

> I have forced myself to dwell upon these scenes of horror, with whatever pain to my own feelings, because in this favoured country, which the mercy of heaven has hitherto preserved from being the theatre of war, and from experiencing the calamities which have visited other nations, I have sometimes thought that the blessings of that exemption are but imperfectly felt, and that the sufferings and the dangers of those whose valour and whose blood have been its security and glory, are but faintly understood and coldly commiserated. I wished that those who had suffered in the cause of their country should be repaid by her gratitude, and that she should learn more justly to estimate "the price of victory." (321–322)

Pieter François argues that she discusses the battle despite her reluctance to deter readers from engaging in future warfare.[69] However, Eaton's explanation suggests not that she opposes war but rather that she wants readers to appreciate its value. As she states, the British might not understand a conflict that they did not experience directly; tragedy souvenirs thus play an important role in making the consequences of the battle visible. Britain also appears ignorant of the Napoleonic Wars' effects on those who fought them. As Jennine Hurl-Eamon and Lynn MacKay note, depictions of suffering reminded civilians that war came at a cost. While the army gained Britons' respect for the victory at Waterloo, the social and economic position of soldiers and their families did not improve, with tens of thousands left unemployed and destitute.[70] Calling attention to the "price of victory," Eaton at once references the loss of human lives in battle and the financial upheaval that followed the end of the wars (322). Writers of war gothic often use images of injury and injustice to better integrate war into the public memory.[71] As Britain appears to forget the dispossessed after Waterloo, Eaton's souvenirs aim to foster a greater recognition of those who enabled the "security and glory" of the nation (322).

While Eaton's work has garnered only modest critical attention, she was an important British eyewitness to Waterloo, and her *Narrative of a Residence in Belgium* played an active political role in shaping views of the battle at home. Her souvenirs not only allowed a wider audience to participate in the celebration of their nation's victory but also recognized those who were part of the battle as integral members of the British nation. Waterloo made Britain the dominant European power for the next hundred years and became a must-see destination on the standard tour.[72] Eaton's account, twice revived later in the century as *The Days of Battle* in 1853 and *Waterloo Days* in 1892, shows that the battle remained a popular event and that her work helped keep it alive in the public imagination. Her journal's longevity was especially important because the national battle between Britain and France continued long after Waterloo's end. Vying for control of the field, the French attempted to change the site of Wellington's victory into a nostalgically idealized vision of Napoleon's rule.[73] As Mary Shelley documented midcentury in *Rambles in Germany and Italy*, this ideological fight to revise history was consequential to shaping national identities in Europe as well as Britain's role in a rapidly globalizing world.

Conclusion

Refiguring the Revolution in Mary Shelley's Rambles in Germany and Italy

Nearly thirty years after his defeat at Waterloo, Napoleon remained a popular icon in Britain and a major tourist attraction in Europe. While the British held mixed opinions about him, they regarded him as a mythic figure long after his defeat.[1] Some, like John Sainsbury, a London musical agent and Napoleonic sympathizer who amassed a large assortment of the former emperor's memorabilia, kept his memory alive through collecting. In the 1820s, Sainsbury began accumulating "every thing worth notice in a portable form relating to Napoleon," Semmel notes, including thousands of letters and documents, bronze statues and marble busts, carvings, gems, drawings, paintings, miniature portraits, coins, medallions, books, furniture, and personal relics. The engraving *Mr. Sainsbury's Napoleon Museum*, shown in Figure C.1, depicts him seated amid his collection, which he kept in his home, surrounded by walls and tables covered in souvenirs and absorbed in perusing a folder of Napoleon prints. He exhibited his collection to the public at the London Museum in 1840; in his introduction to the exhibit catalogue, he states his intention to revise the historical view of Napoleon, claiming that his empire was the natural consequence of the Revolution and the emperor himself its "offspring." Using his collection of souvenirs to connect Napoleon to the events of 1789, Sainsbury posed him as a liberal, democratic leader who was the cause of reformation in Europe.[2]

While collectors like Sainsbury sought to refigure Napoleon as a hero through material culture, I show how Mary Shelley challenges this view through a variety of Napoleonic souvenirs in *Rambles in Germany and Italy*. A two-volume collection of letters written during journeys she made to the Continent between 1840 and 1843, *Rambles* combines the personal reflections of a travel narrative with political commentary, revealing a commitment to cosmopolitan liberal politics similar to that of her mother Mary Wollstonecraft.[3] Jeanne Moskal has examined Shelley's opposition to Napoleon in her 1817 travel journal *History of a Six Weeks' Tour* and her support for Italian nationalism in *Rambles*.[4] Expanding on this work, I argue that Shelley uses souvenirs in *Rambles* to support the cause of

Figure C.1. John Sainsbury sitting in his museum of Napoleon Bonaparte and the Napoleonic Wars, 1845, lithograph. Wellcome Library.

nationalism in Germany and evoke the democratic spirit of the Revolution. As a nineteenth-century tourist, she relied on John Murray's 1836 *A Handbook for Travellers on the Continent*, a guidebook that covered important sites in Europe, and encountered mass-produced souvenirs sold in gift shops.[5] In her text, she observes how the Germans alter monuments and memorial objects associated with Napoleon as they work to create a unified nation. Describing her collecting of figurines of Revolutionary heroes, she bypasses manufactured souvenirs in favor of local ones to champion leaders who resisted tyranny. Her account presents a competing narrative of national identity at midcentury to counter nostalgic perspectives of Napoleonic imperialism at home.

This book has represented an effort to explain how women writers used the souvenir to circulate revolutionary ideas and affect political thought in Britain. By placing Shelley among them, I show how her work, which traces the reemergence of ideas of liberty in the European nationalist movements of the 1840s, reveals the lasting influence of souvenirs in the political realm. The end of the Napoleonic Wars represented a decisive moment in the rise of modern liberalism. In 1815, the Congress of Vienna replaced the absolute monarchies of the old regime with constitutional ones, prompting a desire for liberty across Europe.[6] Shelley's account locates these nationalist movements in the tradition of the French Revolution and emphasizes their

importance in the spread of liberal reform. Her souvenirs were significant for engaging in political conversations that sought to imagine a post-Napoleonic Europe made up of free, independent nations. New international relationships emerged as well, with Britain and Germany, the most powerful nations in Europe, seeking to strengthen their alliance.[7] In replacing Napoleon with Revolutionary figures, Shelley's souvenirs encouraged support for German independence to secure democracy in Europe. Linking its revolutions with those in the Atlantic world, her transnational objects further made visible the connections between countries and reframed the nation as a global entity. In helping to redefine Britain as an integral part of a new consensual Europe, her work renewed and enlarged the cosmopolitan vision of earlier women writers.

German Memorials: Redefining Napoleon's Legacy

On her tour of Germany, Shelley visited Revolutionary sites to reframe Napoleon's legacy. During the wars, the French conquered and occupied nearly all German lands. In 1806, Napoleon mercilessly defeated Prussia at the Battle of Jena-Auerstädt. In wars fought between 1813 and 1815, Prussia proved instrumental in ending Napoleon's empire; once liberated, the German states hoped to become a unified country with a liberal constitution.[8] Shelley emphasizes Napoleon's destruction in a June 18, 1842, letter by connecting him not with liberal reform but instead with war and tyranny. As she states, touring the country appeals to her for being "the stage on which Napoleon's imperial drama ended. What oceans of human blood have drenched the soil of Germany even since my birth."[9] Focusing on the senseless violence and damage of war in the country, she shifts perspective away from the Battle of Waterloo and the mythic status of Napoleon's military prowess. While travel guides popularized notions of what sights were worth seeing in a location, they could also reinforce a narrative that sanitized the broader realities of a person or event.[10] Although "visiting spots often described" in travel books and "pursuing a route" that forms "the common range of the tourist," she provides her own commentary on how to interpret German sites to challenge revisionist views of the former emperor (1.vii).

Shelley contests Napoleon's heroic identity at a well-known military monument in Koblenz. According to Joan Coutu, monuments may function as expressions of imperial goals and manifest power and ambition. "Because they are imbued with notions of permanence, timelessness and posterity," she explains, "monuments are a perfect fit for an empire."[11] In

contrast, Shelley notes that the Koblenz monument provides an ironic commentary on Napoleon's imperial power in a letter from June 15, 1842:

> You know the fair town of Coblentz—its wide, white, clean, rather dull-looking streets: you know the monument erected by French vanity at the time of Napoleon's invasion of Russia, to commemorate with pompous vauntings an expedition that caused his downfal. Even before the carving of the empty boast had been overspread by a little dust, the Commandant of the Russian army, pursuing the flying invader, had the power, but disdained to erase it; adding only in the style of the Emperor's passports—"Vu et approuve par nous, Commandant Russe, de la ville de Coblence, Janvier 1er, 1814." (1.168–169)

Erected in 1812 in front of the St. Castor Basilica by the local French government, the monument that she references features an inscription intended to commemorate Napoleon's successful campaign in Russia. This campaign ended in defeat, however, and when the Russian army entered Koblenz in 1814, the French had already vacated the city. Coutu notes that some leaders used monuments "to manufacture a past for themselves and to push themselves . . . into the future."[12] Prematurely constructed to celebrate France's expected victory, the Koblenz monument aims to construct such posterity for Napoleon. Featuring a fountain, it echoes the numerous fountains he constructed in Paris to celebrate his military victories. Shelley observes that the inscription's declaration of success seems no more than "pompous vauntings" and a meaningless, "empty boast" due to his loss (1.169). She describes its epigraph as having gathered "little dust," indicating how quickly he was conquered and detracting from his fame.

Shelley also shows how, by altering the Koblenz monument, Napoleon's opponents use it to change his reputation and shape visitors' remembrance. As Coutu argues, monuments are less about the events or persons represented and more about how they present those persons or events to successive audiences. They offer not commemoration but "rememoration," a process in which traces of the past assume a new significance in the present.[13] While the Russian commander could have removed the epigraph from the Koblenz monument to "erase" Napoleon's presence, the inscription he adds is a more powerful commentary on his unsuccessful empire (1.169). By "approving" of France's futile boast, he renders ridiculous his adversary's assumed victory. Written "in the style of the Emperor's passports," the message mocks Napoleon by appropriating both his language and how others will view him. Using a metaphor from tourism, Shelley suggests that he will no longer be using his "passport" of power to conquer

other countries. While the monument may afford Napoleon posterity, it immortalizes his defeat rather than his success. She also emphasizes that this was not any battle but the campaign that "caused his downfal" and effectively ended his empire. Inscribed in the durable material of stone, his loss becomes permanent and timeless.

In Berlin, Shelley observes how the Germans use monuments to seize control of the historical narrative and reshape Napoleon's legacy. In a July 27, 1842, letter, she describes touring the capitol city, noting its important statues: "After dinner, we have walked under the lime-trees to the Brandenburg gate—a most beautiful portal, built on the model of the Propylæum at Athens, on a larger scale. Napoleon carried off the car of Victory which decorates the top; it was brought back after the battle of Waterloo. Before its capture it was placed as if leaving the city behind, to rush forward on the world; on its return, it was placed returning to and facing the city" (1.219). Commissioned by Frederick the Great and completed in 1793, the Brandenburg Gate was designed in a neoclassical style that associates it with the greatness and power of ancient Greece. Atop the gate sits the Quadriga, a statue of the goddess of victory in a chariot drawn by four horses. When Napoleon conquered the Prussians, he altered the significance of the gate by using it for a triumphal procession. He then carried the Quadriga to Paris, turning the sculpture into a large-scale souvenir of his military power. Like the art he confiscated from Italy, the Quadriga was one of a collection of Prussian artifacts that he brought back to display publicly as trophies celebrating his empire.[14] Looting was not legally acceptable, however, and Napoleon's exploit earned him the epithet of the horse thief of Berlin; after 1815, the French had to return all the objects they had stolen.[15] The restitution process offered countries the opportunity to retrieve conquest trophies and teach the French a lesson.[16] Retaken "after the battle of Waterloo," Shelley remarks, the Quadriga now serves as a reminder of Prussia's freedom from French control (1.219). She also notes how the reverse placement of the monument alters its meaning. Positioned to face the city, it suggests that victory returns to Berlin and symbolizes Germany's triumph over Napoleon.

By altering their memorials, the Germans employ them for national rather than imperial ends. As Europe worked to rebuild after the wars, its major cities erected or renovated dozens of monuments to forge new national identities.[17] The restitution process had raised awareness of the extent to which art and other objects of cultural heritage were an integral part of an emerging nation's character. Monuments became important political tools that provided a country with a collective identity and a shared national story.[18] In Shelley's text, the reversal of the Quadriga on

the Brandenburg Gate indicates that Germany focuses inward on building its own nation instead of conquering others. The gate is an appropriate monument for such a project due to its prominent location in the center of the city. As Shelley explains in her letter of July 27, "We are here in the best street, which has a double avenue of lime-trees in the middle, running its whole length. One way it leads to the Brandenburg gate, the other to a spot that forms the beauty of Berlin as a capital . . . the New Museum, opposite to which stands the Guard-house, the Italian Opera, and the University . . . the whole forms a splendid assemblage of buildings" (1.218–219). The gate's position at the end of an avenue increases its visibility, while its situation near the city's latest cultural institutions emphasizes its importance as a symbol of national identity. As Berlin's "best" known landmark, the gate adorned souvenirs like snuffboxes, coins, plates, and cups, as Figure C.2 shows, allowing travelers like Shelley to circulate this image of the new German nation.

Shelley shows how the Germans modify art objects as well as monuments to revise their national story. In a July 29, 1842, letter from Berlin, she observes the prominent display of Napoleon's imperial gifts at the Royal Palace: "To-day, we have been doing our duty in sight-seeing. . . . The rooms of the palace are chiefly associated with the name of Napoleon, and are decorated by vases of Sèvre china and by portraits of himself and Josephine, presents from the conqueror to the conquered, which were impertinent enough at the time; but the spirit is changed now, and they remain as trophies of Prussian victories" (1.225–226). In addition to taking objects like the Quadriga as souvenirs, Napoleon bestowed French porcelain and portraits as "presents" on the Germans. Porcelain emerged in the eighteenth century as a key instrument of elite male power, and leaders like Napoleon gifted it to position themselves publicly above others in political hierarchies within Europe.[19] Originally manufactured for the exclusive use of the French court, Sèvres porcelain served as a medium through which to spread his imperial power, and he abandoned traditional designs in favor of imagery that charted the triumphs of his regime.[20] The portraits further signified his presence within and occupation of the country. As Shelley ironically notes, the gifts given by "the conqueror to the conquered" were hardly generous in nature but rather forced upon the Germans as reminders of their submission to his empire (1.225–226). Instead of returning his gifts, the Germans display them in rooms dedicated to him in the palace. As the political landscape changes, notes Coutu, memorials assume new meanings.[21] Shelley likewise shows how the Germans can reframe Napoleon's souvenirs as "trophies" of their own triumph because "the spirit is changed now" (1.226). Calling it her

Figure C.2. Carl von Scheidt, *The Brandenburg Gate*, 1816, German, Berlin, glass, enameled and gilt, 3 7/8 × 3 5/8 in. (9.8 × 9.2 cm). The Metropolitan Museum of Art.

"duty" to view them, she deems it the responsibility of the tourist to partake in experiencing this revised version of the former emperor (1.225).

Revolutionary Figurines: Recollecting Heroes

Shelley witnessed the rememoration of Napoleon not only at important tourist sites but also through the formation of mass-produced souvenirs. She describes this phenomenon in her July 29 letter after visiting the Royal

Prussian Iron Foundry in Berlin, which operated between 1804 and 1874 and produced iron goods including jewelry, accessories, and small statuary:

> The men were at work making moulds in sand. At length a vast cauldron of molten metal was brought from the furnace, and poured into a mould ... molten metal, red and fiery, takes a new appearance, and seems to have life,—the heat appears to give it voluntary action, and the sense of its power of injury adds to the emotion with which it is regarded; as well as the fact that it takes and preserves the form into which it flows. ... After this we were taken to an outhouse, in which there were articles for sale—no bracelets, nor chains, nor necklaces; chiefly small statuettes of Napoleon and Frederic the Great. (1.229–230)

In the eighteenth century, figurines were fashionable consumer goods and a popular means of aesthetic representation. Political celebrities sold the best, with consumers seeking both heroes and antiheroes, whether revolutionaries or royalty. By the middle of the nineteenth century, Napoleon figurines were all the rage, making them the leading article of industrial manufacture. Associated with a mix of nostalgia, nationalism, republicanism, and resistance, miniature Napoleons circulated around the world; there were so many in England that he was reputed to have finally found success in invading the country.[22] Germany subsequently saw a growing demand for memorabilia like those manufactured at the Royal Foundry, and Shelley notes the statuettes of Napoleon on sale in its "outhouse" or gift shop (1.229). In recounting the process of how the factory makes the miniatures, she notices that the melted iron, which "seems to have life" and lends the figures "voluntary action," appears to animate them. Composed of the durable element of iron, the figurines provide the former French emperor with an afterlife, and the mold that "preserves" their shape ensures that his image will last.

Like other memorials of Napoleon, however, the figurines allow for reinterpretations of his legacy. As in Figure C.3, Shelley observes his presence alongside Frederick the Great, the Prussian king and tyrant both glorified and feared for his unscrupulous use of force.[23] In a July 22, 1842, letter from Leipzig, she states, "Our guide-books speak of this as the scenes of battles and victories of ... Frederic the Great" (1.214). In his time, she notes, Frederick was "a man of talent, a warrior," but his legacy changes after his death, and she recalls him for "the evils which, as a conqueror, he brought on his subjects ... there is no sovereign in history, for whom one cares so little." She then compares him with Napoleon, "another name, greater and newer than his," that "has thrust him from his place, and occupies our attention." She remarks that Napoleon possessed "the unflinching, stubborn will of Frederic"

Figure C.3. Pair of cast iron figures of Napoleon and Frederick the Great, 1820, iron, 9.5 × 2.5 × 2.5 in. Patrick Sandberg Antiques, London, England.

and through his imperial wars "attempt[ed] to gain a world by victory" (1.215). By aligning the two figures, she suggests that Napoleon is a similar tyrant; the "fiery" material that composes the statuettes is appropriate, as the "sense of its power of injury" reflects both leaders' dominant personalities and the destruction their wars caused across Europe (1.229). While Napoleon's figurine signals his current renown, viewing him alongside the disgraced Prussian king allows Shelley to imply that his fame might also fade over time.

While Napoleonic souvenirs could signify his popularity, they had a potentially subversive presence as well, especially when displayed in the home. Exhibiting busts and portraits of famous individuals in the parlor, much like the room featured in *Mr. Sainsbury's Napoleon Museum*, was a common practice for boosting social status. Few families could afford the originals that Sainsbury possessed, but they could purchase the reproductions widely available at places like the foundry's gift shop. Far from mere decoration, the objects in the parlor offered lessons; figurines of Napoleon

might suggest his rise to power or military ability, but they were just as likely to serve as a warning about putting ambition above the common good. The lessons that objects taught also reached an audience beyond their owners. In the parlor, families gathered to entertain guests, who would have seen mementos arranged on the fireplace mantel or a central table, which were the focal points of the room.[24] By presenting Napoleon figurines beside those of Frederick the Great, Shelley suggests a possible pairing for display to shape public opinion of him. Napoleon may have dominated Britain as a consumer item, but Simon Bainbridge argues that he met his most significant defeat in the space of the home. Placing him within the domestic sphere was a deliberate attempt to humiliate him, and his statuettes commonly functioned as hat racks. He was further conquered by the process of reproduction; as cheap images of him proliferated, they robbed him of his authenticity and undermined his legendary image.[25]

Shelley expresses disappointment over the appearance of Napoleon figurines at the foundry as they replace Revolutionary souvenirs. Before the visit, she notes, "We asked every one we met where the works in steel were sold; no one could tell us" (1.228–229). Clearly intending to purchase a memento, she instead finds that there were "no bracelets, nor chains, nor necklaces" for sale at the shop (1.229–230). During the Napoleonic Wars, the foundry turned to making cut-steel and iron jewelry, like that in Figure C.4. Production peaked between 1813 and 1815, when the Prussian royal family urged its female citizens to contribute their gold and silver jewelry to fund the uprising against Napoleon. In return, they received iron jewelry, which became a popular emblem of patriotism.[26] The jewelry symbolized Frederick William III's iron determination to liberate his kingdom from French occupation as well as his citizens' fortitude and strength in war. Iron also signified the unification of all citizens in a common cause because it was an everyday material rather than a noble metal. After the threat of Napoleon passed, Frederick William III reverted to authoritarian rule, and Germany's hope for lasting political unity disappeared along with the iron jewelry.[27] As a woman of refined taste and style, Shelley followed and helped set the fashion trends of her time, especially through her choice of accessories.[28] Purchasing the jewelry would have allowed her not only to exhibit her opposition to Napoleon but also to connect with Germany's own revolutionary history and encourage support for its nationalist cause.

Choosing another means of countering Napoleon's image, Shelley draws attention to a different political hero from the region, Andreas Hofer. Her September 9, 1842, letter from the state of Tyrol recounts a lengthy history of Hofer, a peasant and innkeeper who led his country's rebellion against

Figure C.4. Berlin ironwork necklace, c. 1815, German, Berlin, iron, steel, and patinated silver, 18 1/2 in. (47 cm). The Metropolitan Museum of Art.

Napoleon in 1809. Hofer and his small army were no match for Napoleon's military, which captured and executed the Tyrolean leader under the emperor's orders.[29] The Germans viewed Hofer as a symbol of the fight against Napoleon's power, and Romantic writers like Shelley admired him as a token of popular revolution and individual freedom. While she passes over the statuettes of Napoleon at the foundry, "I bought a tiny figure of Hofer, carved in wood, to do honour to the 'Tyrolean Champion,' who, as Wordsworth well expresses it, was 'Murdered, like one ashore by shipwreck Cast, / Murdered without relief'" (2.62). The fashioning of the Hofer figurine reflects his ideologies. Tyrol figures were crafted of pinewood, a local material, and their simple, rustic quality represents Hofer's rural origins and democratic stance.[30] Hand carved rather than mass produced like the miniature Napoleon statues, the Hofer figurine possesses an authenticity that validates his heroism. By purchasing it, Shelley poses him in opposition to Napoleon and upholds him as an alternative political idol.

In recognizing Hofer as a Revolutionary hero, Shelley turns him into a model of resistance to tyranny. By the early nineteenth century, a new trend

in monuments had begun to emerge across Europe. Whereas public statuary was once reserved for kings, rulers, and other government leaders, towns increasingly began to commemorate their own citizens. The subjects immortalized broadened to include radicals and reformers like Hofer.[31] The wooden figurine that Shelley purchased most likely was modeled on the best-known representation of him, a marble statue erected on his tomb in 1834. The statue shows Hofer dressed in military garb and surrounded by iconic national imagery; in one hand, he holds the Tyrolean flag, and behind him lies the wide-brimmed hat typical of his region. A wild landscape of trees and mountains in the background situates him in his alpine homeland, and his upward gaze suggests his political idealism. Hofer's resistance against Napoleon also inspired several sonnets by William Wordsworth that further commemorated his actions and contributed to his legendary status. In the poem that Shelley quotes, he eulogizes Hofer as a martyr. Through repetition of the term "murdered," Wordsworth emphasizes that his death was unjustified, and by comparing him to a castaway, he honors him for fighting Napoleon alone (2.62). Shelley's letter on Hofer similarly directs readers to remember him as they travel, "for these valleys are filled with his name, and it were sacrilege to traverse them without commemorating his glory and lamenting his downfall" (2.55). Like the figurine and Wordsworth poem, her account serves as a memorial to Hofer and the larger European struggle for independence.

Shelley compares Hofer with another radical figure, Toussaint Louverture, to challenge the idea of Napoleon as the leader of liberal reform. In a July 8, 1842, letter, she denotes several "crimes which cast a dark stain on Napoleon's name . . . first, the miserable death of Toussaint l'Ouverture; second, the execution of Hoffer" (1.43–44). Formerly enslaved in Haiti, Toussaint led the 1791 Haitian Revolution, which forced France to abolish enslavement in the colony; however, Napoleon invaded in 1802 to reinstate the practice. Even though the conflict ended peacefully, Napoleon arrested Toussaint the following year and imprisoned him in a dungeon in the French Alps, where he died. He became a popular hero in Britain for embracing revolutionary ideals and rebelling against the French.[32] Shelley grew up during the abolition movement and was aware of insurrection in Haiti.[33] By mentioning Toussaint alongside Hofer, she juxtaposes both leaders against Napoleon and links their nations' struggles for independence. British writers and historians of the era depicted him as a sympathetic and tragic figure.[34] Shelley likewise deems his death a "crime" that resembles Hofer's murder (1.43). By drawing a parallel between authoritarian political

rule in Europe and Haiti, she shows how both imperialism and enslavement constitute unjust forms of domination. Her comparison suggests that if British liberals admire Toussaint and his attempt to end enslavement, then they should support European countries that Napoleon similarly oppressed but that now seek to institute democratic reform. In creating a transnational link between two political radicals whom Napoleon opposed, Shelley contests the refiguring of the former French emperor as a Revolutionary hero.

By replacing Napoleon with Toussaint, Shelley designates the Revolution as the source of liberal ideals and recasts reform as a global issue. Shelley and her readers were likely familiar with Denis Volozan's painting *Equestrian Portrait of Toussaint Louverture on Bel-Argent*, which closely resembles Jacques-Louis David's *Napoleon Crossing the Alps*. David's painting, which depicts Napoleon astride a rearing horse, is one of the best-known historical images of military glory. Volozan's portrait offers a competing image of heroism, featuring Toussaint in military uniform and in the same pose as Napoleon.[35] Like the French emperor, he actively encouraged the circulation of his image on souvenirs and other material items, such as engravings, book covers, opera programs, and Napoleon's favored medium of Sèvres porcelain. Often referred to as "the Black Napoleon," he assumed a relationship of rivalry and opposition to the French emperor, who he demanded recognize him as an equal.[36] Beyond simply challenging Napoleon, his material figuration aligned him with the Revolution, whose values inspired his own. Leaders like Toussaint acted as vectors of revolution, creating a transatlantic dialogue that synthesized African and European voices.[37] By putting Europe and Haiti in conversation through the figures of Hofer and Toussaint in her journal, Shelley continues this dialogue, revealing a shared fight for freedom and redefining liberal reform after the wars as a universal movement. Her collecting of radical figures counters that of Napoleon supporters like Sainsbury to ensure that they will become the true descendants of revolution.

This study began by examining how souvenirs of the French Revolution provided a new direction for thinking about the nation and women's political involvement. Shelley's *Rambles in Germany and Italy* shows the fruition of these early efforts. Her work is significant for using souvenirs to look back at the revolutionary ideals of the 1790s as a way of understanding contemporary political movements. However, it also encourages readers to consider the impact of these ideals on future events. As Napoleon's image and his ideology of empire continued to circulate at midcentury, she warns of unrest as the French once again "begin to dream of dominion

across the Alps" and predicts that, if they succeed, "the peace" of Europe "will be disturbed" (1.xiv–xv). Britain's failure to establish an alliance with Germany and support its emerging nationalist movement would therefore hinder democratic progress around Europe. By refiguring Napoleonic memorials and replacing them with souvenirs of Revolutionary heroes in her text, she reminds her readers of the importance of defending liberal reform abroad and situates Britain as essential to its success. Shelley's work both shared and enlarged the cosmopolitan vision of earlier women writers by expanding the call for liberty and equality beyond national and geographic boundaries. Her souvenirs also continued their legacy by carrying the Revolution's spirit into the nineteenth century and beyond.

Notes

Introduction

1. Helen Maria Williams, *Letters from France*, ed. Janet M. Todd (Delmar, NY: Scholars' Facsimiles and Reprints, 1975), 1.1.52–53.

2. Horace Walpole, *The Yale Edition of Horace Walpole's Correspondence*, ed. W. S. Lewis (New Haven, CT: Yale University Press, 1965), 34:278.

3. Rolf Potts, *Souvenir* (New York: Bloomsbury, 2018), 7–8.

4. Susan Stewart, *On Longing: Narratives of the Miniature, the Gigantic, the Souvenir, the Collection* (Durham, NC: Duke University Press, 1993), 140.

5. Potts, *Souvenir*, 106.

6. Richard Taws, *The Politics of the Provisional: Art and Ephemera in Revolutionary France* (University Park: Penn State University Press, 2013), 3–4.

7. Arthur MacGregor, *Curiosity and Enlightenment: Collectors and Collections from the Sixteenth to the Nineteenth Century* (New Haven, CT: Yale University Press, 2008), 32–35.

8. Emma Gleadhill, *Taking Travel Home: The Material Culture of British Women Tourists, 1770–1830* (Manchester: Manchester University Press, 2022), 1–4, 21.

9. For more on this controversy, see Marilyn Butler, ed., *Burke, Paine, Godwin, and the Revolution Controversy* (Cambridge: Cambridge University Press, 1984); Clive Emsley, *Britain and the French Revolution* (New York: Longman, 2000); Gregory Claeys, *The French Revolution Debate in Britain: The Origins of Modern Politics* (New York: Palgrave Macmillan, 2007).

10. Chloe Wigston Smith and Beth Fowkes Tobin, "Introduction: The Scale and Sense of Small Things," in *Small Things in the Eighteenth Century: The Political and Personal Value of the Miniature*, ed. Chloe Wigston Smith and Beth Fowkes Tobin (Cambridge: Cambridge University Press, 2022), 4.

11. Gillian Russell, *The Ephemeral Eighteenth Century: Print, Sociability, and the Cultures of Collecting* (Cambridge: Cambridge University Press, 2020), 15.

12. Potts, *Souvenir*, 60.

13. Smith and Tobin, "Introduction," 6–10.

14. Marcia Pointon, "'Surrounded with Brilliants': Miniature Portraits in Eighteenth-Century England," *Art Bulletin* 3, no. 1 (March 2001): 48–50.

15. Caroline McCaffrey-Howarth, "Revolutionary Histories in Small Things: Louis XVI and Marie Antoinette on Printed Ceramics, c. 1793–1796," in Smith and Tobin, *Small Things in the Eighteenth Century*, 258.

16. Serena Dyer, "Portable Patriotism: Britannia and Material Nationhood in Miniature," in Smith and Tobin, *Small Things in the Eighteenth Century*, 247.

17. Smith and Tobin, "Introduction," 10.

18. Dyer, "Portable Patriotism," 242–243.

19. Russell, *Ephemeral Eighteenth Century*, 86, 20–21.

20. Beverly Gordon, "The Souvenir: Messenger of the Extraordinary," *Journal of Popular Culture* 20, no. 3 (Winter 1986): 135.

21. Dyer, "Portable Patriotism," 244.

22. Hanneke Grootenboer, "Afterword: A Thing's Perspective," in Smith and Tobin, *Small Things in the Eighteenth Century*, 292.

23. Kelly Fleming, "The Politics of Sophia Western's Muff," *Eighteenth-Century Fiction* 31, no. 4 (Summer 2019): 661.

24. Elaine Chalus and Fiona Montgomery, "Women and Politics," in *Women's History, Britain 1700–1850: An Introduction*, ed. Hannah Barker and Elaine Chalus (London: Routledge, 2005), 4.

25. Elaine Chalus, "Fanning the Flames: Women, Fashion, and Politics," in *Women, Popular Culture, and the Eighteenth Century*, ed. Tiffany Potter (Toronto: University of Toronto Press, 2012), 92.

26. Stewart, *On Longing*, 136.

27. Chalus, "Fanning the Flames," 95.

28. Potts, *Souvenir*, 103.

29. Joan B. Landes, *Visualizing the Nation: Gender, Representation, and Revolution in Eighteenth-Century France* (Ithaca, NY: Cornell University Press, 2001), 94.

30. Williams, *Letters from France*, 1.1.14.

31. Gleadhill, *Taking Travel Home*, 3.

32. Potts, *Souvenir*, 27.

33. Stewart, *On Longing*, 150–151, 156–161.

34. Russell, *Ephemeral Eighteenth Century*, 16.

35. Dyer, "Portable Patriotism," 247.

36. James Daybell and Svante Norrhem, "Introduction: Rethinking Gender and Political Culture in Early Modern Europe," in *Gender and Political Culture in Early Modern Europe, 1400–1800*, ed. James Daybell and Svante Norrhem (London: Routledge, 2017), 10.

37. Ileana Baird, "Introduction: Peregrine Things: Rethinking the Global in Eighteenth-Century Studies," in *Eighteenth-Century Thing Theory in a Global Context: From Consumerism to Celebrity Culture*, ed. Ileana Baird and Christina Ionescu (Farnham: Ashgate, 2013), 9–13.

38. The Acts of Union, passed by the English and Scottish parliaments in 1707, led to the creation of Great Britain. The Acts of Union of 1800 secured Ireland as England's colony. Both Scotland and Ireland were dissatisfied with their lack of political representation within the British government. For more, see Leith Davis, *Acts of Union: Scotland and the Literary Negotiation of the British Nation* (Stanford, CA: Stanford University Press, 1998); Kevin Kenny, ed., *Ireland and the British Empire* (Oxford: Oxford University Press, 2004).

39. The Battle of Waterloo was fought on June 18, 1815, in the Netherlands. An Anglo-Allied force under the command of Britain's Duke of Wellington helped defeat Napoleon's French army; approximately fifty thousand men were wounded or killed in the

conflict. For more, see Luke Reynolds, *Who Owned Waterloo? Battle, Memory, and Myth in British History, 1815–1852* (Oxford: Oxford University Press, 2022).

40. Stewart, *On Longing*, 140.

41. Potts, *Souvenir*, 70–71, 74–76.

42. Dyer, "Portable Patriotism," 252.

43. Potts, *Souvenir*, 33–37.

44. Potts, *Souvenir*, 72, 57.

45. Crystal B. Lake, *Artifacts: How We Think and Write about Found Objects* (Baltimore: Johns Hopkins University Press, 2020).

46. Smith and Tobin, "Introduction," 3.

47. Melinda Alliker Rabb, *Miniature and the English Imagination: Literature, Cognition, and Small-Scale Culture, 1650–1765* (Cambridge: Cambridge University Press, 2019), 5–6.

48. For more on thing theory and it-narratives in the era, see Deidre Lynch, "Personal Effects and Sentimental Fictions," *Eighteenth-Century Fiction* 12, no. 2–3 (2000): 345–368; Bill Brown, "Thing Theory," *Critical Inquiry* 28, no. 1 (Autumn 2001): 1–21; Mark Blackwell, *The Secret Life of Things: Animals, Objects, and It-Narratives in Eighteenth-Century England* (Stanford, CA: Stanford University Press, 2007); Julie Park, *The Self and It: Novel Objects in Eighteenth-Century England* (Stanford, CA: Stanford University Press, 2010); Baird, "Introduction," 1–16.

49. Rabb, *Miniature and Imagination*, 6.

50. Stewart, *On Longing*, 136.

51. With the term "new materialism," I refer to recent approaches in the arts, humanities, and social sciences that share a theoretical and practical "turn to matter." Including both assemblage theory and object-oriented ontology, these approaches emphasize the materiality of the world as well as the objects and their interactions within it. For further explanation, see Diana Coole and Samantha Frost, eds., *New Materialisms: Ontology, Agency, and Politics* (Durham, NC: Duke University Press, 2010); Jane Bennett, *Vibrant Matter: A Political Ecology of Things* (Durham, NC: Duke University Press, 2010); Richard Grusin, ed., *The Nonhuman Turn* (Minneapolis: University of Minnesota Press, 2015); Manuel DeLanda, *Assemblage Theory* (Edinburgh: Edinburgh University Press, 2016).

52. Bruno Latour, "The Berlin Key or How to Do Words with Things," in *Matter, Materiality and Modern Culture*, ed. P. M. Graves-Brown (London: Routledge, 2000), 19.

53. Jane Bennett, "Systems and Things: On Vital Materialism and Object-Oriented Philosophy," in Grusin, *Nonhuman Turn*, 223.

54. Bennett, *Vibrant Matter*, viii, 55–56.

55. Bennett, *Vibrant Matter*, 21–23.

56. Bennett, "Systems and Things," 233.

57. Bennett, *Vibrant Matter*, 5–6, 109.

58. Katherine Behar, "An Introduction to OOF," in *Object-Oriented Feminism*, ed. Katherine Behar (Minneapolis: University of Minnesota Press, 2016), 7.

59. Bennett, *Vibrant Matter*, 14.

60. Bennett, "Systems and Things," 234–235.

61. Bruno Latour, *Reassembling the Social: An Introduction to Actor-Network-Theory* (Oxford: Oxford University Press, 2005), 79–80, 122–128.

62. Arlene Leis and Kacie L. Wills, "Introduction: Women and the Cultures of Collecting," in *Women and the Art and Science of Collecting in Eighteenth-Century Europe*, ed. Arlene Leis and Kacie L. Wills (London: Routledge, 2020), 3.

63. The Jacobins, radical revolutionaries led by Maximilien Robespierre who plotted the downfall of King Louis XVI and the rise of the French Republic, were often associated with the Reign of Terror for considering violence a legitimate political tool. For more, see Hugh Gough, *The Terror in the French Revolution* (London: Bloomsbury, 2010).

64. Stewart, *On Longing*, 135.

65. Amy F. Ogata, "Viewing Souvenirs: Peepshows and the International Expositions," *Journal of Design History* 15, no. 2 (2002): 79–80.

Chapter 1. Helen Maria Williams's Sentimental *Objects* in Letters from France

1. Deborah Kennedy, *Helen Maria Williams and the Age of Revolution* (Lewisburg, PA: Bucknell University Press, 2002), 52–55.

2. Kennedy, *Age of Revolution*, 34–36.

3. Mary A. Favret, "Spectatrice as Spectacle: Helen Maria Williams at Home in the Revolution," *Studies in Romanticism* 32, no. 2 (Summer 1993): 273–295; Gary Kelly, *Women, Writing and Revolution, 1790–1827* (Oxford: Oxford University Press, 1993).

4. Jacqueline LeBlanc, "Politics and Commercial Sensibility in Helen Maria Williams' *Letters from France*," *Eighteenth Century Life* 21, no. 1 (February 1997): 26.

5. Kennedy, *Age of Revolution*.

6. Elizabeth A. Bohls, *Women Travel Writers and the Language of Aesthetics, 1716–1818* (Cambridge: Cambridge University Press, 1995); Angela Keane, *Women Writers and the English Nation in the 1790s* (Cambridge: Cambridge University Press, 2000).

7. LeBlanc, "Politics and Commercial Sensibility," 26.

8. Kennedy, *Age of Revolution*, 53.

9. Adriana Craciun, *British Women Writers and the French Revolution: Citizens of the World* (New York: Palgrave Macmillan, 2005), 6.

10. Hans-Jürgen Lüsebrink and Rolf Reichardt, *The Bastille: A History of a Symbol of Despotism and Freedom*, trans. Norbert Schürer (Durham, NC: Duke University Press, 1997).

11. Luke A. Iantorno, "Revolutionary Games: Helen Maria Williams's Playtime at the Apocalypse," *CEA Critic* 7, no. 1 (2017): 88.

12. Halina Adams, "Imagining the Nation: Transforming the Bastille in Williams's *Letters Written in France* (1790)," *European Romantic Review* 25, no. 6 (2014): 732–737.

13. Helen Maria Williams, *Letters from France*, ed. Janet M. Todd (Delmar, NY: Scholars' Facsimiles and Reprints, 1975). Further citations of this work are given in the text by volume, page, and line numbers.

14. Taws, *Politics of the Provisional*, 107.

15. Adams, "Imagining the Nation," 731–732.

16. Taws, *Politics of the Provisional*, 99, 105.

17. Tom Wilkinson, *Bricks and Mortals: Ten Great Buildings and the People They Made* (London: Bloomsbury, 2014), 30.

18. Lüsebrink and Reichardt, *The Bastille*, 120.

19. Simon Schama, *Citizens: A Chronicle of the French Revolution* (New York: Knopf, 1989), 409.

20. Mark Jones, "Medals of the French Revolution," *RSA Journal* 137, no. 5398 (September 1989): 641.

21. Jones, "Medals of the French Revolution," 641–642.

22. Crystal B. Lake, "On the Smallness of Numismatic Objects," in Smith and Tobin, *Small Things in the Eighteenth Century*, 80–81.

23. Taws, *Politics of the Provisional*, 103.

24. Jones, "Medals of the French Revolution," 641.

25. Adams, "Imagining the Nation," 733.

26. Stewart, *On Longing*, 71, 147.

27. Stewart, *On Longing*, 137–146.

28. Serena Dyer and Chloe Wigston Smith, "Introduction," in *Material Literacy in Eighteenth-Century Britain: A Nation of Makers*, ed. Serena Dyer and Chloe Wigston Smith (London: Bloomsbury, 2020), 10.

29. Alfred F. Young, *Liberty Tree: Ordinary People and the American Revolution* (New York: New York University Press, 2006), 325.

30. Adams, "Imagining the Nation," 724.

31. Adams, "Imagining the Nation," 734.

32. Adams, "Imagining the Nation," 727.

33. Edmund Burke, *Reflections on the Revolution in France*, ed. L. G. Mitchell (Oxford: Oxford University Press, 2009), 35.

34. Yi-Cheng Weng, "An 'Englishwoman's Private Theatrical': Helen Maria Williams and the New Female Citizen," *EurAmerica* 49, no. 3 (September 2019): 359.

35. Lynn Festa, *Sentimental Figures of Empire in Eighteenth-Century Britain and France* (Baltimore: Johns Hopkins University Press, 2006), 68.

36. Nancy du Tertre, *The Art of the Limoges Box* (New York: Harry N. Abrams, 2003), 41.

37. Mattoon M. Curtis, *The Story of Snuff and Snuff Boxes* (New York: Liveright, 1935), 82.

38. Festa, *Sentimental Figures*, 71.

39. Dyer, "Portable Patriotism," 240.

40. Curtis, *Story of Snuff*, 83.

41. Hugh McCausland, *Snuff and Snuff Boxes* (London: Batchworth, 1951), 106.

42. Paul H. Beik, "Abbé Maury and the National Assembly," *Proceedings of the American Philosophical Society* 95, no. 5 (1951): 546–547.

43. LeBlanc, "Politics and Commercial Sensibility," 38.

44. Ron Jenkins, *Subversive Laughter: The Liberating Power of Comedy* (New York: Free Press, 1994), 57, 2.

45. Sianne Ngai, *Our Aesthetic Categories: Zany, Cute, Interesting* (Cambridge, MA: Harvard University Press, 2012), 18, 11.

46. Jenkins, *Subversive Laughter*, 2, 51.

47. Jenkins, *Subversive Laughter*, 57.

48. Festa, *Sentimental Figures*, 73.

49. Beik, "Abbé Maury," 546.

50. Ann Jessie Van Sant, *Eighteenth-Century Sensibility and the Novel: The Senses in Social Context* (Cambridge: Cambridge University Press, 1993), 101.

51. Stewart, *On Longing*, 56.

52. Kennedy, *Age of Revolution*, 53–54.

53. Kennedy, *Age of Revolution*, 54.

54. Rebecca L. Spang, *Stuff and Money in the Time of the French Revolution* (Cambridge, MA: Harvard University Press, 2017), 8–9.

55. Du Tertre, *Limoges Box*, 45.

56. Kennedy, *Age of Revolution*, 42–43.

57. Keane, *Women Writers*, 65.

58. Festa, *Sentimental Figures*, 71.

59. Elaine Chalus, "Elite Women, Social Politics, and the Political World of Late Eighteenth-Century England," *Historical Journal* 43, no. 3 (2000): 694.

60. Jennifer Harris, "The Red Cap of Liberty: A Study of Dress Worn by French Revolutionary Partisans 1789–94," *Eighteenth Century Studies* 14, no. 3 (1981): 292–293.

61. Katrina Navickas, "'That Sash Will Hang You': Political Clothing and Adornment in England, 1780–1840," *Journal of British Studies* 49, no. 3 (2010): 552.

62. Marcia Pointon, "Women and Their Jewels," in *Women and Material Culture, 1660–1830*, ed. Jennie Batchelor and Cora Kaplan (New York: Palgrave Macmillan, 2007), 17, 20.

63. Landes, *Visualizing the Nation*, 91.

64. Julie Ellison, "Redoubled Feeling: Politics, Sentiment and the Sublime in Williams and Wollstonecraft," *Studies in Eighteenth-Century Culture* 20 (1990): 200.

65. Pointon, "Women and Their Jewels," 17.

66. Richard A. Bauman, *Women and Politics in Ancient Rome* (London: Routledge, 1992), 22, 26.

67. Pointon, "Women and Their Jewels," 11.

68. Elaine Chalus, "'That Epidemical Madness': Women and Electoral Politics in the Late Eighteenth Century," in *Gender in Eighteenth-Century England: Roles, Representations, and Responsibilities*, ed. Hannah Barker and Elaine Chalus (London: Addison Wesley Longman, 1997), 153–155. See also Linda Colley, *Britons: Forging the Nation, 1707–1837* (New Haven, CT: Yale University Press, 1992), 273.

69. Pointon, "Women and Their Jewels," 23.

70. Kennedy, *Age of Revolution*, 67.

71. LeBlanc, "Politics and Commercial Sensibility," 32.

72. Pointon, "Women and Their Jewels," 21.

73. Adams, "Imagining the Nation," 734.

74. Arjun Appadurai, "Introduction: Commodities and the Politics of Value," in *The Social Life of Things: Commodities in Cultural Perspective*, ed. Arjun Appadurai (Cambridge: Cambridge University Press, 1986), 40.

75. Pointon, "Women and Their Jewels," 11.

76. Marcia Pointon, *Brilliant Effects: A Cultural History of Gem Stones and Jewellery* (New Haven, CT: Yale University Press, 2009), 147–148.

77. Adams, "Imagining the Nation," 734–735.

78. Chalus and Montgomery, "Women and Politics," 242.

79. LeBlanc, "Politics and Commercial Sensibility," 33.

80. Bronwyn Winter, "Marianne Goes Multicultural: *Ni putes ni soumises* and the Republicanisation of Ethnic Minority Women in France," in *French History and Civilization: Papers from the George Rudé Seminar 2*, ed. Vesna Drapac and André Lambelet (Melbourne: George Rudé Society, 2009), 229.

81. Harris, "Red Cap of Liberty," 286.

82. Landes, *Visualizing the Nation*, 94–95.

83. Weng, "New Female Citizen," 344, 366.

84. Darline Gay Levy and Harriet B. Applewhite, "Women and Militant Citizenship in Revolutionary Paris," in *Rebel Daughters: Women and the French Revolution*, ed. Sara E. Melzer and Leslie W. Rabine (Oxford: Oxford University Press, 1992), 79.

85. Weng, "New Female Citizen," 352.

86. Jennifer Heuer, "Hats on for the Nation! Women, Servants, Soldiers and the 'Sign of the French,'" *French History* 16, no. 1 (2002): 29–30.

87. Kennedy, *Age of Revolution*, 56.

88. Weng, "New Female Citizen," 352.

89. Kennedy, *Age of Revolution*, 171.

90. Kennedy, *Age of Revolution*, 177–181.

Chapter 2. Mary Wollstonecraft and Political Spectacle in An Historical and Moral View of the French Revolution

1. Sylvana Tomaselli, *Wollstonecraft: Philosophy, Passion, and Politics* (Princeton, NJ: Princeton University Press, 2020).

2. Daniel I. O'Neill, "John Adams versus Mary Wollstonecraft on the French Revolution and Democracy," *Journal of the History of Ideas* 68, no. 3 (2007): 474.

3. Janet Todd, "Introduction," in *A Vindication of the Rights of Men; A Vindication of the Rights of Woman; An Historical and Moral View of the French Revolution*, ed. Janet Todd (Oxford: Oxford University Press, 1993).

4. Tom Furniss, "Mary Wollstonecraft's French Revolution," in *The Cambridge Companion to Mary Wollstonecraft*, ed. Claudia Johnson (Cambridge: Cambridge University Press, 2002); Michelle Callander, "'The Grand Theatre of Political Changes': Marie Antoinette, the Republic, and the Politics of Spectacle in Mary Wollstonecraft's *An Historical and Moral View of the French Revolution*," *European Romantic Review* 11, no. 4 (2000): 375–392.

5. Todd, "Introduction"; Gary Kelly, *Revolutionary Feminism: The Mind and Career of Mary Wollstonecraft* (New York: St. Martin's, 1992); Virginia Sapiro, *A Vindication of Political Virtue: The Political Theory of Mary Wollstonecraft* (Chicago: University of Chicago Press, 1992); Lori J. Marso, "Defending the Queen: Wollstonecraft and Staël on the Politics of Sensibility and Feminine Difference," *Eighteenth Century* 43, no. 1 (2002): 43–60.

6. Catherine Packham, "Domesticity, Objects, and Idleness: Mary Wollstonecraft and Political Economy," *Women's Writing* 19, no. 4 (2012): 545.

7. Iris Moon and Richard Taws, "Introduction," in *Time, Media, and Visuality in Post-Revolutionary France*, ed. Iris Moon and Richard Taws (London: Bloomsbury, 2021), 3–4.

8. Ashli White, "On Ribbon and Revolution: Rethinking Cockades in the Atlantic," *Age of Revolutions*, last modified March 25, 2019, https://ageofrevolutions.com/2019/03/25/on-ribbon-and-revolution-rethinking-cockades-in-the-atlantic/. See also her book *Revolutionary Things* (New Haven, CT: Yale University Press, 2023).

9. Laura Kirkley, *Mary Wollstonecraft: Cosmopolitan* (Edinburgh: Edinburgh University Press, 2022), 4–6.

10. Packham, "Domesticity, Objects, and Idleness," 545.

11. Favret, "Spectatrice as Spectacle," 278–279.

12. Ogata, "Viewing Souvenirs," 70.

13. Mary Wollstonecraft, *An Historical and Moral View of the French Revolution* (1794), in *The Works of Mary Wollstonecraft*, ed. Janet Todd and Marilyn Butler (New York: New York University Press, 1989), 23. Further citations of this work are given in the text.

14. Regina Janes, *Losing Our Heads: Beheadings in Literature and Culture* (New York: New York University Press, 2005), 41.

15. Ogata, "Viewing Souvenirs," 79.

16. Richard Balzer, *Peepshows: A Visual History* (New York: Harry N. Abrams, 1998), 12.

17. Balzer, *Peepshows*, 26, 42.

18. Ronen Steinberg, "Between Silence and Speech: Spectres and Images in the Aftermath of the Reign of Terror," *Acta Academica* 47, no. 1 (2015): 248.

19. Richard Taws, "The Guillotine as Anti-Monument," *Sculpture Journal* 19, no. 1 (2010): 40.

20. Steinberg, "Spectres and Images," 253.

21. Jessica Goodman, "'Le peuple veut du sang': The Guillotine and the General Will in Revolutionary Pamphlet Theatre," in *Death Sentences: Literature and State Killing*, ed. Birte Christ and Ève Morisi (Oxford: Legenda, 2019), 60.

22. Stephanie O'Rourke, "Beholder, Beheaded: Theatrics of the Guillotine and the Spectacle of Rupture," in *Visual Culture and the Revolutionary and Napoleonic Wars*, ed. Satish Padiyar, Philip Shaw, and Philippa Simpson (London: Routledge, 2017), 26.

23. Emma Galbally and Conrad Brunström, "'This Dreadful Machine': The Spectacle of Death and the Aesthetics of Crowd Control," in *The Gothic and Death*, ed. Carol Margaret Davison (Manchester: Manchester University Press, 2017), 65.

24. Galbally and Brunström, "Spectacle of Death," 63.

25. Janes, *Losing Our Heads*, 42.

26. Steinberg, "Spectres and Images," 248.

27. Steinberg, "Spectres and Images."

28. Janes, *Losing Our Heads*, 78.

29. Goodman, "Guillotine and the General Will," 58.

30. Janes, *Losing Our Heads*, 71, 76.

31. Goodman, "Guillotine and the General Will," 73–74.

32. Goodman, "Guillotine and the General Will," 57.

33. Janes, *Losing Our Heads*, 75, 67, 41.

34. Galbally and Brunström, "Spectacle of Death," 72.

35. Ogata, "Viewing Souvenirs," 70.

36. Ralph Hyde, *Paper Peepshows: The Jaqueline and Jonathan Gestetner Collection* (New York: Antique Collectors' Club, 2015).

37. Janes, *Losing Our Heads*, 68.

38. Goodman, "Guillotine and the General Will," 59.

39. Callander, "Politics of Spectacle," 380.

40. Ogata, "Viewing Souvenirs," 70.

41. McCaffrey-Howarth, "Revolutionary Histories," 271.

42. Ogata, "Viewing Souvenirs," 69.

43. Jones, "Medals of the French Revolution," 641.

44. Lake, "Numismatic Objects," 81.

45. Jones, "Medals of the French Revolution," 640.

46. Lake, *Artifacts*, 14.

47. Festa, *Sentimental Figures*, 79.

48. Furniss, "Wollstonecraft's French Revolution," 74.

49. Jeanne Morgan Zarucchi, "Medals Catalogues of Louis XIV: Art and Propaganda," *Notes in the History of Art* 17, no. 4 (Summer 1998): 26–27.

50. Jones, "Medals of the French Revolution," 640–641.

51. Julian Baker, "Medals of the French Revolution," Ashmolean Museum, https://www.ashmolean.org/article/medals-french-revolution.

52. Lake, "Numismatic Objects," 85.

53. Jones, "Medals of the French Revolution," 644.

54. Reacting to food scarcity and anti-Revolutionary actions by the king's soldiers, crowds of Parisian market women marched on Versailles, demanding reforms and forcing Louis to return with them to Paris. The march was considered a defining moment of the Revolution.

55. Marso, "Defending the Queen," 55.

56. Packham, "Domesticity, Objects, and Idleness," 551–554.

57. Constance Wallace, "Symbols of the French Revolution: Colors of Cockades, Fabric and Their Importance in Politics of 1789," *North Alabama Historical Review* 3, no. 3 (2013): 33–34.

58. Kelly, *Revolutionary Feminism*, 7.

59. Marso, "Defending the Queen," 44.

60. Pointon, *Brilliant Effects*, 36.

61. Callander, "Politics of Spectacle," 379.

62. Kate Davies, "A Moral Purchase: Femininity, Commerce and Abolition, 1788–1792," in *Women, Writing and the Public Sphere, 1700–1830*, ed. Elizabeth Eger, Charlotte Grant, Clíona Ó Gallchoir, and Penny Warburton (Cambridge: Cambridge University Press, 2001), 140.

63. Mary Wollstonecraft, *A Vindication of the Rights of Woman* (Amherst, NY: Prometheus, 1989), 130.

64. Steven Adams, "Sèvres Porcelain and the Articulation of Imperial Identity in Napoleonic France," *Journal of Design History* 20, no. 3 (2007).

65. Wallace, "Colors of Cockades," 41–48.

66. Wallace, "Colors of Cockades," 49.

67. Wallace, "Colors of Cockades," 35–36.

68. White, "Ribbon and Revolution."

69. Marso, "Defending the Queen," 55.

70. Wallace, "Colors of Cockades," 37, 51–53.

71. Kelly, *Revolutionary Feminism*, 170.

72. O'Neill, "John Adams versus Mary Wollstonecraft," 469.

73. Packham, "Domesticity, Objects, and Idleness," 553.

74. Eileen Hunt Botting, "Wollstonecraft in Europe, 1792–1904: A Revisionist Reception History," *History of European Ideas* 39, no. 4 (2013): 510.

75. Furniss, "Wollstonecraft's French Revolution," 68–69.

Chapter 3. Imperial Collecting in Catherine and Martha Wilmot's Travel Journals

1. Thomas U. Sadleir, "Introduction," in *An Irish Peer on the Continent 1801–1803*, ed. Thomas U. Sadleir (London: Williams and Norgate, 1920), v–xiii.

2. Alexis Wolf, "The 'Original' Journals of Katherine Wilmot: Women's Travel Writing in the Salon of Helen Maria Williams," *European Romantic Review* 30, no. 5–6 (2019): 615, 629.

3. Edith Londonderry, "Introduction," in *The Russian Journals of Martha and Catherine Wilmot*, ed. Edith Londonderry and Harford Montgomery Hyde (London: Macmillan, 1934), xiii–xxvi.

4. Wolf, "'Original' Journals," 616.

5. MacGregor, *Curiosity and Enlightenment*, 35.

6. Nigel Leask, *Curiosity and the Aesthetics of Travel Writing, 1770–1840* (Oxford: Oxford University Press, 2002), 103.

7. Dominique Poulot, "The Musée Napoléon as an Imperial Louvre," in *Collecting and Empires: An Historical and Global Perspective*, ed. Maia Wellington Gahtan and Eva-Marie Troelenberg (London: Harvey Miller, 2019), 202.

8. Barbara M. Benedict, *Curiosity: A Cultural History of Early Modern Inquiry* (Chicago: University of Chicago Press, 2001), 204, 2.

9. Maxine Berg, *Luxury and Pleasure in Eighteenth-Century Britain* (Oxford: Oxford University Press, 2005), 8.

10. Leask, *Curiosity and the Aesthetics of Travel Writing*, 32.

11. Catherine Wilmot, *An Irish Peer on the Continent 1801–1803*, ed. Thomas U. Sadleir (London: Williams and Norgate, 1920), 11. Further citations of this work are given in the text.

12. Poulot, "Musée Napoléon," 202.

13. Poulot, "Musée Napoléon," 208.

14. Andrew McClellan, *Inventing the Louvre: Art, Politics, and the Origins of the Modern Museum in Eighteenth-Century Paris* (Berkeley: University of California Press, 1994), 119, 116.

15. Marjorie Swann, *Curiosities and Texts: The Culture of Collecting in Early Modern England* (Philadelphia: University of Pennsylvania Press, 2001), 6.

16. Swann, *Curiosities and Texts*, 18, 20–21.

17. Philip G. Dwyer, "Napoleon and the Drive for Glory: Reflections on the Making of French Foreign Policy," in *Napoleon and Europe*, ed. Philip G. Dwyer (London: Longman, 2001), 128.

18. Susan M. Pearce, *On Collecting: An Investigation into Collecting in the European Tradition* (London: Routledge, 1995), 184.

19. Stewart, *On Longing*, 165, 151–152.

20. McClellan, *Inventing the Louvre,* 131.

21. Swann, *Curiosities and Texts*, 27.

22. Benedict, *Curiosity*, 181.

23. Benedict, *Curiosity*, 10.

24. Benedict, *Curiosity*, 5.

25. Judith Pascoe, *The Hummingbird Cabinet: A Rare and Curious History of Romantic Collectors* (Ithaca, NY: Cornell University Press, 2006), 87, 90.

26. Swann, *Curiosities and Texts*, 27.

27. Benedict, *Curiosity*, 163.

28. Jann Matlock, "Miniature Style, 1789–1815," in Moon and Taws, *Time, Media, and Visuality*, 27.

29. Martha Wilmot, *The Russian Journals of Martha and Catherine Wilmot*, ed. Edith Londonderry and Harford Montgomery Hyde (London: Macmillan, 1934), 67. Further citations of Martha Wilmot's writing from this work are given in the text.

30. Rabb, *Miniature and Imagination*, 11.

31. Amanda Herbert, *Female Alliances: Gender, Identity, and Friendship in Early Modern Britain* (New Haven, CT: Yale University Press, 2014), 55, 76.

32. Pointon, "Surrounded with Brilliants," 53.

33. Dyer, "Portable Patriotism," 247.

34. Pointon, "Surrounded with Brilliants," 58.

35. Berg, *Luxury and Pleasure*, 28, 6.

36. Chalus, "Fanning the Flames," 99–100.

37. Stewart, *On Longing*, 144.

38. Marcia Pointon, *Hanging the Head: Portraiture and Social Formation in Eighteenth-Century England* (New Haven, CT: Yale University Press, 1993), 13, 34.

39. Pointon, "Surrounded with Brilliants," 48.

40. Iris Moon, "Rupture, Interrupted: Rococo Recursions and Political Futures in Percier and Fontaine's Napoleon Fan," in Moon and Taws, *Time, Media, and Visuality*, 58.

41. Berg, *Luxury and Pleasure*, 38, 19.

42. Emma Gleadhill and Ekaterina Heath, "Giving Women History: A History of Ekaterina Dashkova through Her Gifts to Catherine the Great and Others," *Women's History Review* 31, no. 3 (2022): 373.

43. Marcel Mauss, *The Gift: The Form and Reason for Exchange in Archaic Societies*, trans. W. D. Halls (London: Routledge, 2002), 3.

44. Catherine Wilmot, *Russian Journals*, 246.

45. Mauss, *The Gift*, 15.

46. Martha Wilmot, *Russian Journals*, 347.

47. Stewart, *On Longing*, 126.

48. Pointon, "Surrounded with Brilliants," 57.

49. Pointon, "Surrounded with Brilliants," 56.

50. Marcia Pointon, *Strategies for Showing: Women, Possession, and Representation in English Visual Culture 1665–1800* (Oxford: Oxford University Press, 1997), 176.

51. Elena Igorevna Stolbova, "Portraits of Princess Dashkova," in *The Princess and the Patriot: Ekaterina Dashkova, Benjamin Franklin, and the Age of Enlightenment*, ed. Sue Ann Prince (Philadelphia: American Philosophical Society, 2006), 102–103.

52. Pointon, "Surrounded with Brilliants," 51.

53. Meghan Kobza, "Dazzling or Fantastically Dull? Re-Examining the Eighteenth-Century London Masquerade," *Journal for Eighteenth-Century Studies* 43, no. 2 (2020): 168; Meghan Kobza, "The Habit of Habits: Material Culture and the Eighteenth-Century London Masquerade," *Studies in Eighteenth-Century Culture* 50 (2021): 283–285.

54. Kobza, "Habit of Habits," 279, 287.

55. Marc Raeff, "The Emergence of the Russian European: Russia as a Full Partner of Europe," in *Russia Engages the World, 1453–1825*, ed. Cynthia Hyla Whittaker (Cambridge, MA: Harvard University Press, 2003), 124.

56. Ann Gerritsen and Giorgio Riello, "The Global Lives of Things: Material Culture in the First Global Age," in *The Global Lives of Things: The Material Culture of Collections in the Early Modern World*, ed. Ann Gerritsen and Giorgio Riello (London: Routledge, 2016), 5–6.

57. Stewart, *On Longing*, 147.

58. Kobza, "Dazzling or Fantastically Dull?," 162.

59. Douglas Fordham, "Costume Dramas: British Art at the Court of the Marathas," *Representations* 101, no. 1 (2008): 59.

60. Raeff, "Russian European," 124.

61. Olga Vassilieva-Codognet, "The French Language of Fashion in Early Nineteenth-Century Russia," in *French and Russian in Imperial Russia: Language, Attitudes, and Identity*, ed. Derek Offord, Lara Ryazanova-Clarke, Vladislav Rjeoutski, and Gesine Argent (Edinburgh: Edinburgh University Press, 2015).

62. Vassilieva-Codognet, "French Language of Fashion."

63. R. E. F. Smith and David Christian, *Bread and Salt: A Social and Economic History of Food and Drink in Russia* (Cambridge: Cambridge University Press, 1984), 65.

64. Bohls, *Women Travel Writers*, 202–203.

65. Kobza, "Habit of Habits," 281.

66. Catherine Wilmot, *Russian Journals*, 198.

67. Kobza, "Habit of Habits," 267, 285.

68. Martha Wilmot, *Russian Journals*, 50.

69. Wolf, "'Original' Journals," 625.

70. Martha Wilmot, *Russian Journals*, 414.

Chapter 4. Charlotte Eaton's Battlefield Relics in Narrative of a Residence in Belgium

1. Reynolds, *Who Owned Waterloo?*, 44.

2. Susan Pearce, "The *Matériel* of War: Waterloo and Its Culture," in *Conflicting Visions: War and Visual Culture in Britain and France*, ed. John Bonehill and Geoff Quilley (Farnham: Ashgate, 2005), 210.

3. Stuart Semmel, "Reading the Tangible Past: British Tourism, Collecting, and Memory after Waterloo," *Representations* 69 (Winter 2000): 10.

4. Marysa Demoor, "Waterloo as a Small 'Realm of Memory': British Writers, Tourism, and the Periodical Press," *Victorian Periodicals Review* 48, no. 4 (Winter 2015): 453.

5. Jennine Hurl-Eamon and Lynn MacKay, *Women, Families, and the British Army, 1700–1880* (London: Routledge, 2020).

6. Philip Shaw, *Waterloo and the Romantic Imagination* (New York: Palgrave Macmillan, 2002), 5–6.

7. Pieter François, "'The Best Way to See Waterloo Is with Your Eyes Shut': British 'Histourism,' Authenticity and Commercialisation in the Mid-Nineteenth Century," *Anthropological Journal of European Cultures* 22, no. 1 (2013): 28–29.

8. Hurl-Eamon and MacKay, *Women, Families*.

9. Richard Altick, *The Shows of London* (Cambridge, MA: Belknap, 1978), 134.

10. Demoor, "Realm of Memory," 453.

11. Altick, *Shows of London*, 180–182.

12. Sibylle Erle, "Understanding the Field of Waterloo: Viewing Waterloo and the Narrative Strategies of the Panorama Programmes," *Interférences Littéraires* 20 (2017): 48–49.

13. Charlotte Waldie Eaton and Jane Waldie Watts, *Narrative of a Residence in Belgium during the Campaign of 1815 and of a Visit to the Field of Waterloo* (London: John Murray, 1817), iii. Further citations of this work are given in the text.

14. Erle, "Viewing Waterloo," 48.

15. Neil Ramsey and Gillian Russell, "Introduction: Tracing War in Enlightenment and Romantic Culture," in *Tracing War in British Enlightenment and Romantic Culture*, ed. Neil Ramsey and Gillian Russell (New York: Palgrave Macmillan, 2015), 5.

16. Erle, "Viewing Waterloo," 49.

17. Erle, "Viewing Waterloo," 48, 54.

18. Shaw, *Romantic Imagination*, 73, 82.

19. Semmel, "Tangible Past," 20.

20. Semmel, "Tangible Past," 21.

21. Semmel, "Tangble Past," 20.

22. Erle, "Viewing Waterloo," 49, 55.

23. Shaw, *Romantic Imagination*, 83.

24. Shaw, *Romantic Imagination*, 74.

25. Erle, "Viewing Waterloo," 58.

26. Erle, "Viewing Waterloo," 61.

27. Mary A. Favret, *War at a Distance: Romanticism and the Making of Modern Wartime* (Princeton, NJ: Princeton University Press, 2009), 15.

28. Shaw, *Romantic Imagination*, 2.

29. Reynolds, *Who Owned Waterloo?*, 45.

30. Semmel, "Tangible Past," 17.

31. François, "British 'Histourism,'" 32.

32. Catriona Kennedy, *Narratives of the Revolutionary and Napoleonic Wars: Military and Civilian Experience in Britain and Ireland* (New York: Palgrave Macmillan, 2013), 190–191.

33. Reynolds, *Who Owned Waterloo?*, 65.

34. Kennedy, *Napoleonic Wars*, 191.

35. Kate Hill, *Britain and the Narration of Travel in the Nineteenth Century: Texts, Images, Objects* (London: Routledge, 2016), 183.

36. Gareth Glover, *Waterloo in 100 Objects* (Gloucestershire, UK: History Press, 2015), 43.

37. Quoted in Antoine-Claire Thibaudeau, *Mémoires sur le Consulat, 1799 à 1804* (Chez Ponthieu, 1827), 83–84.

38. Semmel, "Tangible Past," 25.

39. Glover, *Waterloo in 100 Objects*, 95, 48.

40. Hill, *Narration of Travel*, 182.

41. Semmel, "Tangible Past," 24.

42. Reynolds, *Who Owned Waterloo?*, 67.

43. Semmel, "Tangible Past," 26.

44. Hurl-Eamon and MacKay, *Women, Families*.

45. Pearce, "*Matériel* of War," 216–220.

46. Evan Gottlieb, *Feeling British: Sympathy and National Identity in Scottish and English Writing, 1707–1832* (Lewisburg, PA: Bucknell University Press, 2007), 208.

47. M. K. H. Crumplin, "Surgery at Waterloo," *Journal of the Royal Society of Medicine* 81 (January 1988): 40–41.

48. Philip Shaw, *Suffering and Sentiment in Romantic Military Art* (London: Routledge, 2013), 175.

49. Ramsey and Russell, "Tracing War," 5.

50. Andrew Roberts, *Waterloo: Napoleon's Last Gamble* (New York: HarperCollins, 2005), 58.

51. Semmel, "Tangible Past," 12, 9.

52. Hill, *Narration of Travel*, 182, 176.

53. Reynolds, *Who Owned Waterloo?*, 45.

54. Maureen Daly Goggin and Beth Fowkes Tobin, "Connecting Women and Death: An Introduction," in *Women and the Material Culture of Death*, ed. Maureen Daly Goggin and Beth Fowkes Tobin (Farnham: Ashgate, 2013), 3.

55. François, "British 'Historium,'" 37.

56. Susan Matthews, "Charlotte Malkin's Waterloo Diary and the Politics of Waterloo Tourism," *Literature Compass* 11, no. 3 (March 2014).

57. Jolien Gijbels, "Tangible Memories: Waterloo Relics in the Nineteenth Century," *Rijksmuseum Bulletin* 63, no. 3 (2015): 241.

58. Shaw, *Romantic Imagination*, 70; Kennedy, *Napoleonic Wars*, 190.

59. Steffen Hantke and Agnieszka Soltysik Monnet, "Ghosts from the Battlefields: A Short Historical Introduction to the War Gothic," in *War Gothic in Literature and Culture*, ed. Steffen Hantke and Agnieszka Soltysik Monnet (London: Routledge, 2016).

60. Goggin and Tobin, "Women and Death," 1–2.

61. James Fox, "Poppy Politics: Remembrance of Things Present," in *Cultural Heritage Ethics: Between Theory and Practice*, ed. Constantine Sandis (Cambridge: Open Book, 2015), 22.

62. Russell, *Ephemeral Eighteenth Century*, 19.

63. Hantke and Monnet, "War Gothic."

64. Hurl-Eamon and MacKay, *Women, Families*.

65. Katherine Astbury, "Witnesses, Wives, Politicians, Soldiers: The Women of Waterloo," *The Conversation*, last modified June 12, 2015, https://theconversation .com/witnesses-wives-politicians-soldiers-the-women-of-waterloo-42648.

66. Hurl-Eamon and MacKay, *Women, Families*.

67. Ramsey and Russell, "Tracing War," 4.

68. Mary A. Favret, "Coming Home: The Public Spaces of Romantic War," *Studies in Romanticism* 33, no. 4 (Winter 1994).

69. François, "British 'Historium,'" 34.

70. Hurl-Eamon and MacKay, *Women, Families*.

71. Hantke and Monnet, "War Gothic."

72. François, "British 'Historium,'" 31.

73. Neil Asher Silberman, "Reshaping Waterloo," *Archaeology* 60, no. 1 (2007): 57.

Conclusion. Refiguring the Revolution in Mary Shelley's Rambles in Germany and Italy

1. Susan L. Siegfried, "Picturing the Battlefield of Victory: Document, Drama, Image," in Padiyar, Shaw, and Simpson, *Visual Culture and the Revolutionary and Napoleonic Wars*, 213.

2. Stuart Semmel, *Napoleon and the British* (New Haven, CT: Yale University Press, 2004), 226–227.

3. Jeanne Moskal, "Travel Writing," in *The Cambridge Companion to Mary Shelley*, ed. Esther Schor (Cambridge: Cambridge University Press, 2003), 242.

4. Jeanne Moskal, "Gender and Italian Nationalism in Mary Shelley's *Rambles in Germany and Italy*," *Romanticism* 5, no. 2 (1999): 188.

5. James Buzard, *The Beaten Track: European Tourism, Literature, and the Ways to "Culture," 1800–1918* (Oxford: Oxford University Press, 1993), 97–107.

6. Lynn Hunt and Jack R. Censer, *The French Revolution and Napoleon: Crucible of the Modern World* (London: Bloomsbury, 2017), viii.

7. Siegfried, "Picturing the Battlefield," 227.

8. Neil MacGregor, *Germany: Memoirs of a Nation* (New York: Penguin, 2014).

9. Mary Shelley, *Rambles in Germany and Italy in 1840, 1842, and 1843* (London: Edward Moxon, 1844), 1.175. Further citations of this work are given in the text.

10. Potts, *Souvenir*, 57, 72.

11. Joan Coutu, *Persuasion and Propaganda: Monuments and the Eighteenth-Century British Empire* (Montreal: McGill-Queens University Press, 2006), 8.

12. Coutu, *Persuasion and Propaganda*, 14.

13. Coutu, *Persuasion and Propaganda*, 11.

14. Poulot, "Musée Napoléon," 203.

15. Krzysztof Pomian, "Afterword: The Imperial Style of Collecting," in Gahtan and Troelenberg, *Collecting and Empires*, 381.

16. Poulot, "Musée Napoléon," 209.

17. Hans Pohlsander, *National Monuments and Nationalism in Nineteenth-Century Germany* (New York: Peter Lang, 2008), 23.

18. Poulot, "Musée Napoléon," 210.

19. Susan Broomhall and Jacqueline Van Gent, "The Gendered Power of Porcelain among Early Modern European Dynasties," in Daybell and Norrhem, *Gender and Political Culture in Early Modern Europe*, 63.

20. Adams, "Sèvres Porcelain."

21. Coutu, *Persuasion and Propaganda*, 21.

22. Ralph Mills, "A Chimney-Piece in Plumtree-Court, Holborn: Plaster of Paris 'Images' and Nineteenth-Century Working Class Material Culture," in *Paraphernalia! Victorian Objects*, ed. Kate Lister and Helen Kingstone (London: Routledge, 2018).

23. Tim Blanning, *Frederick the Great: King of Prussia* (New York: Random House, 2016), 497.

24. Louise Stevenson, *The Victorian Homefront: American Thought and Culture, 1860–1880* (Ithaca, NY: Cornell University Press, 2001), 5–8.

25. Simon Bainbridge, "Battling Bonaparte after Waterloo: Re-enactment, Representation, and 'The Napoleon Bust Business,'" in Ramsey and Russell, *Tracing War*, 141–145.

26. Anne Clifford, *Cut-Steel and Berlin Iron Jewelry* (New York: A. S. Barnes, 1971).

27. MacGregor, *Germany*.

28. Pamela Siska, "'The Things I So Indispensably Needed': Material Objects as a Reflection of Mary Shelley's Life," in *Material Women, 1750–1950: Consuming Desires and Collecting Practices*, ed. Maureen Daly Goggin and Beth Fowkes Tobin (Farnham: Ashgate, 2009): 26.

29. Laurence Cole, *Andreas Hofer: The Social and Cultural Construction of a National Myth in Tirol, 1809–1909* (Florence: European University Institute, 1994), 6.

30. Cole, *Andreas Hofer*.

31. Paul Pickering and Alex Tyrrell, *Contested Sites: Commemoration, Memorial and Popular Politics in Nineteenth-Century Britain* (London: Routledge, 2004).

32. Helen Weston, "The Many Faces of Toussaint Louverture," in *Slave Portraiture in the Atlantic World*, ed. Agnes Lugo-Ortiz and Angela Rosenthal (Cambridge: Cambridge University Press, 2012), 352.

33. Allan Lloyd Smith, "'This Thing of Darkness': Racial Discourse in Mary Shelley's *Frankenstein*," *Gothic Studies* 6, no. 2 (2004): 209.

34. Deirdre Coleman, "The Cultural Afterlives of Toussaint Louverture and the Haitian Revolution," in Ramsey and Russell, *Tracing War*, 88–89.

35. David A. Bell, *Men on Horseback: The Power of Charisma in the Age of Revolution* (New York: Farrar, Straus and Giroux, 2020), 126, 162.

36. Weston, "Toussaint Louverture," 349–357.

37. Peter Linebaugh and Marcus Rediker, *The Many-Headed Hydra: Sailors, Slaves, Commoners, and the Hidden History of the Revolutionary Atlantic* (Boston: Beacon, 2000), 241, 306.

Bibliography

Adams, Halina. "Imagining the Nation: Transforming the Bastille in Williams's *Letters Written in France* (1790)." *European Romantic Review* 25, no. 6 (2014): 723–741.

Adams, Steven. "Sèvres Porcelain and the Articulation of Imperial Identity in Napoleonic France." *Journal of Design History* 20, no. 3 (2007): 183–204.

Agulhon, Maurice. *Marianne into Battle: Republican Imagery and Symbolism in France, 1789–1880*. Cambridge: Cambridge University Press, 1981.

Altick, Richard. *The Shows of London*. Cambridge, MA: Belknap, 1978.

Appadurai, Arjun. "Introduction: Commodities and the Politics of Value." In *The Social Life of Things: Commodities in Cultural Perspective*, edited by Arjun Appadurai, 3–63. Cambridge: Cambridge University Press, 1986.

Astbury, Katherine. "Witnesses, Wives, Politicians, Soldiers: The Women of Waterloo." *The Conversation*, last modified June 12, 2015. https://theconversation.com/witnesses-wives-politicians-soldiers-the-women-of-waterloo-42648.

Bainbridge, Simon. "Battling Bonaparte after Waterloo: Re-enactment, Representation, and 'The Napoleon Bust Business.'" In *Tracing War in British Enlightenment and Romantic Culture*, edited by Neil Ramsey and Gillian Russell, 132–150. New York: Palgrave Macmillan, 2015.

Baird, Ileana. "Introduction: Peregrine Things: Rethinking the Global in Eighteenth-Century Studies." In *Eighteenth-Century Thing Theory in a Global Context: From Consumerism to Celebrity Culture*, edited by Ileana Baird and Christina Ionescu, 1–16. Farnham: Ashgate, 2013.

Baker, Julian. "Medals of the French Revolution." Ashmolean Museum. https://www.ashmolean.org/article/medals-french-revolution.

Balzer, Richard. *Peepshows: A Visual History*. New York: Harry N. Abrams, 1998.

Bauman, Richard A. *Women and Politics in Ancient Rome*. London: Routledge, 1992.

Behar, Katherine. "An Introduction to OOF." In *Object-Oriented Feminism*, edited by Katherine Behar, 1–36. Minneapolis: University of Minnesota Press, 2016.

Beik, Paul H. "Abbé Maury and the National Assembly." *Proceedings of the American Philosophical Society* 95, no. 5 (1951): 546–555.

Bell, David A. *Men on Horseback: The Power of Charisma in the Age of Revolution*. New York: Farrar, Straus and Giroux, 2020.

Benedict, Barbara M. *Curiosity: A Cultural History of Early Modern Inquiry*. Chicago: University of Chicago Press, 2001.

Bennett, Jane. "Systems and Things: On Vital Materialism and Object-Oriented Philosophy." In *The Nonhuman Turn*, edited by Richard Grusin, 223–239. Minneapolis: University of Minnesota Press, 2015.

———. *Vibrant Matter: A Political Ecology of Things*. Durham, NC: Duke University Press, 2010.

Berg, Maxine. *Luxury and Pleasure in Eighteenth-Century Britain*. Oxford: Oxford University Press, 2005.

Blackwell, Mark. *The Secret Life of Things: Animals, Objects, and It-Narratives in Eighteenth-Century England*. Stanford, CA: Stanford University Press, 2007.

Blanning, Tim. *Frederick the Great: King of Prussia*. New York: Random House, 2016.

Bohls, Elizabeth A. *Women Travel Writers and the Language of Aesthetics, 1716–1818*. Cambridge: Cambridge University Press, 1995.

Botting, Eileen Hunt. "Wollstonecraft in Europe, 1792–1904: A Revisionist Reception History." *History of European Ideas* 39, no. 4 (2013): 503–527.

Broomhall, Susan, and Jacqueline Van Gent. "The Gendered Power of Porcelain among Early Modern European Dynasties." In *Gender and Political Culture in Early Modern Europe, 1400–1800*, edited by James Daybell and Svante Norrhem, 49–67. London: Routledge, 2017.

Brown, Bill. "Thing Theory." *Critical Inquiry* 28, no. 1 (Autumn 2001): 1–21.

Burke, Edmund. *Reflections on the Revolution in France*. Edited by L. G. Mitchell. Oxford: Oxford University Press, 2009.

Butler, Marilyn, ed. *Burke, Paine, Godwin, and the Revolution Controversy*. Cambridge: Cambridge University Press, 1984.

Buzard, James. *The Beaten Track: European Tourism, Literature, and the Ways to "Culture," 1800–1918*. Oxford: Oxford University Press, 1993.

Callander, Michelle. "'The Grand Theatre of Political Changes': Marie Antoinette, the Republic, and the Politics of Spectacle in Mary Wollstonecraft's *An Historical and Moral View of the French Revolution*." *European Romantic Review* 11, no. 4 (2000): 375–392.

Chalus, Elaine. "Elite Women, Social Politics, and the Political World of Late Eighteenth-Century England." *Historical Journal* 43, no. 3 (2000): 669–697.

———. "Fanning the Flames: Women, Fashion, and Politics." In *Women, Popular Culture, and the Eighteenth Century*, edited by Tiffany Potter, 92–112. Toronto: University of Toronto Press, 2012.

———. "'That Epidemical Madness': Women and Electoral Politics in the Late Eighteenth Century." In *Gender in Eighteenth-Century England: Roles, Representations, and Responsibilities*, edited by Hannah Barker and Elaine Chalus, 151–178. London: Addison Wesley Longman, 1997.

Chalus, Elaine, and Fiona Montgomery. "Women and Politics." In *Women's History, Britain 1700–1850: An Introduction*, edited by Hannah Barker and Elaine Chalus, 217–259. London: Routledge, 2005.

Claeys, Gregory. *The French Revolution Debate in Britain: The Origins of Modern Politics*. New York: Palgrave Macmillan, 2007.

Clifford, Anne. *Cut-Steel and Berlin Iron Jewelry*. New York: A. S. Barnes, 1971.

Cole, Laurence. *Andreas Hofer: The Social and Cultural Construction of a National Myth in Tirol, 1809–1909*. Florence: European University Institute, 1994.

Coleman, Deirdre. "The Cultural Afterlives of Toussaint Louverture and the Haitian Revolution." In *Tracing War in British Enlightenment and Romantic Culture*, edited by Neil Ramsey and Gillian Russell, 77–95. New York: Palgrave Macmillan, 2015.

Colley, Linda. *Britons: Forging the Nation, 1707–1837*. New Haven, CT: Yale University Press, 1992.

Coole, Diana, and Samantha Frost, eds. *New Materialisms: Ontology, Agency, and Politics*. Durham, NC: Duke University Press, 2010.

Coutu, Joan. *Persuasion and Propaganda: Monuments and the Eighteenth-Century British Empire*. Montreal: McGill-Queens University Press, 2006.

Craciun, Adriana. *British Women Writers and the French Revolution: Citizens of the World*. New York: Palgrave Macmillan, 2005.

Crumplin, M. K. H. "Surgery at Waterloo." *Journal of the Royal Society of Medicine* 81 (January 1988): 38–42.

Curtis, Mattoon M. *The Story of Snuff and Snuff Boxes*. New York: Liveright, 1935.

Davies, Kate. "A Moral Purchase: Femininity, Commerce and Abolition, 1788–1792." In *Women, Writing and the Public Sphere, 1700–1830*, edited by Elizabeth Eger, Charlotte Grant, Clíona Ó Gallchoir, and Penny Warburton, 133–162. Cambridge: Cambridge University Press, 2001.

Davis, Leith. *Acts of Union: Scotland and the Literary Negotiation of the British Nation*. Stanford, CA: Stanford University Press, 1998.

Daybell, James, and Svante Norrhem. "Introduction: Rethinking Gender and Political Culture in Early Modern Europe." In *Gender and Political Culture in Early Modern Europe, 1400–1800*, edited by James Daybell and Svante Norrhem, 3–24. London: Routledge, 2017.

DeLanda, Manuel. *Assemblage Theory*. Edinburgh: Edinburgh University Press, 2016.

Demoor, Marysa. "Waterloo as a Small 'Realm of Memory': British Writers, Tourism, and the Periodical Press." *Victorian Periodicals Review* 48, no. 4 (Winter 2015): 453–468.

Du Tertre, Nancy. *The Art of the Limoges Box*. New York: Harry N. Abrams, 2003.

Dwyer, Philip G. "Napoleon and the Drive for Glory: Reflections on the Making of French Foreign Policy." In *Napoleon and Europe*, edited by Philip G. Dwyer, 118–135. London: Longman, 2001.

Dyer, Serena. "Portable Patriotism: Britannia and Material Nationhood in Miniature." In Smith and Tobin, *Small Things in the Eighteenth Century*, 240–256.

Dyer, Serena, and Chloe Wigston Smith. "Introduction." In *Material Literacy in Eighteenth-Century Britain: A Nation of Makers*, edited by Serena Dyer and Chloe Wigston Smith, 1–16. London: Bloomsbury, 2020.

Eaton, Charlotte Waldie, and Jane Waldie Watts. *Narrative of a Residence in Belgium during the Campaign of 1815 and of a Visit to the Field of Waterloo*. London: John Murray, 1817.

Ellison, Julie. "Redoubled Feeling: Politics, Sentiment and the Sublime in Williams and Wollstonecraft." *Studies in Eighteenth-Century Culture* 20 (1990): 197–215.

Emsley, Clive. *Britain and the French Revolution*. New York: Longman, 2000.

Erle, Sibylle. "Understanding the Field of Waterloo: Viewing Waterloo and the Narrative Strategies of the Panorama Programmes." *Interférences Littéraires* 20 (2017): 47–61.

Favret, Mary A. "Coming Home: The Public Spaces of Romantic War." *Studies in Romanticism* 33, no. 4 (Winter 1994): 539–548.

———. "Spectatrice as Spectacle: Helen Maria Williams at Home in the Revolution." *Studies in Romanticism* 32, no. 2 (Summer 1993): 273–295.

———. *War at a Distance: Romanticism and the Making of Modern Wartime.* Princeton, NJ: Princeton University Press, 2009.

Festa, Lynn. *Sentimental Figures of Empire in Eighteenth-Century Britain and France.* Baltimore: Johns Hopkins University Press, 2006.

Fleming, Kelly. "The Politics of Sophia Western's Muff." *Eighteenth-Century Fiction* 31, no. 4 (Summer 2019): 659–684.

Fordham, Douglas. "Costume Dramas: British Art at the Court of the Marathas." *Representations* 101, no. 1 (2008): 57–85.

Fox, James. "Poppy Politics: Remembrance of Things Present." In *Cultural Heritage Ethics: Between Theory and Practice*, edited by Constantine Sandis, 21–30. Cambridge: Open Book, 2015.

François, Pieter. "'The Best Way to See Waterloo Is with Your Eyes Shut': British 'Histourism,' Authenticity and Commercialisation in the Mid-Nineteenth Century." *Anthropological Journal of European Cultures* 22, no. 1 (2013): 26–41.

Furniss, Tom. "Mary Wollstonecraft's French Revolution." In *The Cambridge Companion to Mary Wollstonecraft*, edited by Claudia Johnson, 59–81. Cambridge: Cambridge University Press, 2002.

Galbally, Emma, and Conrad Brunström. "'This Dreadful Machine': The Spectacle of Death and the Aesthetics of Crowd Control." In *The Gothic and Death*, edited by Carol Margaret Davison, 63–75. Manchester: Manchester University Press, 2017.

Gerritsen, Ann, and Giorgio Riello. "The Global Lives of Things: Material Culture in the First Global Age." In *The Global Lives of Things: The Material Culture of Collections in the Early Modern World*, edited by Ann Gerritsen and Giorgio Riello, 1–28. London: Routledge, 2016.

Gijbels, Jolien. "Tangible Memories: Waterloo Relics in the Nineteenth Century." *Rijksmuseum Bulletin* 63, no. 3 (2015): 228–257.

Gleadhill, Emma. *Taking Travel Home: The Material Culture of British Women Tourists, 1770–1830.* Manchester: Manchester University Press, 2022.

Gleadhill, Emma, and Ekaterina Heath. "Giving Women History: A History of Ekaterina Dashkova through Her Gifts to Catherine the Great and Others." *Women's History Review* 31, no. 3 (2022): 361–386.

Glover, Gareth. *Waterloo in 100 Objects.* Gloucestershire, UK: History Press, 2015.

Goggin, Maureen Daly, and Beth Fowkes Tobin. "Connecting Women and Death: An Introduction." In *Women and the Material Culture of Death*, edited by Maureen Daly Goggin and Beth Fowkes Tobin, 1–10. Farnham: Ashgate, 2013.

Goodman, Jessica. "'Le peuple veut du sang': The Guillotine and the General Will in Revolutionary Pamphlet Theatre." In *Death Sentences: Literature and State Killing*, edited by Birte Christ and Ève Morisi, 57–77. Oxford: Legenda, 2019.

Gordon, Beverly. "The Souvenir: Messenger of the Extraordinary." *Journal of Popular Culture* 20, no. 3 (Winter 1986): 135–146.

Gottlieb, Evan. *Feeling British: Sympathy and National Identity in Scottish and English Writing, 1707–1832.* Lewisburg, PA: Bucknell University Press, 2007.

Gough, Hugh. *The Terror in the French Revolution.* London: Bloomsbury, 2010.

Grootenboer, Hanneke. "Afterword: A Thing's Perspective." In Smith and Tobin, *Small Things in the Eighteenth Century,* 291–294.

Grusin, Richard, ed. *The Nonhuman Turn.* Minneapolis: University of Minnesota Press, 2015.

Hantke, Steffen, and Agnieszka Soltysik Monnet. "Ghosts from the Battlefields: A Short Historical Introduction to the War Gothic." In *War Gothic in Literature and Culture,* edited by Steffen Hantke and Agnieszka Soltysik Monnet. London: Routledge, 2016.

Harris, Jennifer. "The Red Cap of Liberty: A Study of Dress Worn by French Revolutionary Partisans 1789–94." *Eighteenth Century Studies* 14, no. 3 (1981): 283–312.

Herbert, Amanda. *Female Alliances: Gender, Identity, and Friendship in Early Modern Britain.* New Haven, CT: Yale University Press, 2014.

Heuer, Jennifer. "Hats on for the Nation! Women, Servants, Soldiers and the 'Sign of the French.'" *French History* 16, no. 1 (2002): 28–52.

Hill, Kate. *Britain and the Narration of Travel in the Nineteenth Century: Texts, Images, Objects.* London: Routledge, 2016.

Hunt, Lynn, and Jack R. Censer. *The French Revolution and Napoleon: Crucible of the Modern World.* London: Bloomsbury, 2017.

Hurl-Eamon, Jennine, and Lynn MacKay. *Women, Families, and the British Army, 1700–1880.* London: Routledge, 2020.

Hyde, Ralph. *Paper Peepshows: The Jaqueline and Jonathan Gestetner Collection.* New York: Antique Collectors' Club, 2015.

Iantorno, Luke A. "Revolutionary Games: Helen Maria Williams's Playtime at the Apocalypse." *CEA Critic* 7, no. 1 (2017): 87–96.

Janes, Regina. *Losing Our Heads: Beheadings in Literature and Culture.* New York: New York University Press, 2005.

Jenkins, Ron. *Subversive Laughter: The Liberating Power of Comedy.* New York: Free Press, 1994.

Jones, Mark. "Medals of the French Revolution." *RSA Journal* 137, no. 5398 (September 1989): 640–646.

Keane, Angela. *Women Writers and the English Nation in the 1790s.* Cambridge: Cambridge University Press, 2000.

Kelly, Gary. *Revolutionary Feminism: The Mind and Career of Mary Wollstonecraft.* New York: St. Martin's, 1992.

———. *Women, Writing and Revolution, 1790–1827.* Oxford: Oxford University Press, 1993.

Kennedy, Catriona. *Narratives of the Revolutionary and Napoleonic Wars: Military and Civilian Experience in Britain and Ireland.* New York: Palgrave Macmillan, 2013.

Kennedy, Deborah. *Helen Maria Williams and the Age of Revolution.* Lewisburg, PA: Bucknell University Press, 2002.

Kenny, Kevin, ed. *Ireland and the British Empire*. Oxford: Oxford University Press, 2004.

Kirkley, Laura. *Mary Wollstonecraft: Cosmopolitan*. Edinburgh: Edinburgh University Press, 2022.

Kobza, Meghan. "Dazzling or Fantastically Dull? Re-examining the Eighteenth-Century London Masquerade." *Journal for Eighteenth-Century Studies* 43, no. 2 (2020): 161–181.

———. "The Habit of Habits: Material Culture and the Eighteenth-Century London Masquerade." *Studies in Eighteenth-Century Culture* 50 (2021): 265–293.

Kohle, Hubertus, and Rolf Reichardt. *Visualizing the Revolution: Politics and Pictorial Arts in Late Eighteenth-Century France*. London: Reaktion Books, 2008.

Lake, Crystal B. *Artifacts: How We Think and Write about Found Objects*. Baltimore: Johns Hopkins University Press, 2020.

———. "On the Smallness of Numismatic Objects." In Smith and Tobin, *Small Things in the Eighteenth Century*, 79–94.

Landes, Joan B. *Visualizing the Nation: Gender, Representation, and Revolution in Eighteenth-Century France*. Ithaca, NY: Cornell University Press, 2001.

Latour, Bruno. "The Berlin Key or How to Do Words with Things." In *Matter, Materiality and Modern Culture*, edited by P. M. Graves-Brown, 10–21. London: Routledge, 2000.

———. *Reassembling the Social: An Introduction to Actor-Network-Theory*. Oxford: Oxford University Press, 2005.

Leask, Nigel. *Curiosity and the Aesthetics of Travel Writing, 1770–1840*. Oxford: Oxford University Press, 2002.

LeBlanc, Jacqueline. "Politics and Commercial Sensibility in Helen Maria Williams' *Letters from France*." *Eighteenth Century Life* 21, no. 1 (February 1997): 26–44.

Leis, Arlene, and Kacie L. Wills. "Introduction: Women and the Cultures of Collecting." In *Women and the Art and Science of Collecting in Eighteenth-Century Europe*, edited by Arlene Leis and Kacie L. Wills, 1–18. London: Routledge, 2020.

Levy, Darline Gay, and Harriet B. Applewhite. "Women and Militant Citizenship in Revolutionary Paris." In *Rebel Daughters: Women and the French Revolution*, edited by Sara E. Melzer and Leslie W. Rabine, 79–101. Oxford: Oxford University Press, 1992.

Linebaugh, Peter, and Marcus Rediker. *The Many-Headed Hydra: Sailors, Slaves, Commoners, and the Hidden History of the Revolutionary Atlantic*. Boston: Beacon, 2000.

Londonderry, Edith. "Introduction." In *The Russian Journals of Martha and Catherine Wilmot*, edited by Edith Londonderry and Harford Montgomery Hyde, xiii–xxvi. London: Macmillan, 1934.

Lüsebrink, Hans-Jürgen, and Rolf Reichardt. *The Bastille: A History of a Symbol of Despotism and Freedom*. Translated by Norbert Schürer. Durham, NC: Duke University Press, 1997.

Lynch, Deidre. "Personal Effects and Sentimental Fictions." *Eighteenth-Century Fiction* 12, no. 2–3 (2000): 345–368.

MacGregor, Arthur. *Curiosity and Enlightenment: Collectors and Collections from the Sixteenth to the Nineteenth Century.* New Haven, CT: Yale University Press, 2008.

MacGregor, Neil. *Germany: Memoirs of a Nation.* New York: Penguin, 2014.

Marso, Lori J. "Defending the Queen: Wollstonecraft and Staël on the Politics of Sensibility and Feminine Difference." *Eighteenth Century* 43, no. 1 (2002): 43–60.

Matlock, Jann. "Miniature Style, 1789–1815." In *Time, Media, and Visuality in Post-Revolutionary France*, edited by Iris Moon and Richard Taws, 27–55. London: Bloomsbury, 2021.

Matthews, Susan. "Charlotte Malkin's Waterloo Diary and the Politics of Waterloo Tourism." *Literature Compass* 11, no. 3 (2014): 218–231.

Mauss, Marcel. *The Gift: The Form and Reason for Exchange in Archaic Societies.* Translated by W. D. Halls. London: Routledge, 2002.

McCaffrey-Howarth, Caroline. "Revolutionary Histories in Small Things: Louis XVI and Marie Antoinette on Printed Ceramics, c. 1793–1796." In Smith and Tobin, *Small Things in the Eighteenth Century*, 257–273.

McCausland, Hugh. *Snuff and Snuff Boxes.* London: Batchworth, 1951.

McClellan, Andrew. *Inventing the Louvre: Art, Politics, and the Origins of the Modern Museum in Eighteenth-Century Paris.* Berkeley: University of California Press, 1994.

Mills, Ralph. "A Chimney-Piece in Plumtree-Court, Holborn: Plaster of Paris 'Images' and Nineteenth-Century Working Class Material Culture." In *Paraphernalia! Victorian Objects*, edited by Kate Lister and Helen Kingstone, 59–73. London: Routledge, 2018.

Moon, Iris. "Rupture, Interrupted: Rococo Recursions and Political Futures in Percier and Fontaine's Napoleon Fan." In *Time, Media, and Visuality in Post-Revolutionary France*, edited by Iris Moon and Richard Taws, 57–79. London: Bloomsbury, 2021.

Moon, Iris, and Richard Taws. "Introduction." In *Time, Media, and Visuality in Post-Revolutionary France*, edited by Iris Moon and Richard Taws, 1–26. London: Bloomsbury, 2021.

Moskal, Jeanne. "Gender and Italian Nationalism in Mary Shelley's *Rambles in Germany and Italy.*" *Romanticism* 5, no. 2 (1999): 188–201.

———. "Travel Writing." In *The Cambridge Companion to Mary Shelley*, edited by Esther Schor, 242–258. Cambridge: Cambridge University Press, 2003.

Navickas, Katrina. "'That Sash Will Hang You': Political Clothing and Adornment in England, 1780–1840." *Journal of British Studies* 49, no. 3 (2010): 540–565.

Ngai, Sianne. *Our Aesthetic Categories: Zany, Cute, Interesting.* Cambridge, MA: Harvard University Press, 2012.

Ogata, Amy F. "Viewing Souvenirs: Peepshows and the International Expositions." *Journal of Design History* 15, no. 2 (2002): 69–82.

O'Neill, Daniel I. "John Adams versus Mary Wollstonecraft on the French Revolution and Democracy." *Journal of the History of Ideas* 68, no. 3 (2007): 451–476.

O'Rourke, Stephanie. "Beholder, Beheaded: Theatrics of the Guillotine and the Spectacle of Rupture." In *Visual Culture and the Revolutionary and Napoleonic Wars*, edited by Satish Padiyar, Philip Shaw, and Philippa Simpson, 25–39. London: Routledge, 2017.

Packham, Catherine. "Domesticity, Objects, and Idleness: Mary Wollstonecraft and Political Economy." *Women's Writing* 19, no. 4 (2012): 544–562.

Park, Julie. *The Self and It: Novel Objects in Eighteenth-Century England*. Stanford, CA: Stanford University Press, 2010.

Pascoe, Judith. *The Hummingbird Cabinet: A Rare and Curious History of Romantic Collectors*. Ithaca, NY: Cornell University Press, 2006.

Pearce, Susan M. "The *Matériel* of War: Waterloo and Its Culture." In *Conflicting Visions: War and Visual Culture in Britain and France*, edited by John Bonehill and Geoff Quilley, 207–226. Farnham: Ashgate, 2005.

———. *On Collecting: An Investigation into Collecting in the European Tradition*. London: Routledge, 1995.

Pickering, Paul, and Alex Tyrrell. *Contested Sites: Commemoration, Memorial and Popular Politics in Nineteenth-Century Britain*. London: Routledge, 2004.

Pohlsander, Hans. *National Monuments and Nationalism in Nineteenth-Century Germany*. New York: Peter Lang, 2008.

Pointon, Marcia. *Brilliant Effects: A Cultural History of Gem Stones and Jewellery*. New Haven, CT: Yale University Press, 2009.

———. *Hanging the Head: Portraiture and Social Formation in Eighteenth-Century England*. New Haven, CT: Yale University Press, 1993.

———. *Strategies for Showing: Women, Possession, and Representation in English Visual Culture 1665–1800*. Oxford: Oxford University Press, 1997.

———. "'Surrounded with Brilliants': Miniature Portraits in Eighteenth-Century England." *Art Bulletin* 3, no. 1 (March 2001): 48–71.

———. "Women and Their Jewels." In *Women and Material Culture, 1660–1830*, edited by Jennie Batchelor and Cora Kaplan, 11–30. New York: Palgrave Macmillan, 2007.

Pomian, Krzysztof. "Afterword: The Imperial Style of Collecting." In *Collecting and Empires: An Historical and Global Perspective*, edited by Maia Wellington Gahtan and Eva-Marie Troelenberg, 372–383. London: Harvey Miller, 2019.

Potts, Rolf. *Souvenir*. New York: Bloomsbury, 2018.

Poulot, Dominique. "The Musée Napoléon as an Imperial Louvre." In *Collecting and Empires: An Historical and Global Perspective*, edited by Maia Wellington Gahtan and Eva-Marie Troelenberg, 197–217. London: Harvey Miller, 2019.

Rabb, Melinda Alliker. *Miniature and the English Imagination: Literature, Cognition, and Small-Scale Culture, 1650–1765*. Cambridge: Cambridge University Press, 2019.

Raeff, Marc. "The Emergence of the Russian European: Russia as a Full Partner of Europe." In *Russia Engages the World, 1453–1825*, edited by Cynthia Hyla Whittaker, 118–137. Cambridge, MA: Harvard University Press, 2003.

Ramsey, Neil, and Gillian Russell. "Introduction: Tracing War in Enlightenment and Romantic Culture." In *Tracing War in British Enlightenment and Romantic Culture*, edited by Neil Ramsey and Gillian Russell, 1–15. New York: Palgrave Macmillan, 2015.

Reynolds, Luke. *Who Owned Waterloo? Battle, Memory, and Myth in British History, 1815–1852*. Oxford: Oxford University Press, 2022.

Roberts, Andrew. *Waterloo: Napoleon's Last Gamble*. New York: HarperCollins, 2005.

Russell, Gillian. *The Ephemeral Eighteenth Century: Print, Sociability, and the Cultures of Collecting*. Cambridge: Cambridge University Press, 2020.

Sadleir, Thomas U. "Introduction." In *An Irish Peer on the Continent 1801–1803*, edited by Thomas U. Sadleir, v–xiii. London: Williams and Norgate, 1920.

Sapiro, Virginia. *A Vindication of Political Virtue: The Political Theory of Mary Wollstonecraft*. Chicago: University of Chicago Press, 1992.

Schama, Simon. *Citizens: A Chronicle of the French Revolution*. New York: Knopf, 1989.

Semmel, Stuart. *Napoleon and the British*. New Haven, CT: Yale University Press, 2004.

———. "Reading the Tangible Past: British Tourism, Collecting, and Memory after Waterloo." *Representations* 69 (Winter 2000): 9–37.

Shaw, Philip. *Suffering and Sentiment in Romantic Military Art*. London: Routledge, 2013.

———. *Waterloo and the Romantic Imagination*. New York: Palgrave Macmillan, 2002.

Shelley, Mary. *Rambles in Germany and Italy in 1840, 1842, and 1843*. 2 vols. London: Edward Moxon, 1844.

Siegfried, Susan L. "Picturing the Battlefield of Victory: Document, Drama, Image." In *Visual Culture and the Revolutionary and Napoleonic Wars*, edited by Satish Padiyar, Philip Shaw, and Philippa Simpson, 213–245. London: Routledge, 2017.

Silberman, Neil Asher. "Reshaping Waterloo." *Archaeology* 60, no. 1 (2007): 53–58.

Siska, Pamela. "'The Things I So Indispensably Needed': Material Objects as a Reflection of Mary Shelley's Life." In *Material Women, 1750–1950: Consuming Desires and Collecting Practices*, edited by Maureen Daly Goggin and Beth Fowkes Tobin, 17–31. Farnham: Ashgate, 2009.

Smith, Allan Lloyd. "'This Thing of Darkness': Racial Discourse in Mary Shelley's *Frankenstein*." *Gothic Studies* 6, no. 2 (2004): 208–222.

Smith, Chloe Wigston, and Beth Fowkes Tobin. "Introduction: The Scale and Sense of Small Things." In Smith and Tobin, *Small Things in the Eighteenth Century*, 1–11.

———, eds. *Small Things in the Eighteenth Century: The Political and Personal Value of the Miniature*. Cambridge: Cambridge University Press, 2022

Smith, R. E. F., and David Christian. *Bread and Salt: A Social and Economic History of Food and Drink in Russia*. Cambridge: Cambridge University Press, 1984.

Spang, Rebecca L. *Stuff and Money in the Time of the French Revolution*. Cambridge, MA: Harvard University Press, 2017.

St. Clair, William. *Lord Elgin and the Marbles*. Oxford: Oxford University Press, 1998.

Steinberg, Ronen. "Between Silence and Speech: Spectres and Images in the Aftermath of the Reign of Terror." *Acta Academica* 47, no. 1 (2015): 247–265.

Stevenson, Louise. *The Victorian Homefront: American Thought and Culture, 1860–1880*. Ithaca, NY: Cornell University Press, 2001.

Stewart, Susan. *On Longing: Narratives of the Miniature, the Gigantic, the Souvenir, the Collection*. Durham, NC: Duke University Press, 1993.

Stolbova, Elena Igorevna. "Portraits of Princess Dashkova." In *The Princess and the Patriot: Ekaterina Dashkova, Benjamin Franklin, and the Age of Enlightenment*, edited by Sue Ann Prince, 97–104. Philadelphia: American Philosophical Society, 2006.

Swann, Marjorie. *Curiosities and Texts: The Culture of Collecting in Early Modern England*. Philadelphia: University of Pennsylvania Press, 2001.

Taws, Richard. "The Guillotine as Anti-Monument." *Sculpture Journal* 19, no. 1 (2010): 33–48.

———. *The Politics of the Provisional: Art and Ephemera in Revolutionary France*. University Park: Penn State University Press, 2013.

Thibaudeau, Antoine-Claire. *Mémoires sur le Consulat, 1799 à 1804*. Chez Ponthieu, 1827.

Todd, Janet. "Introduction." In *A Vindication of the Rights of Men; A Vindication of the Rights of Woman; An Historical and Moral View of the French Revolution*, edited by Janet Todd, vii–xxx. Oxford: Oxford University Press, 1993.

Tomaselli, Sylvana. *Wollstonecraft: Philosophy, Passion, and Politics*. Princeton, NJ: Princeton University Press, 2020.

Van Sant, Ann Jessie. *Eighteenth-Century Sensibility and the Novel: The Senses in Social Context*. Cambridge: Cambridge University Press, 1993.

Vassilieva-Codognet, Olga. "The French Language of Fashion in Early Nineteenth-Century Russia." In *French and Russian in Imperial Russia: Language, Attitudes, and Identity*, edited by Derek Offord, Lara Ryazanova-Clarke, Vladislav Rjeoutski, and Gesine Argent, 156–178. Edinburgh: Edinburgh University Press, 2015.

Wallace, Constance. "Symbols of the French Revolution: Colors of Cockades, Fabric and Their Importance in Politics of 1789." *North Alabama Historical Review* 3, no. 3 (2013): 31–53.

Walpole, Horace. *The Yale Edition of Horace Walpole's Correspondence*. 48 vols. Edited by W. S. Lewis. New Haven, CT: Yale University Press, 1965.

Weng, Yi-Cheng. "An 'Englishwoman's Private Theatrical': Helen Maria Williams and the New Female Citizen." *EurAmerica* 49, no. 3 (September 2019): 341–374.

Weston, Helen. "The Many Faces of Toussaint Louverture." In *Slave Portraiture in the Atlantic World*, edited by Agnes Lugo-Ortiz and Angela Rosenthal, 345–374. Cambridge: Cambridge University Press, 2012.

White, Ashli. "On Ribbon and Revolution: Rethinking Cockades in the Atlantic." *Age of Revolutions*, last modified March 25, 2019. https://ageofrevolutions.com/2019/03/25/on-ribbon-and-revolution-rethinking-cockades-in-the-atlantic/.

———. *Revolutionary Things*. New Haven, CT: Yale University Press, 2023.

Wilkinson, Tom. *Bricks and Mortals: Ten Great Buildings and the People They Made*. London: Bloomsbury, 2014.

Williams, Helen Maria. *Letters from France*. 8 vols. Edited by Janet M. Todd. Delmar, NY: Scholars' Facsimiles and Reprints, 1975.

Wilmot, Catherine. *An Irish Peer on the Continent 1801–1803*. Edited by Thomas U. Sadleir. London: Williams and Norgate, 1920.

Wilmot, Martha, and Catherine Wilmot. *The Russian Journals of Martha and Catherine Wilmot*. Edited by Edith Londonderry and Harford Montgomery Hyde. London: Macmillan, 1934.

Winter, Bronwyn. "Marianne Goes Multicultural: *Ni putes ni soumises* and the Republicanisation of Ethnic Minority Women in France." In *French History and*

Civilization: Papers from the George Rudé Seminar 2, edited by Vesna Drapac and André Lambelet, 228–240. Melbourne: George Rudé Society, 2009.

Wolf, Alexis. "The 'Original' Journals of Katherine Wilmot: Women's Travel Writing in the Salon of Helen Maria Williams." *European Romantic Review* 30, no. 5–6 (2019): 615–637.

Wollstonecraft, Mary. *An Historical and Moral View of the French Revolution* (1794). In *The Works of Mary Wollstonecraft*, edited by Janet Todd and Marilyn Butler, 1–235. New York: New York University Press, 1989.

———. *A Vindication of the Rights of Woman*. Amherst, NY: Prometheus, 1989.

Young, Alfred F. *Liberty Tree: Ordinary People and the American Revolution*. New York: New York University Press, 2006.

Zarucchi, Jeanne Morgan. "Medals Catalogues of Louis XIV: Art and Propaganda." *Notes in the History of Art* 17, no. 4 (Summer 1998): 26–34.

Index

Page numbers in italics refer to figures.

Abandonment of Privileges, 57, 58
actant, 9–10
Adams, Halina, 18, 39, 40
alliances. *See* international alliances
American War of Independence, 15, 33
Antwerp, Belgium, 106
Apollo Belvedere, 80, 81
Appadurai, Arjun, 39
artifact compared to souvenir, 8
Artifacts (Lake), 8
assemblages, 10, 11
assignats, 31–32, 32
At Home and Abroad (Eaton), 107

Bainbridge, Simon, 144
Balzer, Richard, 48–49
Barker, Henry Aston, 108, 109, 113
Barker, Robert, 108
Barrett, Eaton Stannard, 125
Bastille, the: guillotine shows compared
 to, 51; horrors of, 18–19; medals, 20–21,
 21; scale model, 16, 18–20, 19; siege of,
 17–18; souvenirs from prison materi-
 als, 21–26; stone set alongside
 diamonds, 38–40; symbol of mon-
 arch's dictatorial rule, 17
battlefield relics: brass eagles, 106,
 118–120, 119; cuirasses, 118, 120; Eaton's
 purchase of, 116–117, 120–121; as
 exhibition of patriotism, 117; inau-
 thentic objects, 121; Legion of Honor
 cross, 118; as participation in British
 victory, 107, 118, 120–122; Scottish
 Highlanders at Battle of Waterloo, 107,
 122–123; trade in military relics,
 116–117. *See also* Eaton, Charlotte;
 Narrative of a Residence in Belgium
battlefield tourism, 106
Behar, Katherine, 10

Belgium, 115
Benedict, Barbara M., 78, 84, 87, 88
Bennett, Jane, 9–10, 11
Berg, Maxine, 79, 93, 94
Blerzy, Joseph Etienne, 92
Bohls, Elizabeth, 16, 103
Bologna, Italy, 83
Bonaparte, Joséphine, 140
Boulton, Matthew, 65
Bourbon, House of, 53
Brandenburg Gate, 139, 140, 141
British Museum, 88
Brulart, Madame (Comtesse de Genlis),
 38–40
Brussels, Belgium, 106
Burke, Edmund, 3, 16, 25, 53, 54–55, 68

cabinet of art, compared to museum, 5–6
cabinets of curiosities, 76–77, 77. *See also*
 Wilmot, Catherine: curiosity
 collecting
Callander, Michelle, 45, 55, 69
Canova, Antonio, 81–82
Cashell, Lady, 76
Cashell, Lord, 76
Catherine the Great, 78, 90–91, 92, 93, 98
Catherine II. *See* Catherine the Great
Catholic Church, 31–32, 48–49
Chalus, Elaine, 5, 34, 37
Chateau de Hougoumont (Dighton),
 132, 133
China, fabric from, 98
"citizen of the world," 42
cockade, tricolor: motivation for
 revolutionary activism, 71, 72, 73;
 symbolism of, 5, 11, 34–35, 35, 66, 74.
 See also Williams, Helen Maria:
 tricolor cockade; Wollstonecraft,
 Mary: wearing of cockade

on Great Britain's reactionary response to Revolution, 64–65; luxury and sensibility as objects of corruption, 45; National Assembly as profane theater, 61; on performance by aristocracy, 69; reason for violence, 54–55; on revolution in female manners, 66; support for French democracy, 3; use of material culture, 45–46; use of medals (*see* medals: "fatal mock patriotism"); use of rare-show, 12 (*see also* rare-show); wearing of cockade, 5, 11, 71, 74; Williams's influence on, 43, 44; *A Vindication of the Rights of Men*, 44; *A Vindication of the Rights of Woman*, 66; visit to Versailles, 52–54. See also *Historical and Moral View of the French Revolution, An*

women: education, 44; freedom, 22, 69, 73; as memory keepers, 125–126 (*see also* women and souvenir collecting); perceived as objects, 0–11, 66; rights not extended to, 65; simple clothing styles, 71, 73; tragedy souvenirs and effects of war on women, 107, 125, 130–132

women and souvenir collecting: challenge to gender roles, 8–9; contributions to national identity, 1, 6; during Grand Tour, 2–3, 8; empowered by physical proof of eyewitness experience, 3; feminine fashion as responses to political events, 4–5; jewels (*see* jewelry and female activism); looters at battle sites, 131; masculine realm of war redefined, 6–7; means to advocate for citizenship, 5, 41–42; means of conveying political ideas, 3–4; opportunities for public involvement, 1, 4–5, 9; political identity and, 5, 11; souvenir exchange and international alliances, 1–2. *See also* home; *specific souvenir*

Women's March on Versailles, 65–66, 71, 73

Wordsworth, William, 17, 107, 146

About the Author

PAMELA BUCK is an associate professor of English at Sacred Heart University in Fairfield, Connecticut. Her research focuses on women's writing and material culture in late eighteenth- and early nineteenth-century British literature.